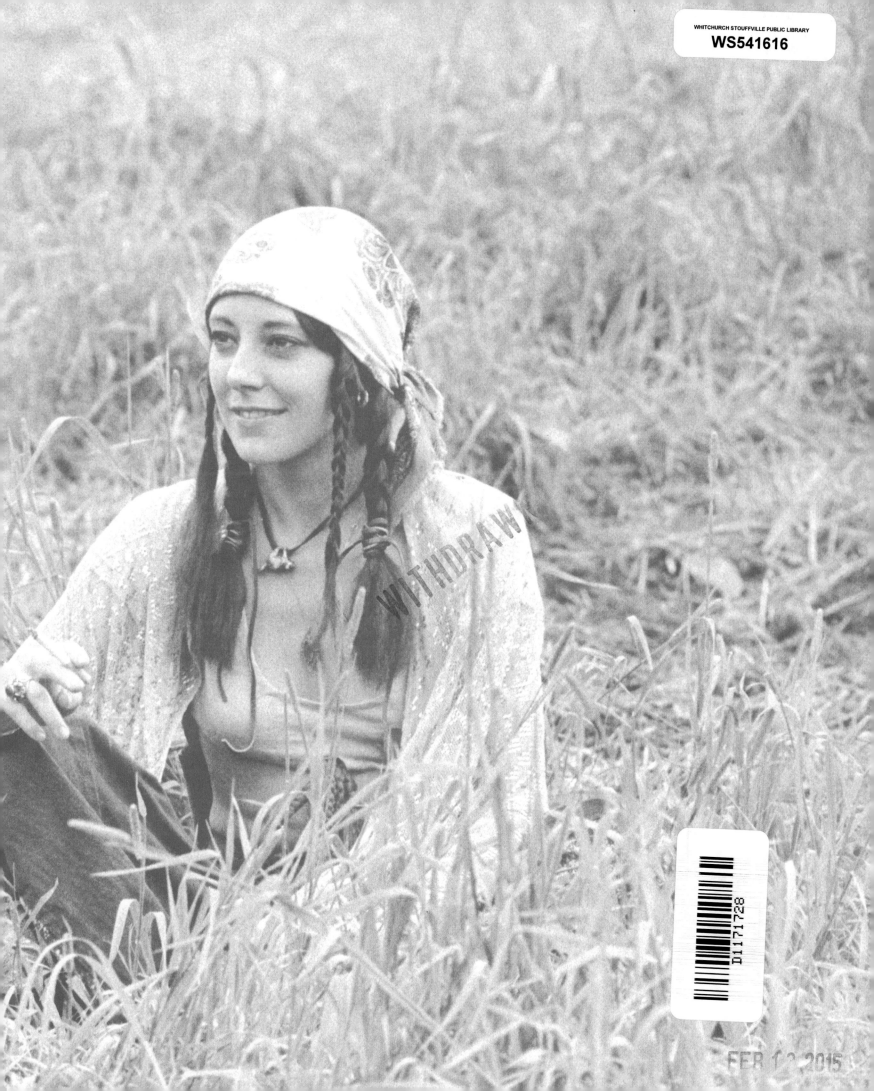

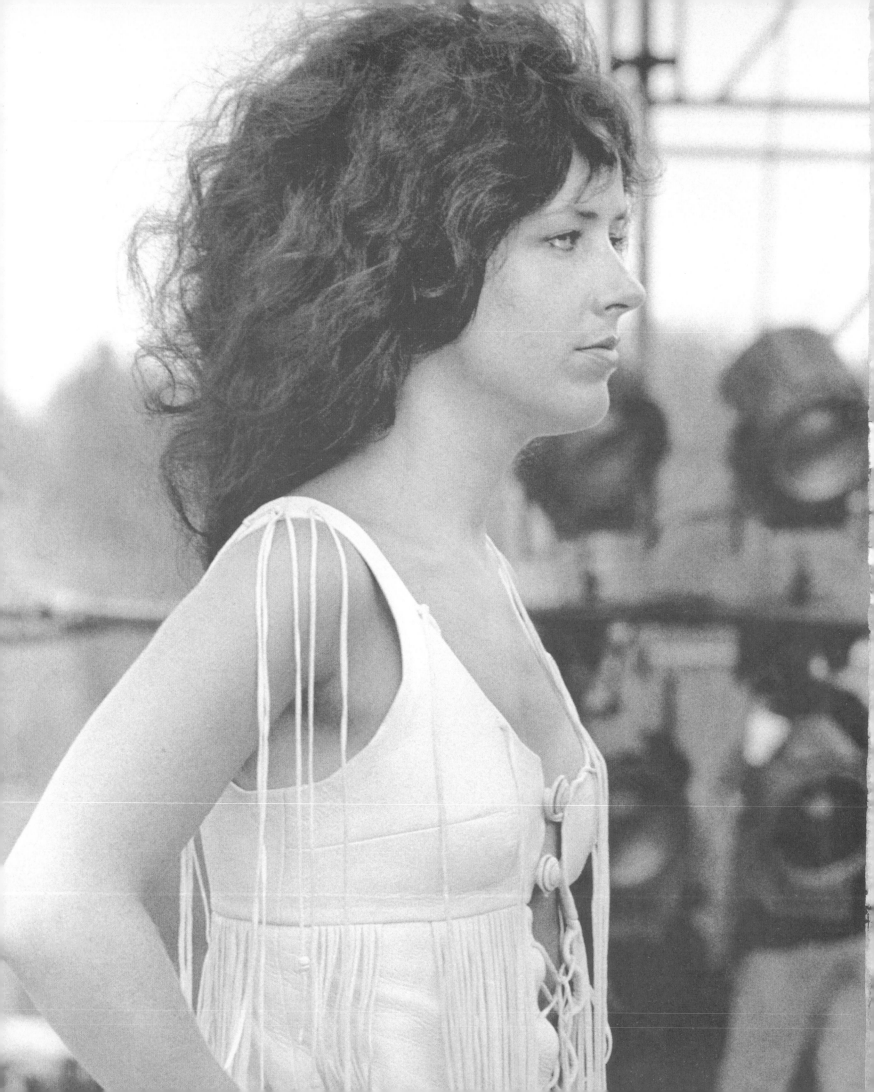

WOODSTOCK

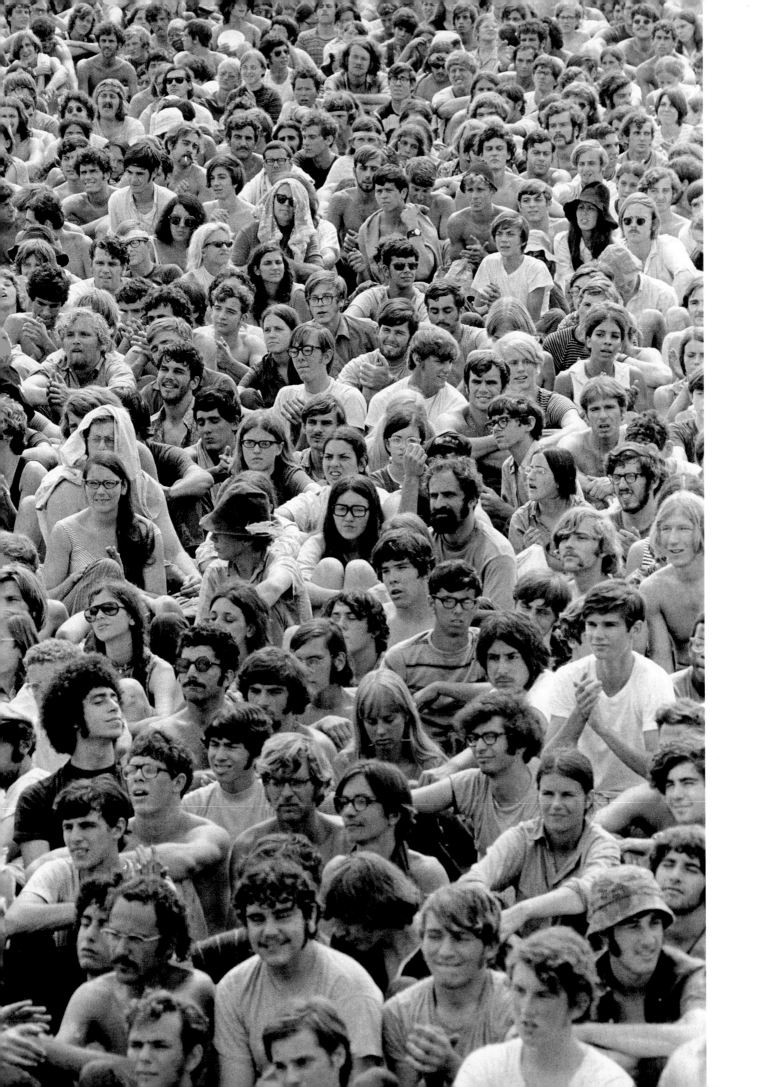

WOODSTOCK

PHOTOGRAPHS BY

BARON WOLMAN

R|A|P

REEL ART PRESS

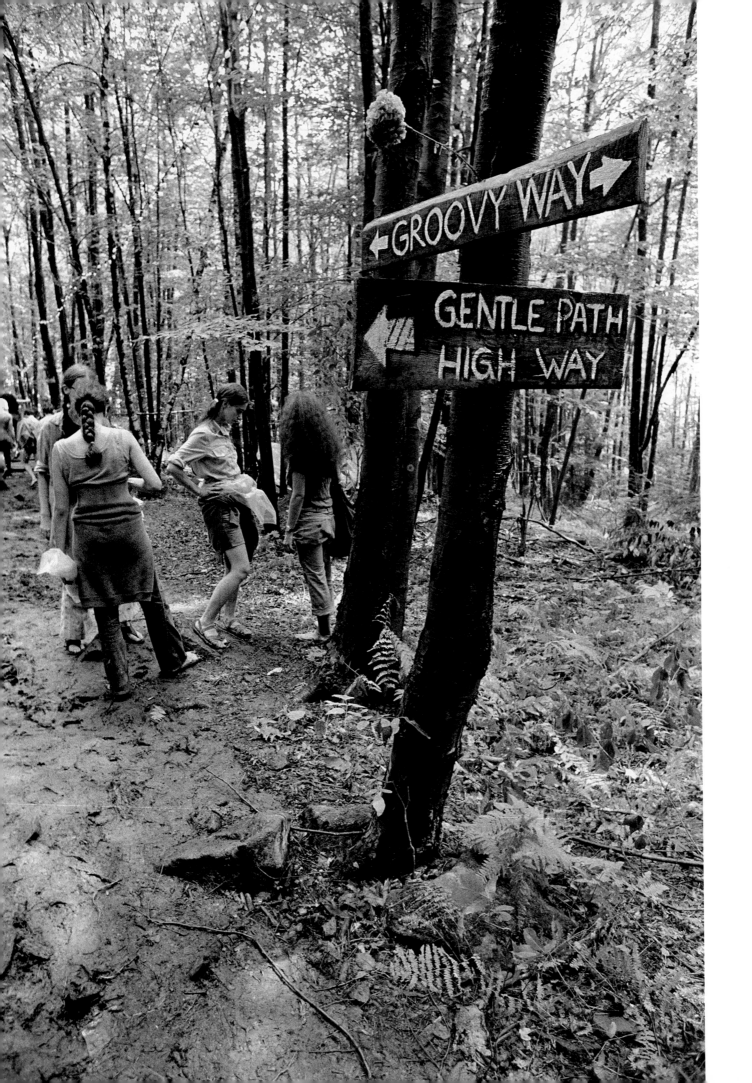

WITH

MICHAEL LANG

FOREWORD BY

CARLOS SANTANA

EDITED BY

DAGON JAMES

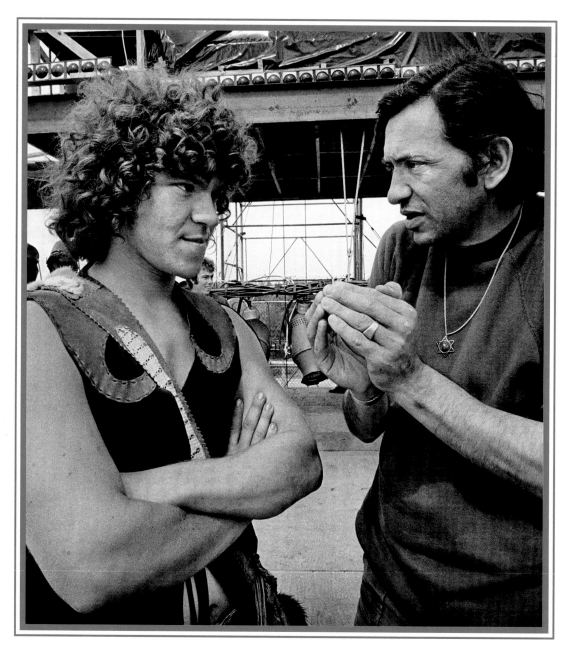

Michael Lang and Bill Graham photographed by Jim Marshall.

WE ARE GOLDEN

BARON WOLMAN

No one could have predicted the enduring influence of the Woodstock experience. Yes, the bands were first-rate and there were many of them. And the location, isolated in nature as it was, was picture-perfect and tranquil, a bucolic setting for relaxing with friends and listening to music and getting high. But in unexpected ways, Woodstock became more than a concert for all of us. For me, for my photographer friend Jim Marshall who took this photo of Michael Lang and Bill Graham, and for Michael and Bill themselves. I can only speak for myself and indirectly for Jim. All summer long he and I had been shotgun riders as we traversed the country photographing a variety of music festivals. Woodstock trumped them all – there was no way to compare what we came upon that August weekend in Bethel to any other concert anywhere, ever. For three days, Jim pretty much stayed on the stage and behind the stage, tripping with the best of them and still producing impeccable and memorable photographs. I, on the other hand, was fascinated, captivated, enchanted and transfixed by the crowd, the hundreds of thousands of kind and gentle souls who made the trek to Yasgur's farm. It was the people upon whom I focused my cameras. I wandered among them daily, taking pictures, building a personal diary of three miraculous days that I somehow knew were both a promise and an aberration. We held out hope that the former would characterize our future lives. Yet, as we look back, we realize with great sadness it was the latter that became the world we live in. Jim Marshall is now but a memory, as is Bill Graham, as are those three days of peace, love and music. I remember them all with great fondness and affection, and give thanks to the photo gods who put me and my cameras at that place, at that time, and gave me the foresight to remember the moment in pictures.

Baron Wolman
Santa Fe, 2013

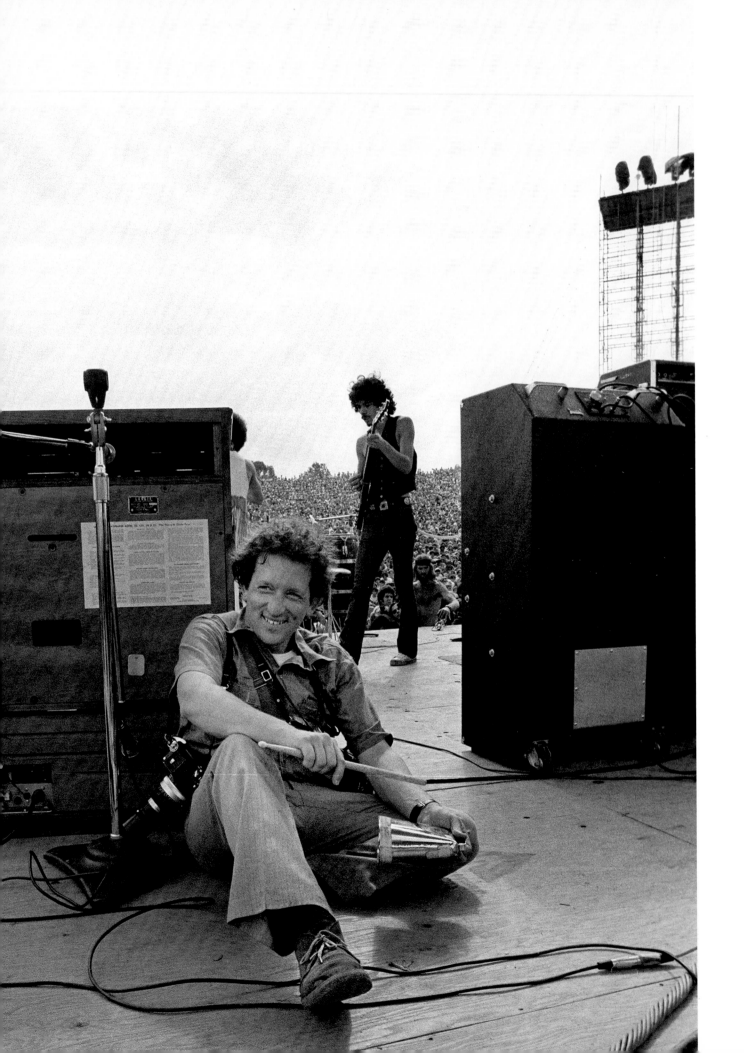

FOREWORD

CARLOS SANTANA

For me, Woodstock begins with my good friend Bill Graham. I remember when I was young and Bill would often catch me sneaking into the Fillmore, he would get really angry, looking at me like he was Yul Brynner in *The King and I.* After being caught several times I finally said, "Bill, I only have enough money to get into the first show. I'm a dishwasher, I love to play guitar and I don't have enough money for the second show but I've got to see Eric, Jimi, B.B. King and Paul Butterfield!" Bill finally surrendered, adopted me in friendship and really took me under his wing when I got my band together. Bill was the first person before Miles Davis or Tito Puente who invested emotionally in my band, he hovered over us, wanted to know what we were doing, he groomed us for our path in music.

One day, Bill said, "Carlos, I want you and the band to come to Sausalito to talk about this festival I want to get you in, it's called Woodstock, but first I want to tell you what's happening with Sly and Jimi and Jim Morrison. They're all getting in trouble because their heads have gotten too big and the same shit is going to happen to you." I said, "Awe man, we're just dudes from Mission High School, that's not going to happen to us." ... "Oh, it's going to happen to you," he said. He really cared about us.

Officially Bill wasn't our manager, he was more of a mentor, which was fortunate because if Bill had been our manager we wouldn't have ended up on very good terms. Bill was very opinionated, set in his ways; it was always his way or the highway. Even up until the week before he passed, Bill was still trying to persuade me that he should be my manager. I quoted Dylan to him, "I'll let you be in my dreams if I can be in yours." He was a promoter, an impresario, not a musician, and he would have tried to tell me what to do so much that it would have been the end of our friendship. The last thing Bill ever said to me was, "If you ever get stuck on the ten yard line, call me." I loved Bill.

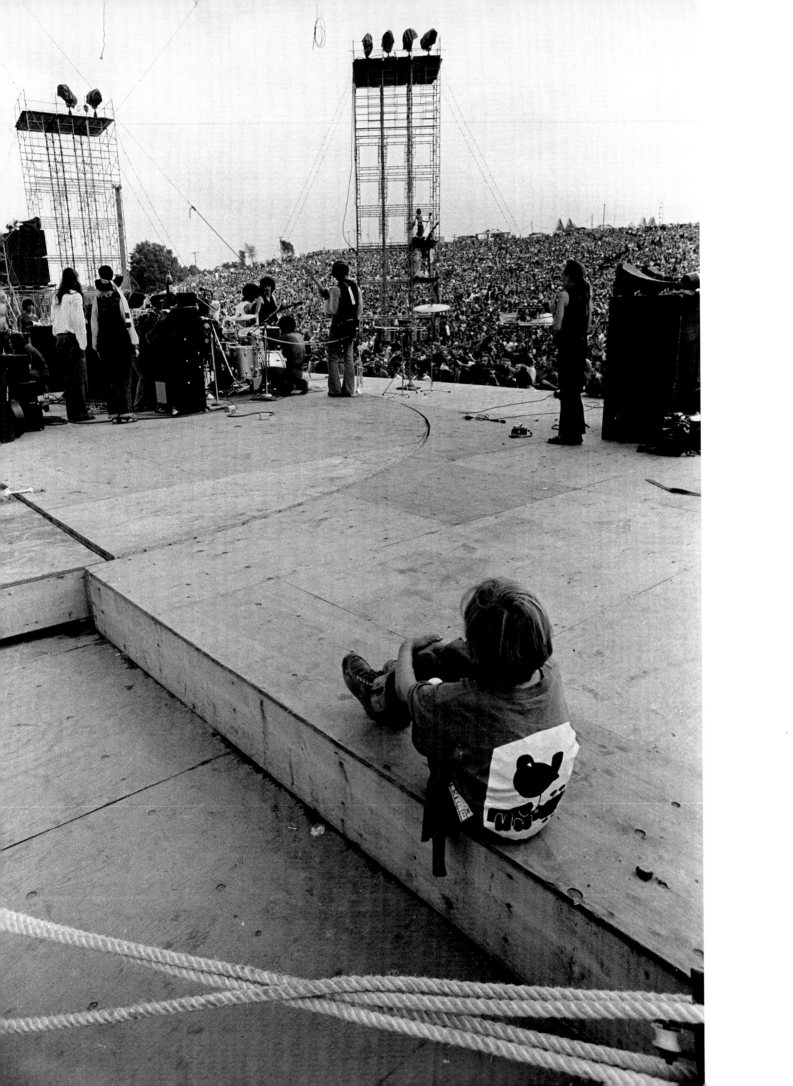

In the early days Bill helped us get started by booking us shows at the Fillmore West and other cities on the West Coast, opening for artists like Steppenwolf, The Who, Grateful Dead; we opened for everybody. Bill was really smart and he trained us psychologically like you would train a boxer. Bill knew that Woodstock was important and as it approached he talked other festivals into putting us on so we could get used to larger crowds and not be petrified by the time we got to Woodstock. We set out on a two week tour which started at a festival in Texas where we played for about 15,000 people. From there we played a festival in Atlanta for about 40,000, we had never seen crowds that big before. Eventually we made our way to New York, where we played a show in Flushing Meadows with Buddy Miles and shows at the Fillmore East on August 1st and 2nd. It was a four act bill with Three Dog Night, Sha Na Na, Canned Heat and Santana. At first everyone was like, "Who the hell is Santana? Get off the stage!" But as soon we got into playing, the mood in the room changed. Everyone was like, "Oh shit!" because we were bringing what the other groups were bringing and more. We were heavy but with the flavor of Tito Puente and Olatunji.

By the time we got to Woodstock two weeks later we were ready. I remember flying in on the helicopter, looking down at all the people thinking, "Oh my god, it's like a single living organism. An ocean of hair and teeth and eyes and arms!" The sound of the crowd was so loud you could hear it over the sound of the helicopter engine. Bill was right, this was amazing!

We got in early and were hanging around when I ran into Jerry Garcia who asked, "Do you want to take some … whatever?" I said, "Sure, we don't go on until after midnight; it's only 2 p.m. now, I'll be perfect by then, right?" Well, that's not how it happened at all. Just as the mescaline was coming on a face appeared and said, "Carlos, you need to go on now or you're not going to play at all." As we went out on stage I was asking, "God, please help me stay in tune and on time and I'll never do this shit again. I'll never mess with mescaline or any of that stuff, I promise it will be my last time." As we started playing I repeated my mantra over and over to myself, "Keep in tune and on time, in tune and on time …" When you see the film and the way I look it's because I was wrestling with the tension of paranoia and fear but I didn't ever let it dominate me. It was like when you tell someone, "I'm busy, I don't have time for this right now." The neck was slithering like a snake in my hand and through my playing I was dominating the snake, trying to keep it still. After we finished playing it hit me even more and I felt like an amoeba, I was so high with my beach ball eyes and I had to reboot. The experience of Woodstock was scary for me personally but in the end it all turned out well for us.

The next year I was in New York and went to see Jimi in his hotel but he had just left for Hawaii. His lady, Devon Wilson, was there and she said, "Let's go see the *Woodstock* movie." I was surprised. "There's a *Woodstock* movie?" She said, "Man, let me tell you, when you guys went on it flipped out Jimi so much. It really made an impact on him the way you attacked the music."

Woodstock was a real turning point in my career, and since then my life has only been an abundance of blessings and opportunities.

Carlos Santana
Las Vegas, 2013

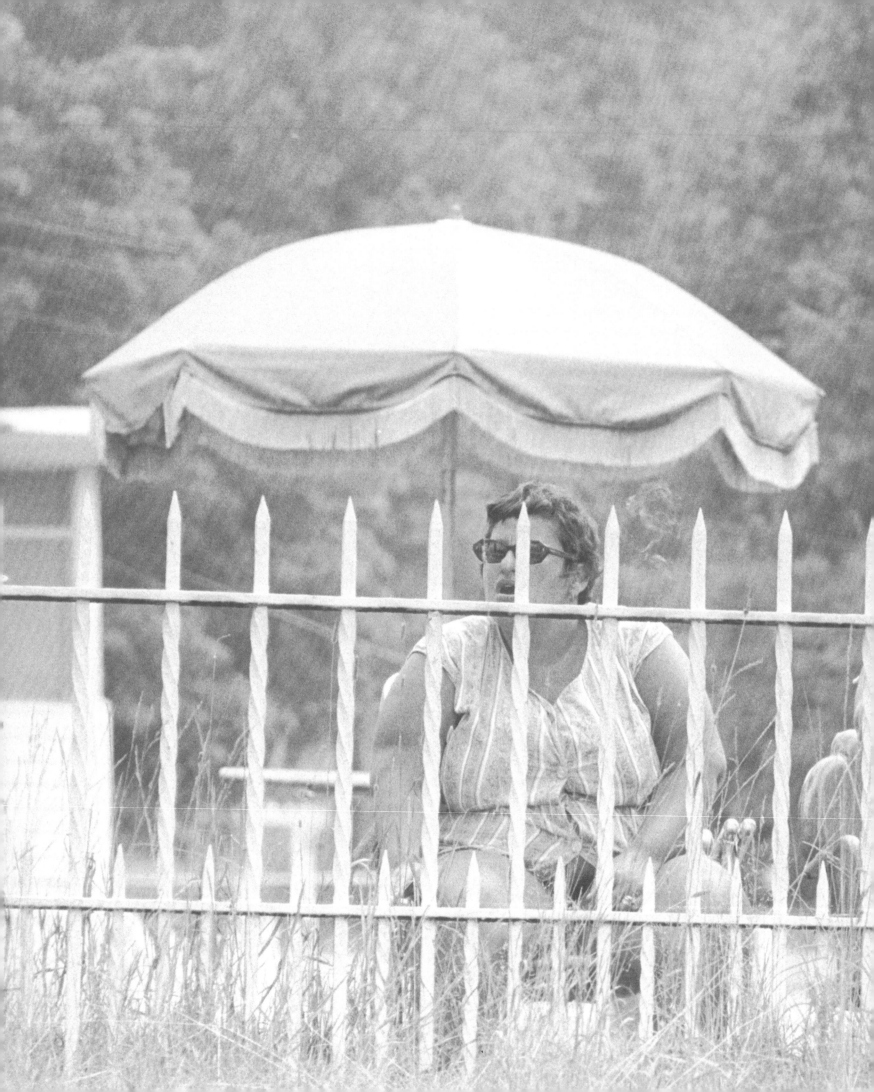

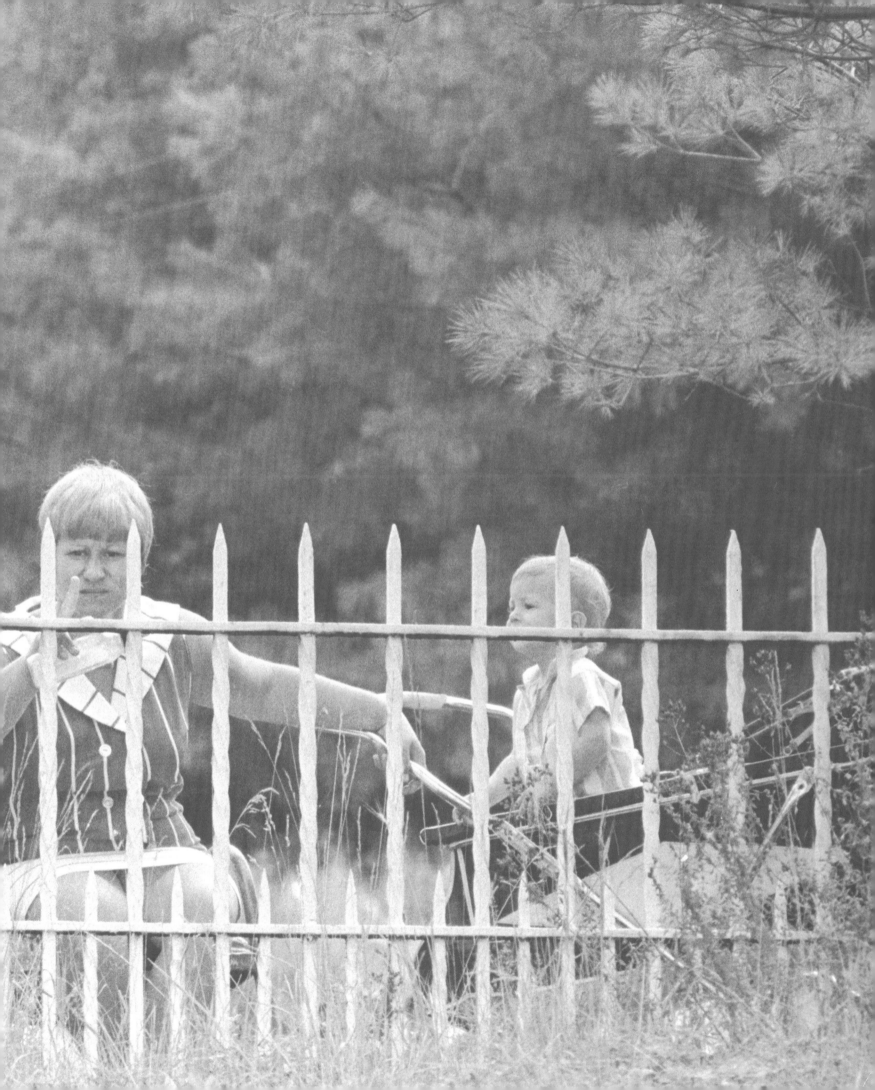

"

*Woodstock
speaks to the hopes
of that generation
and even so
many years later
the spirit of Woodstock
hasn't diminished,
it's endured.*

"

- Michael Lang

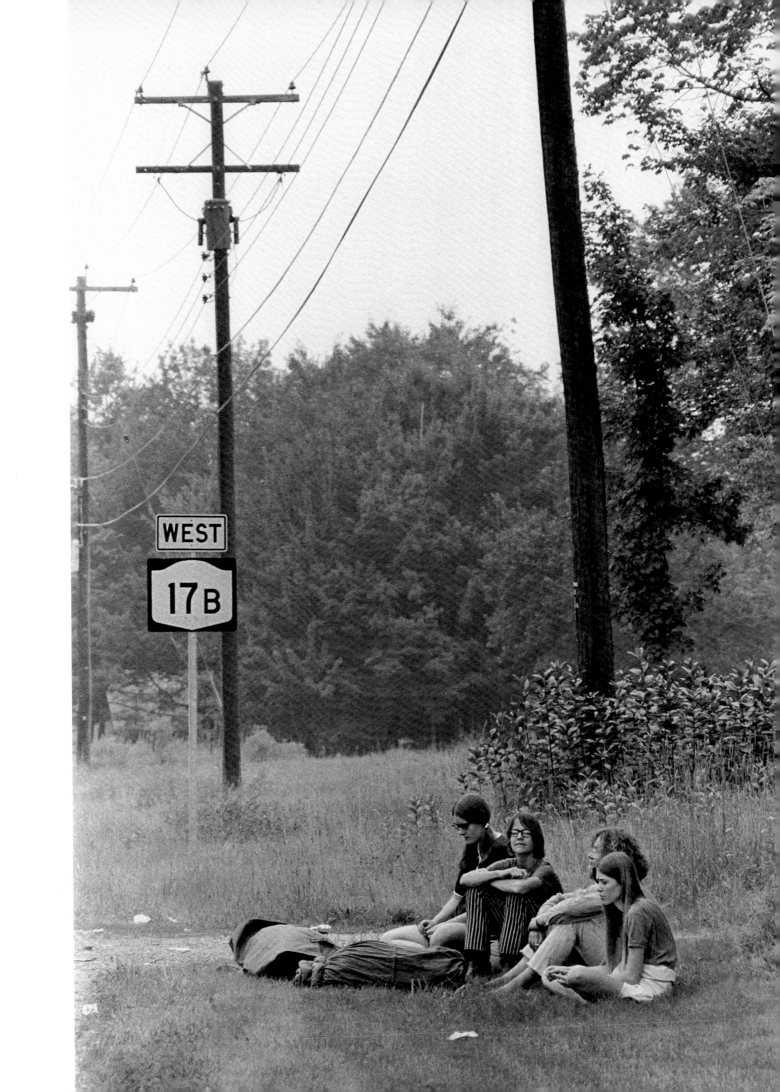

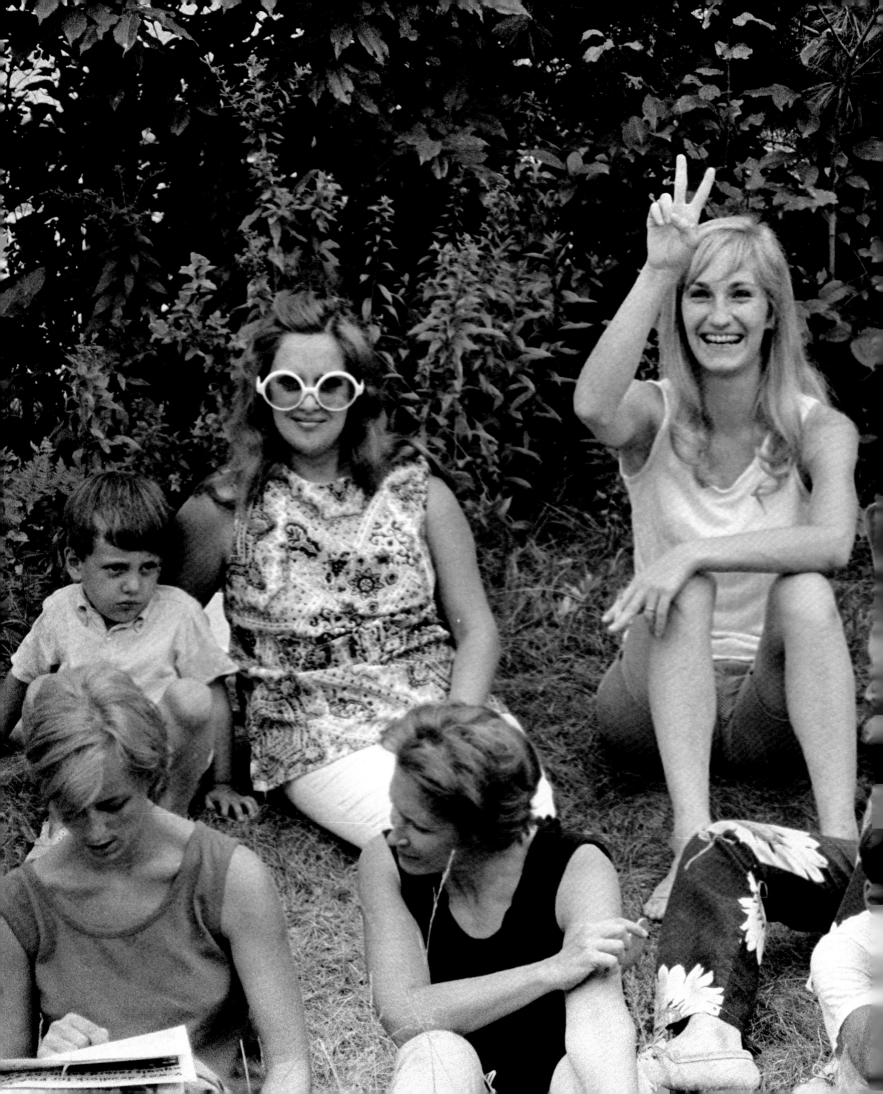

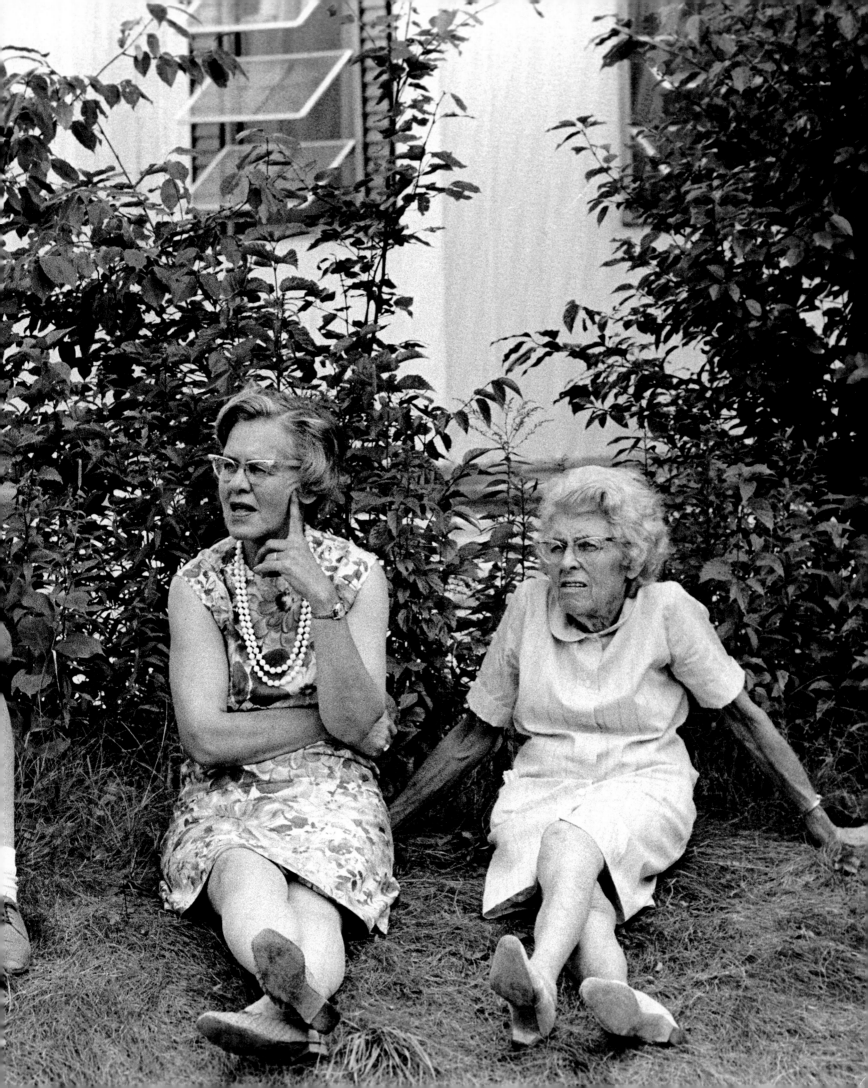

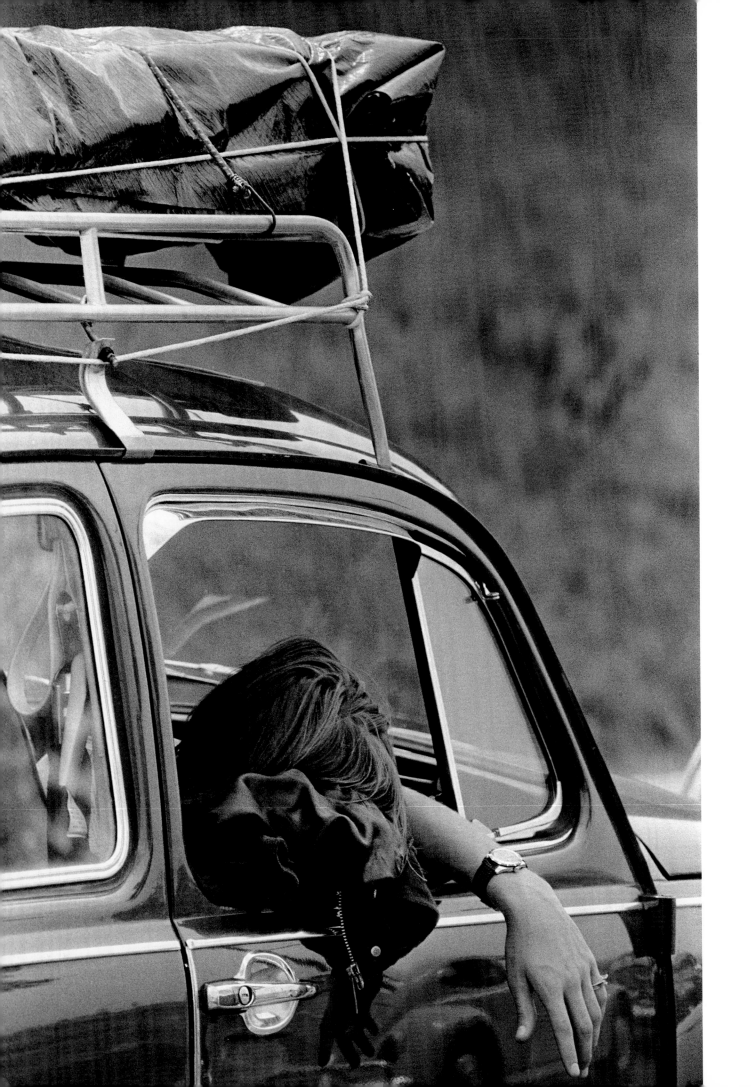

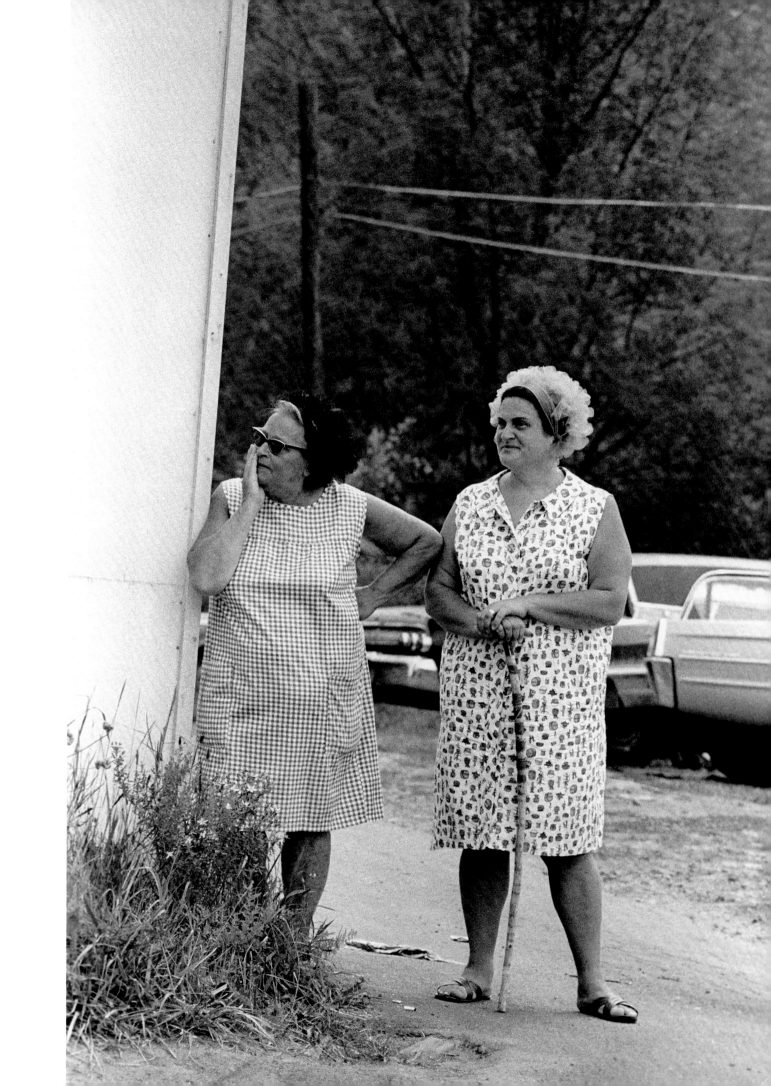

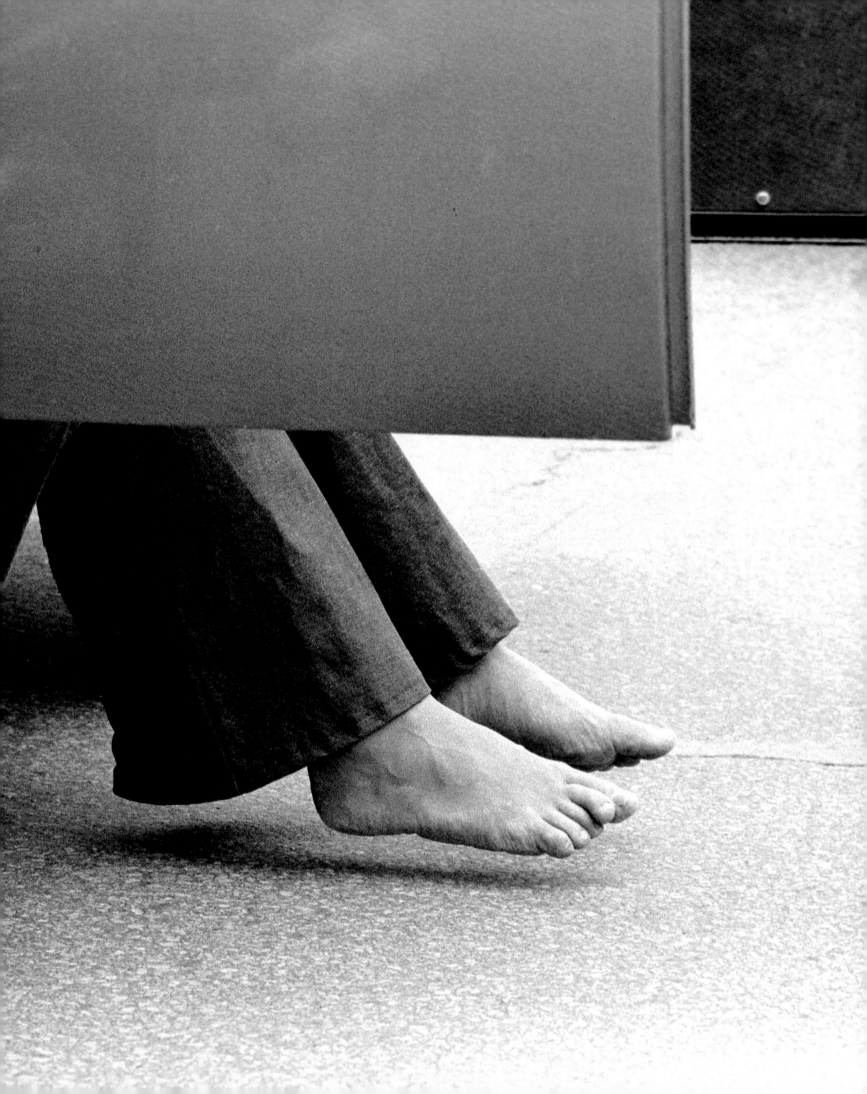

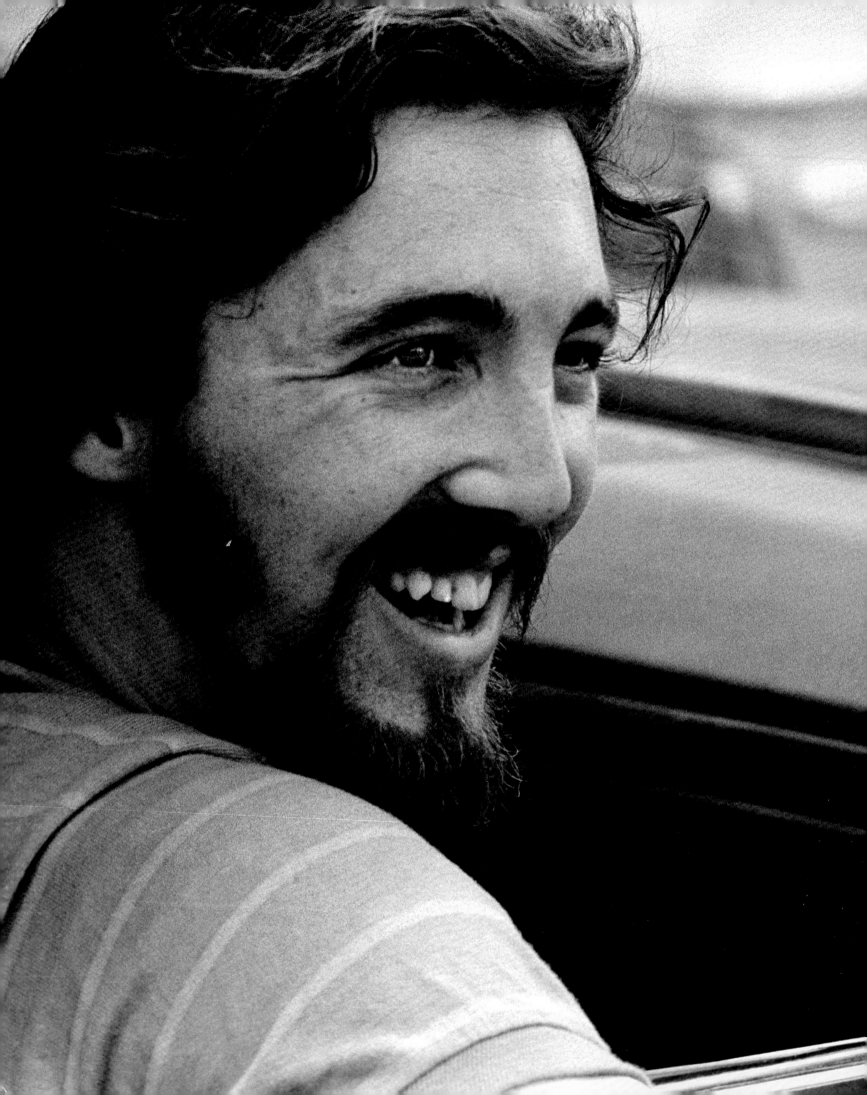

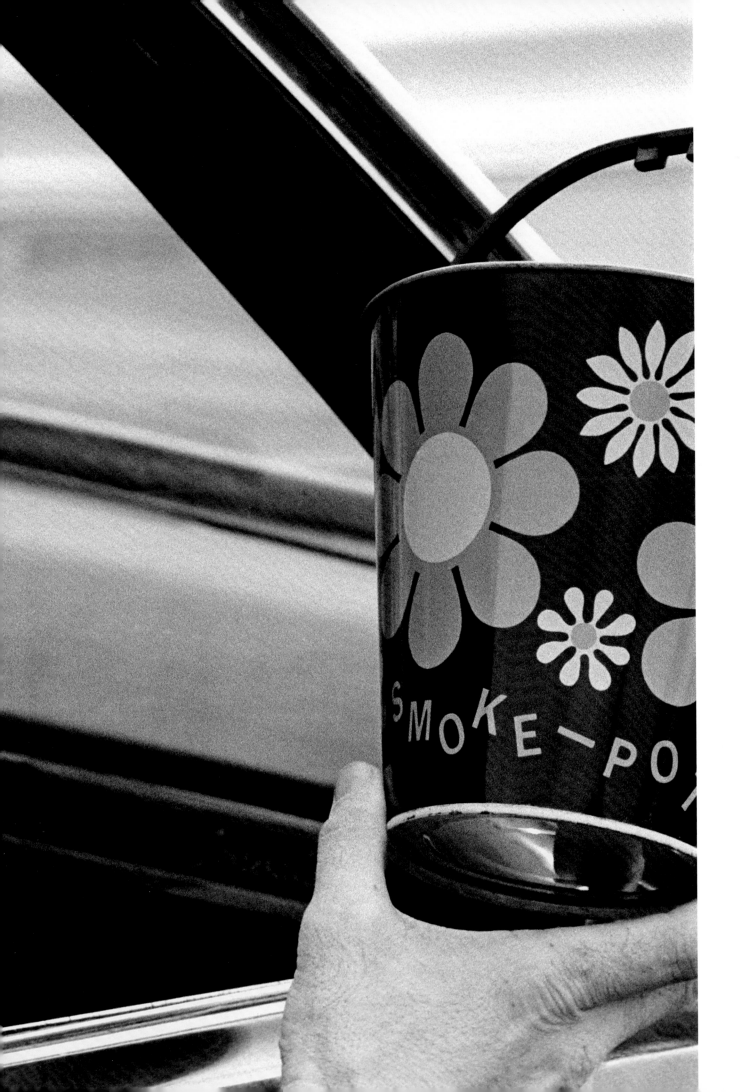

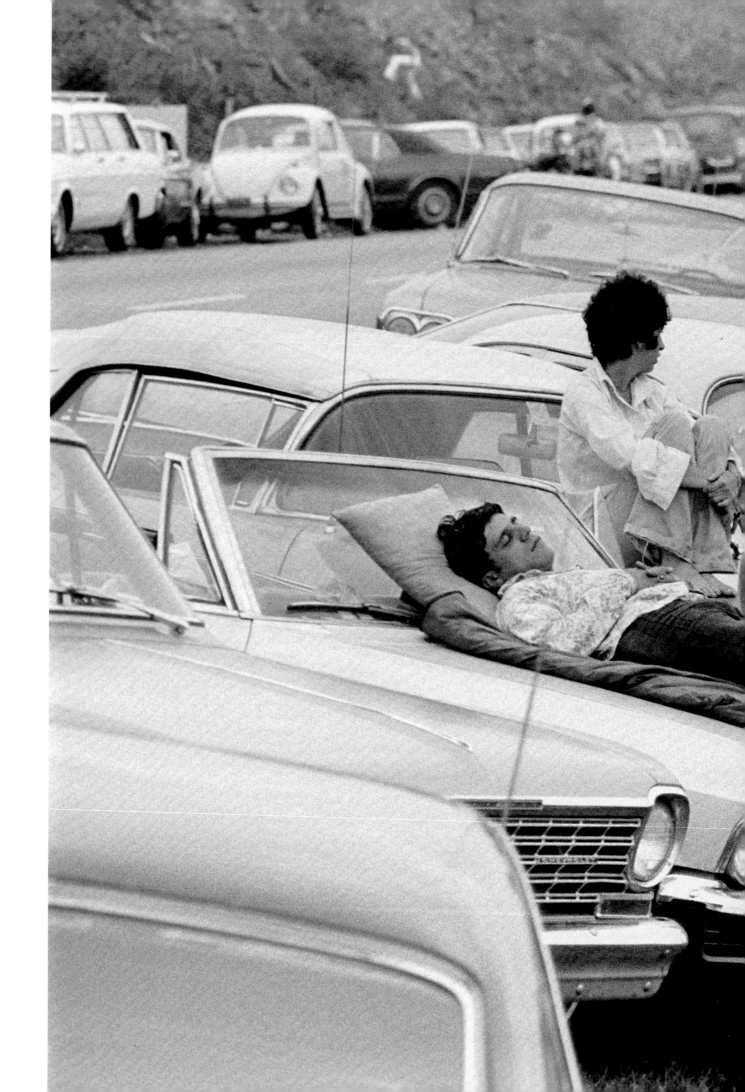

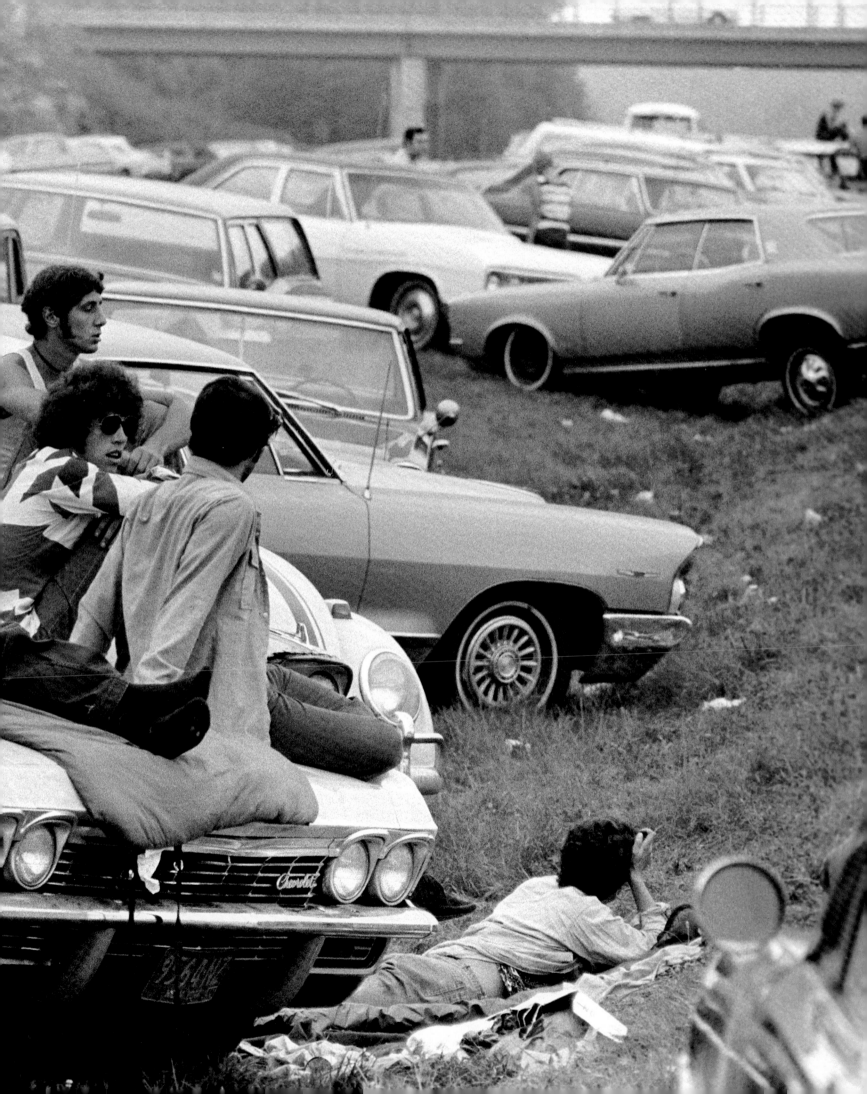

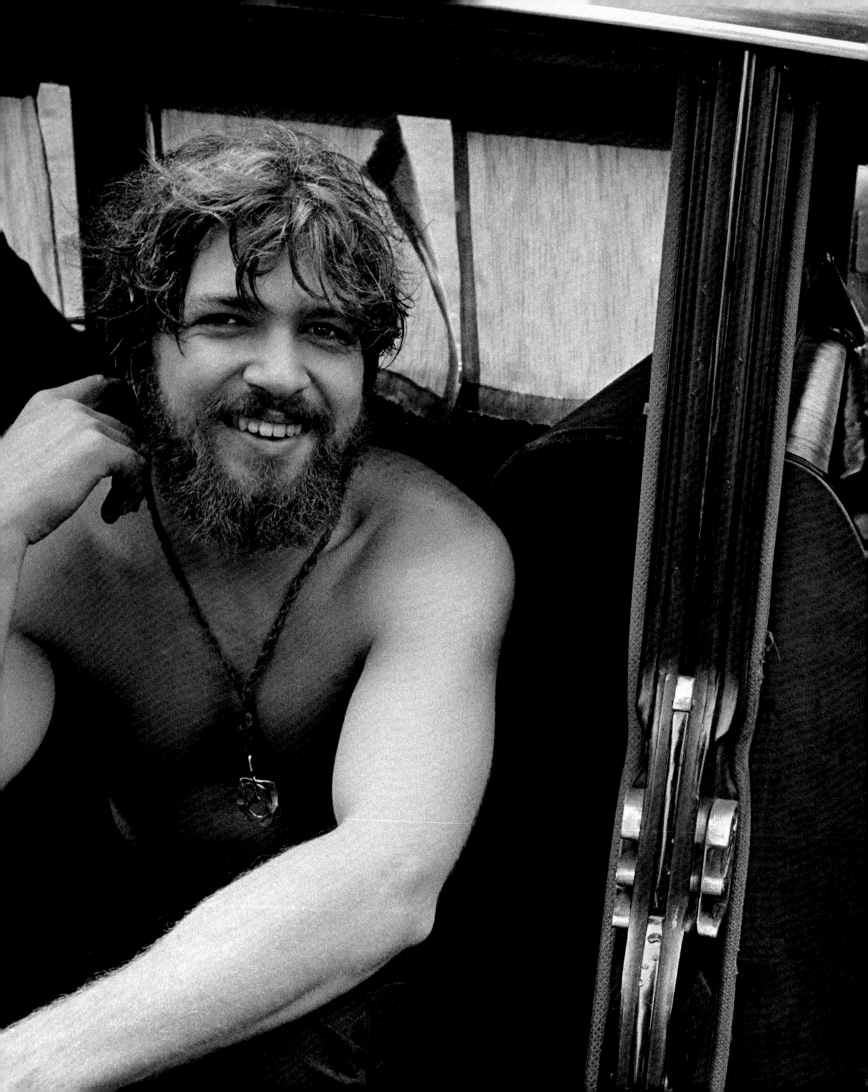

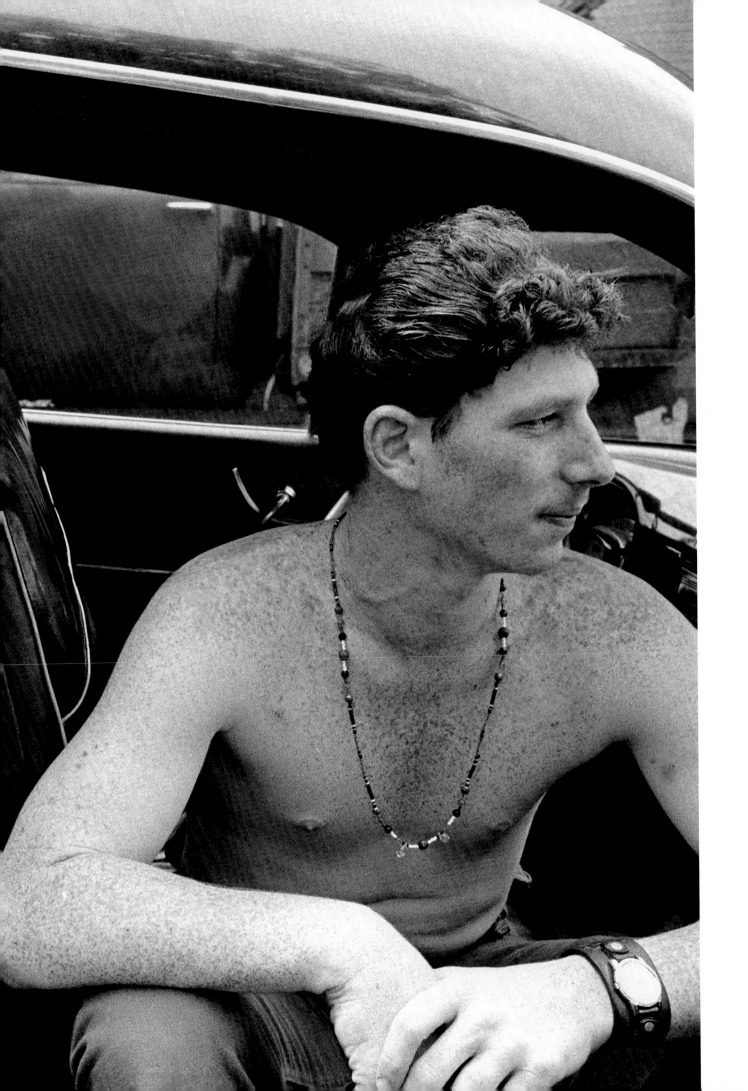

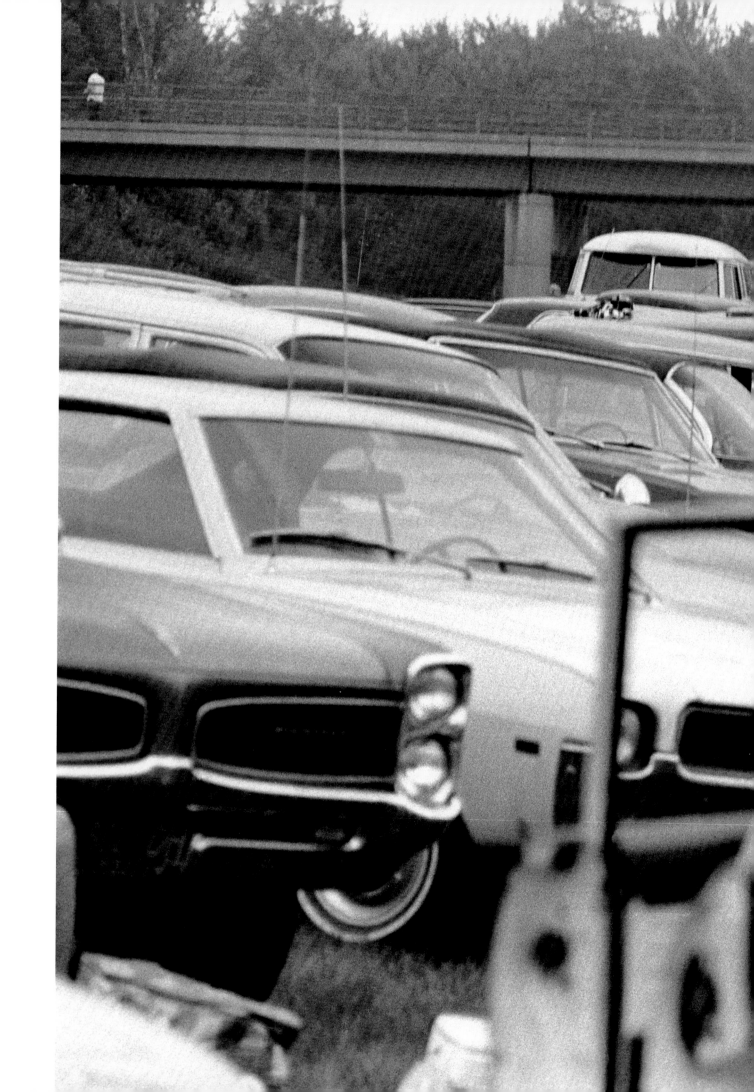

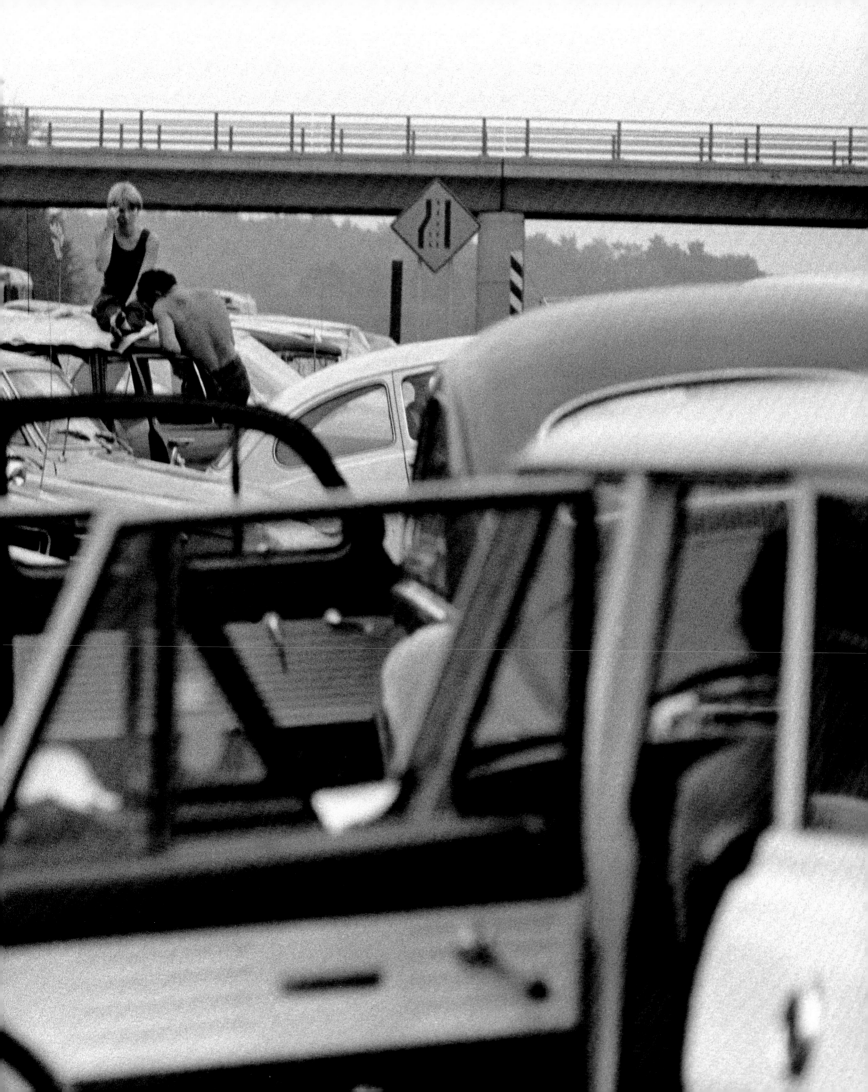

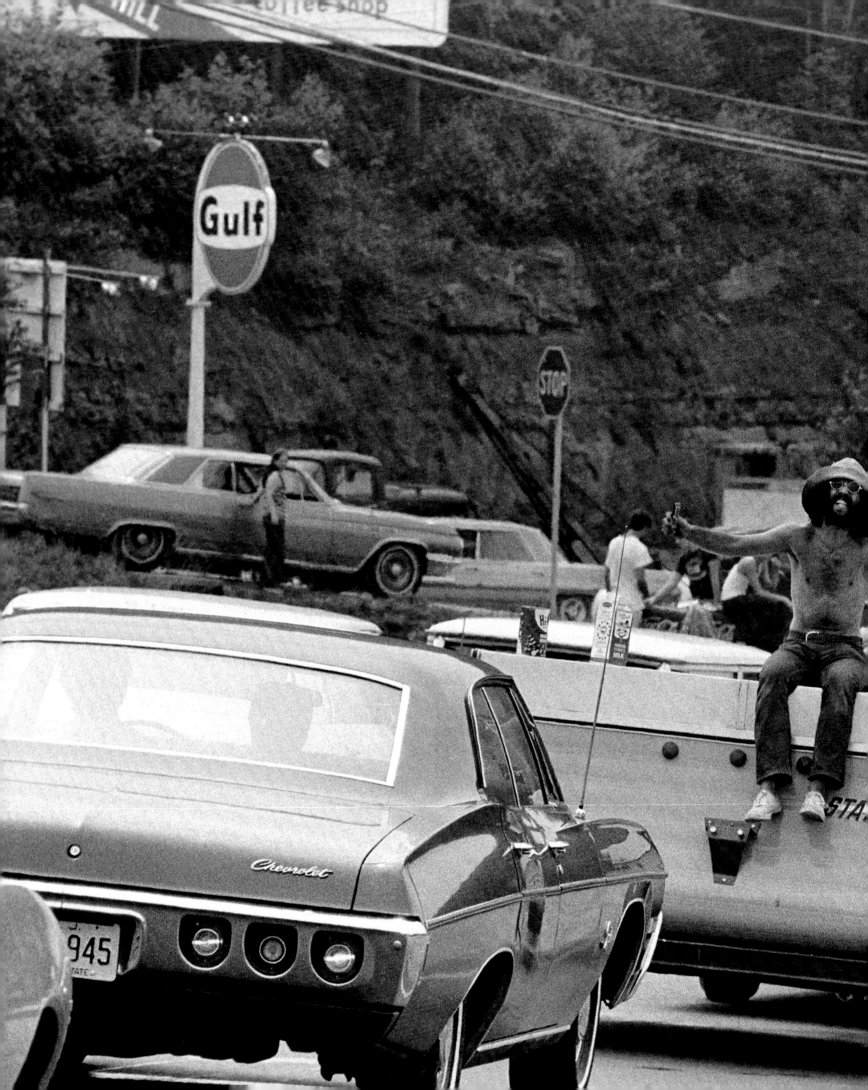

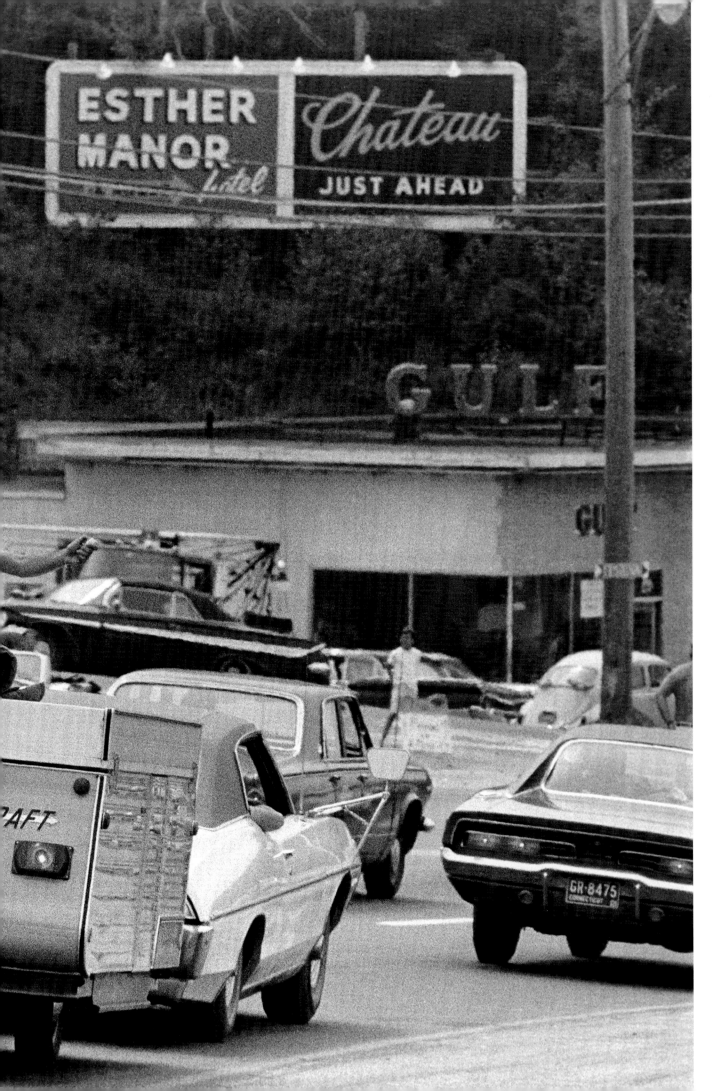

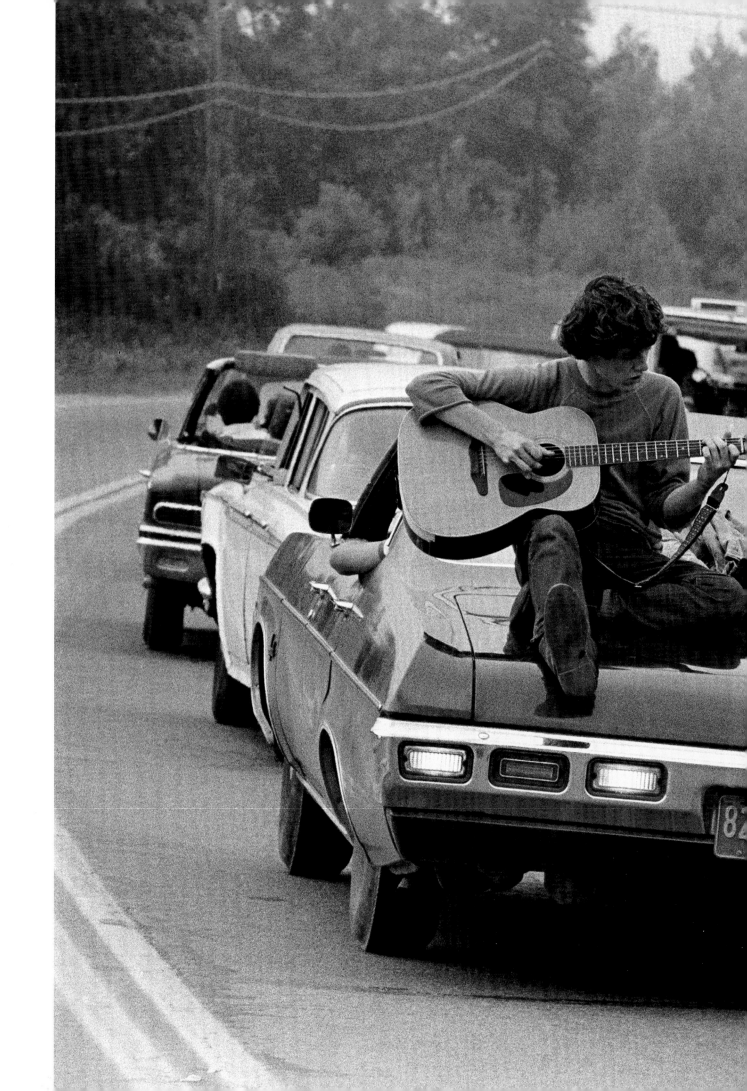

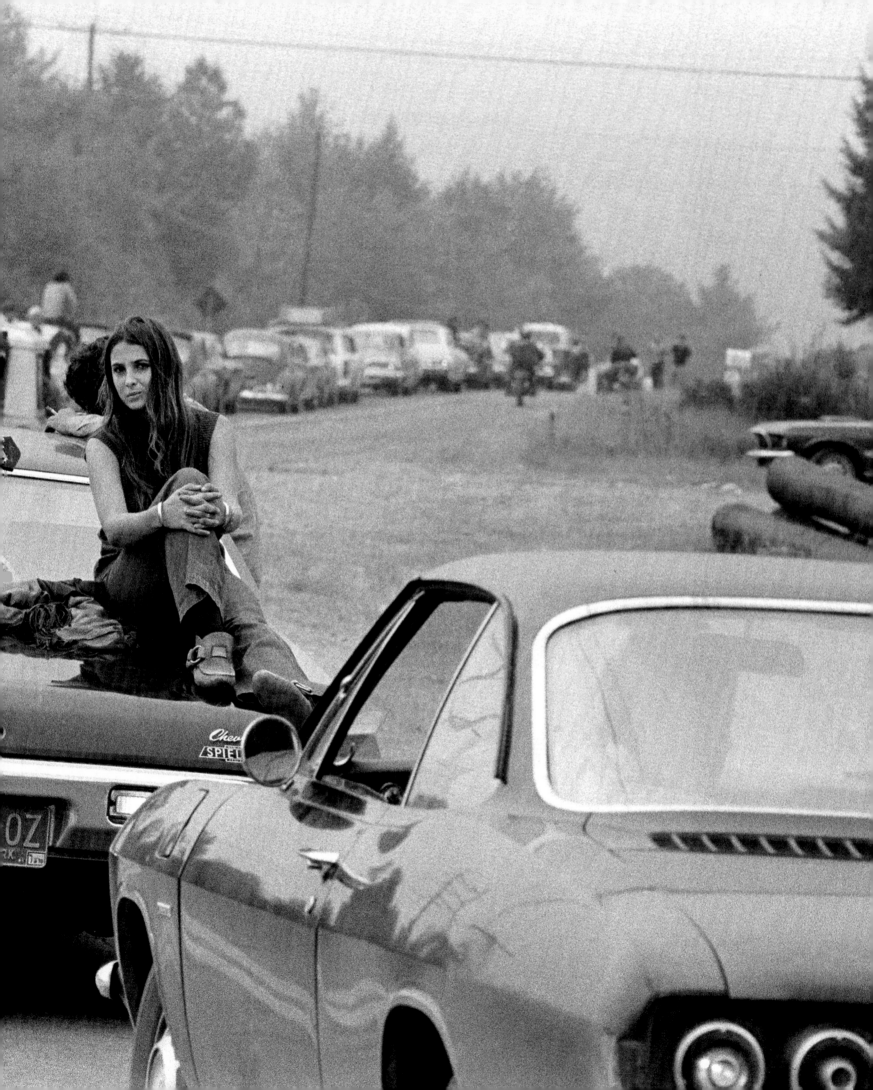

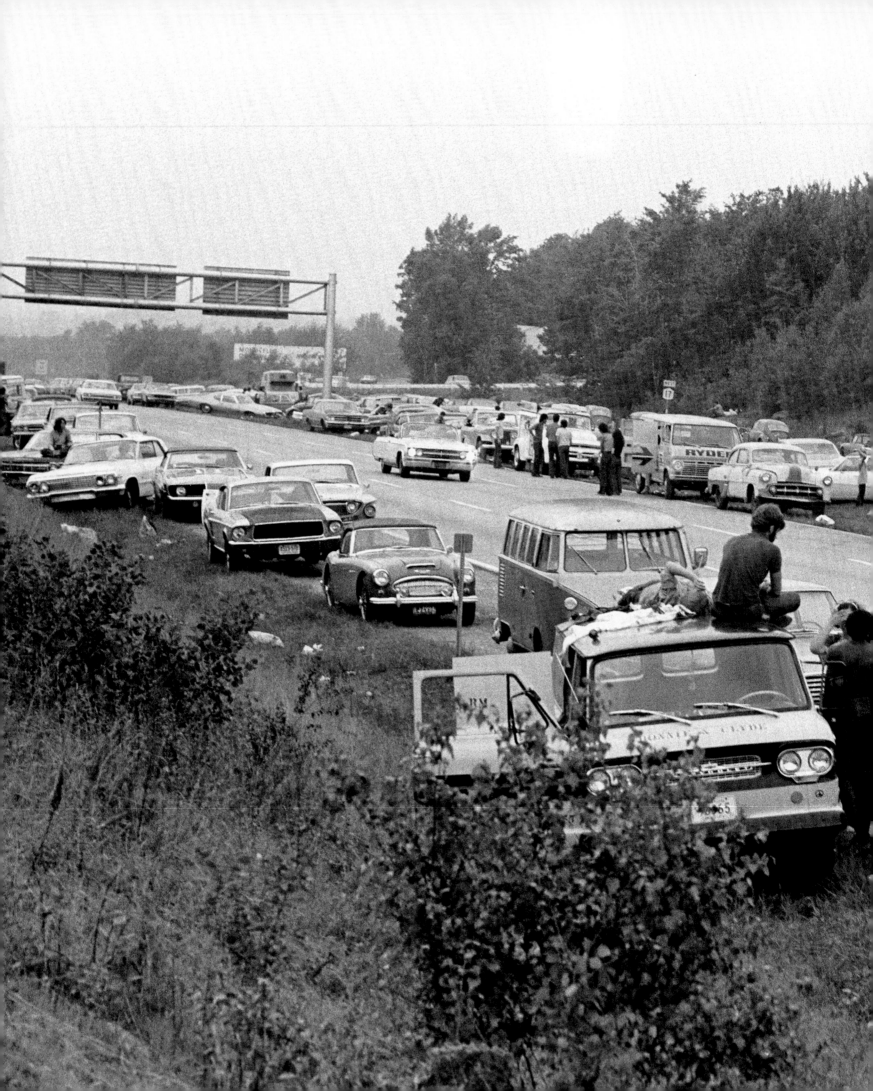

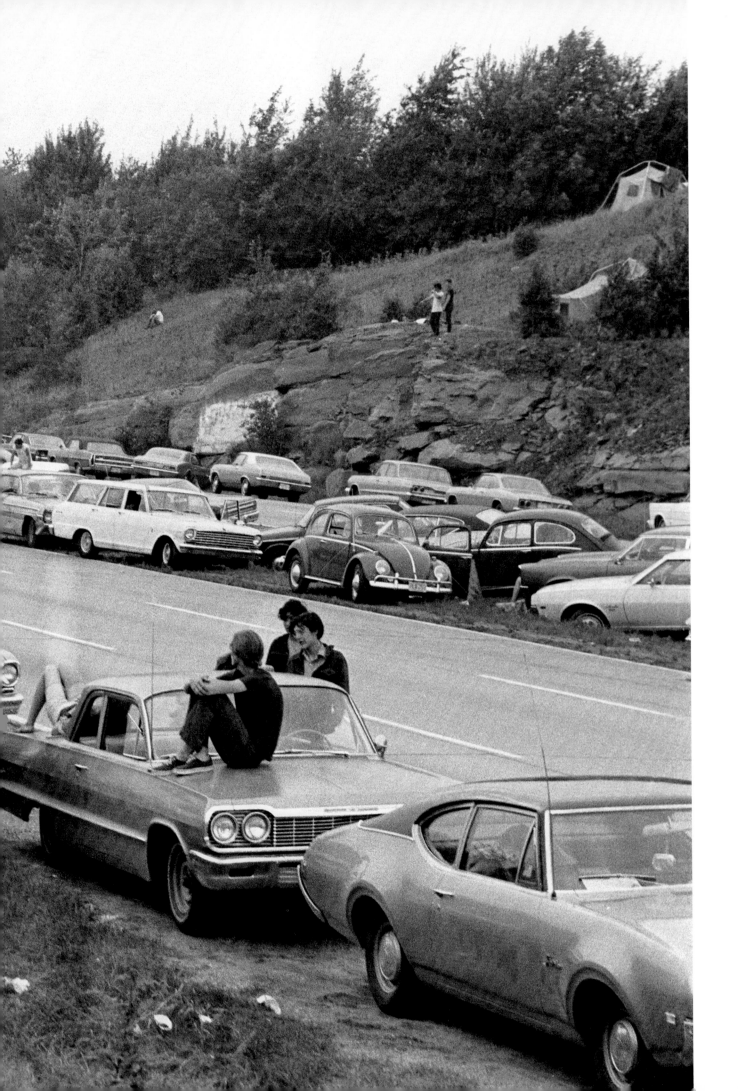

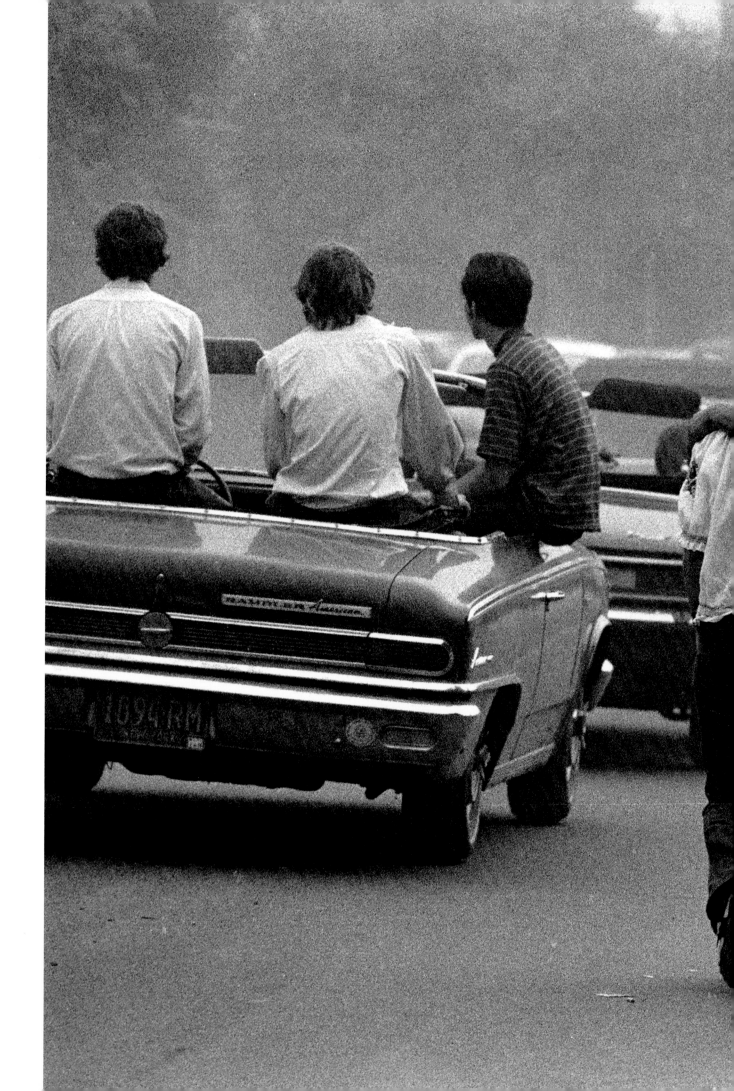

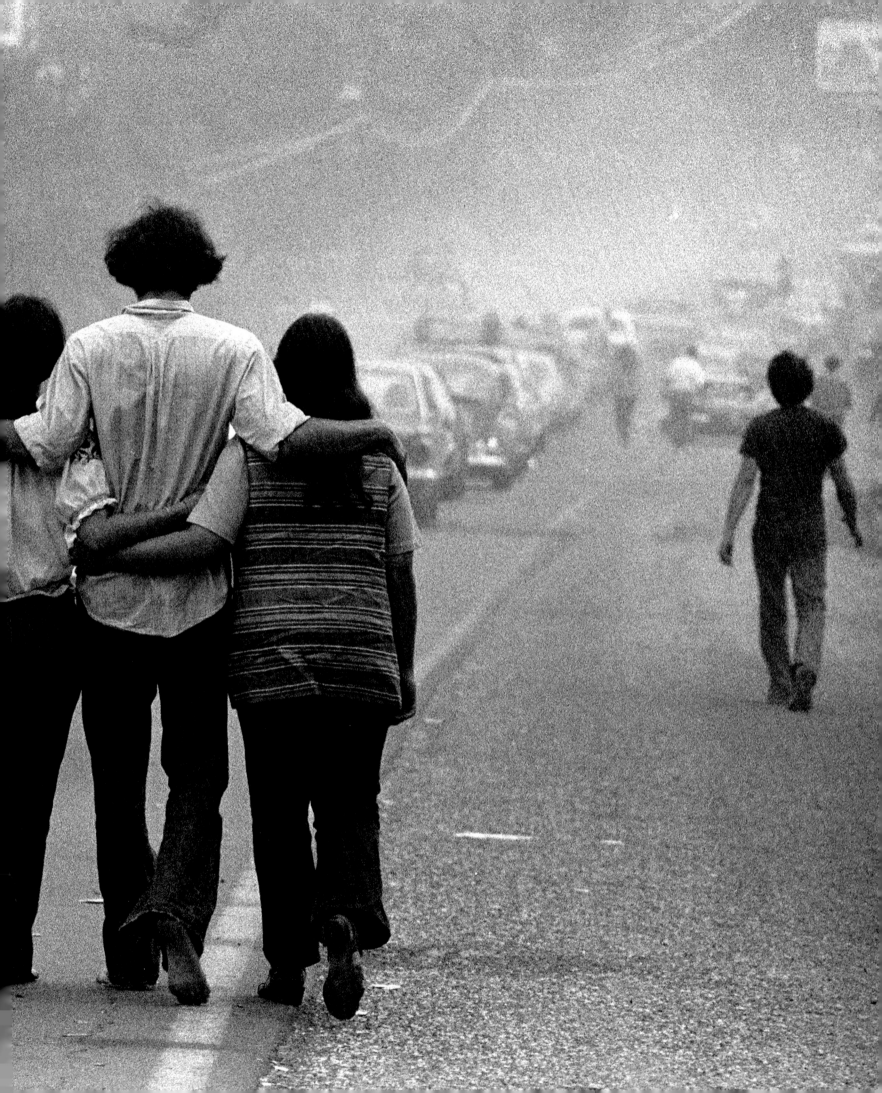

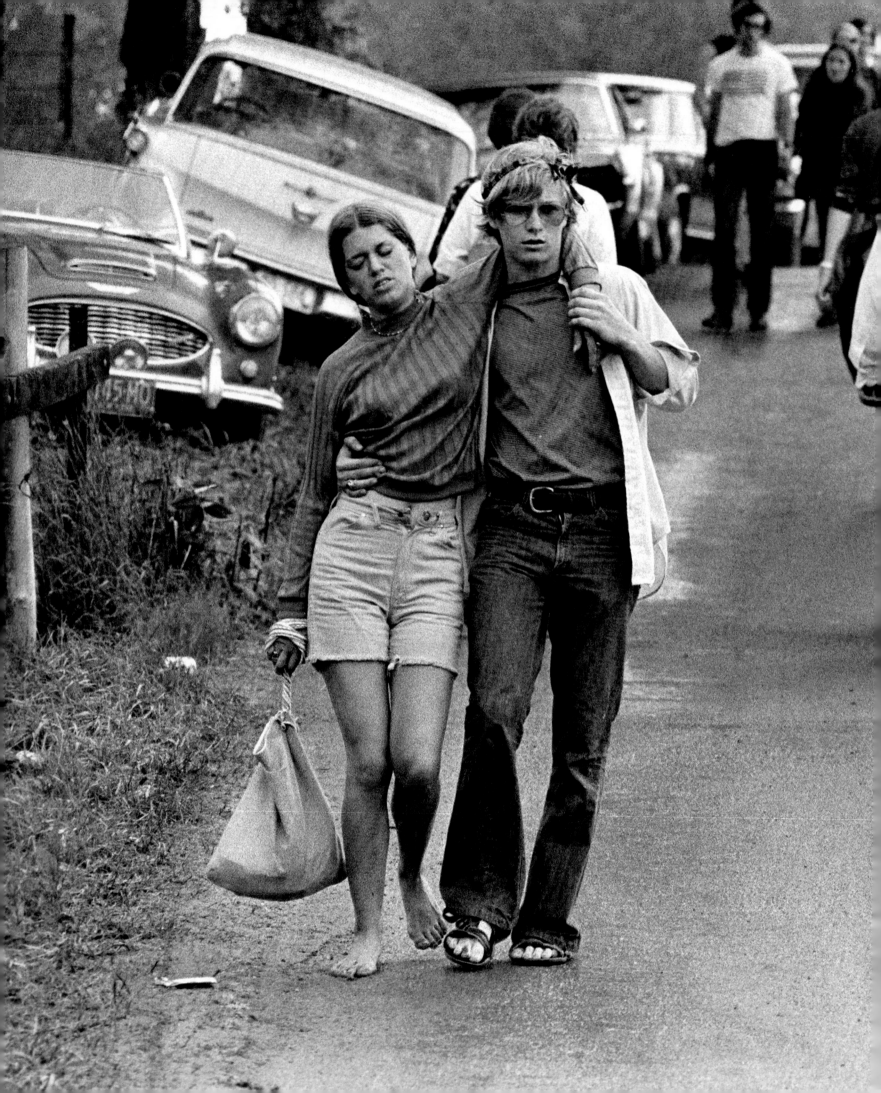

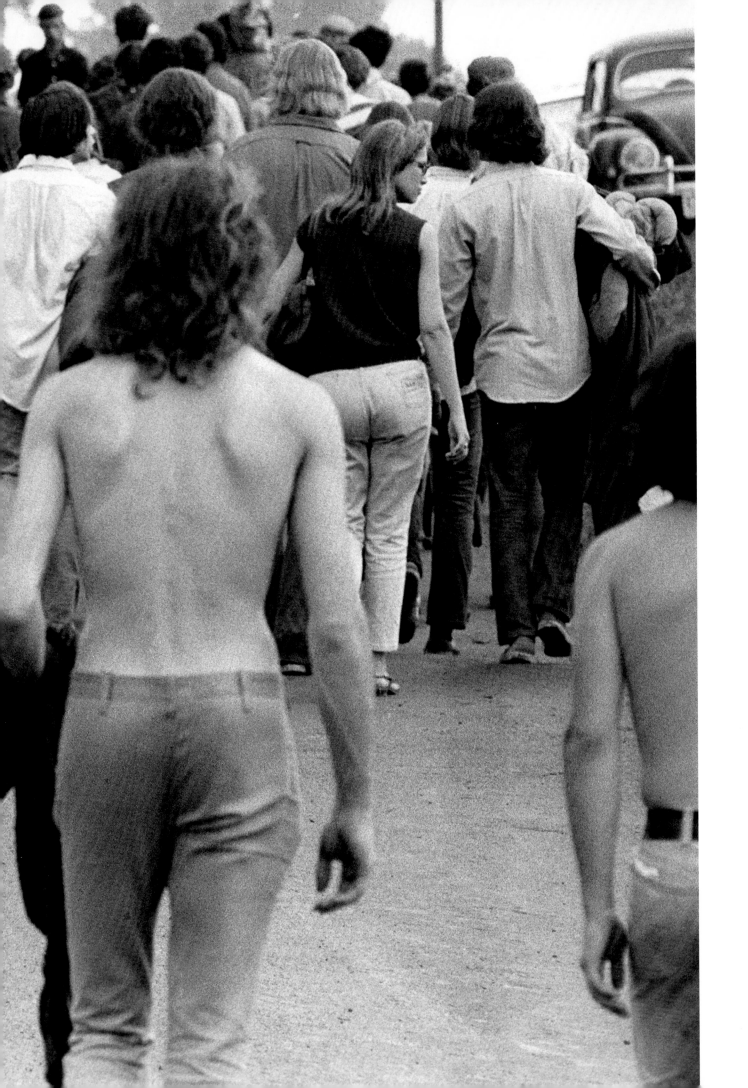

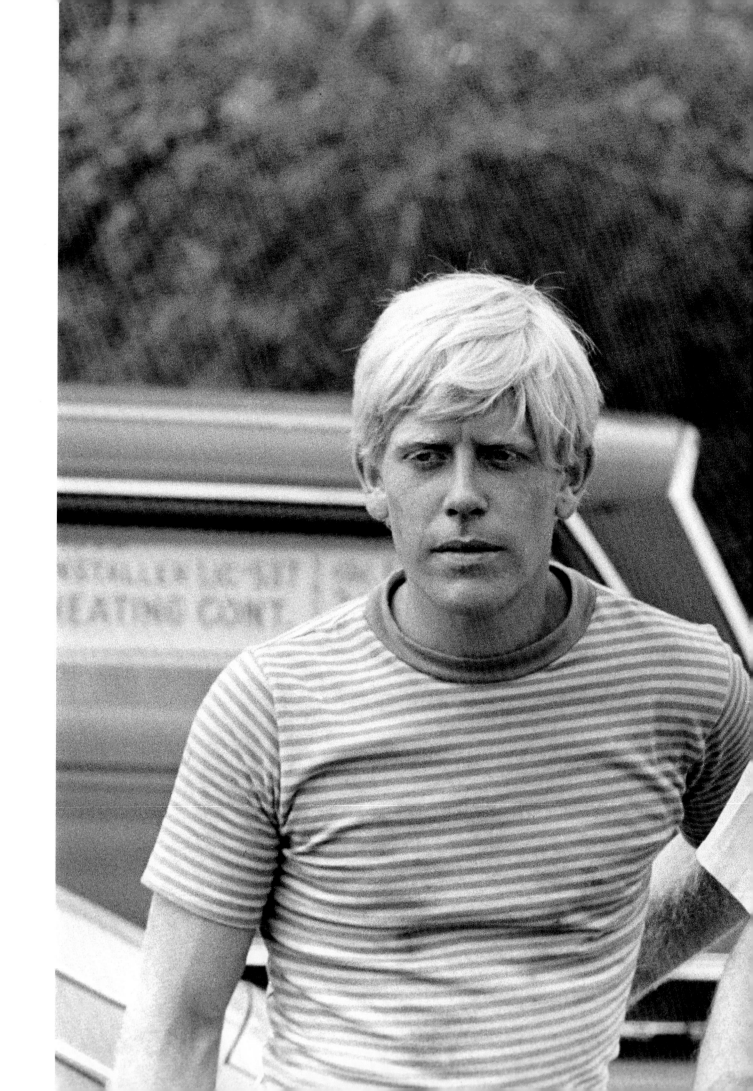

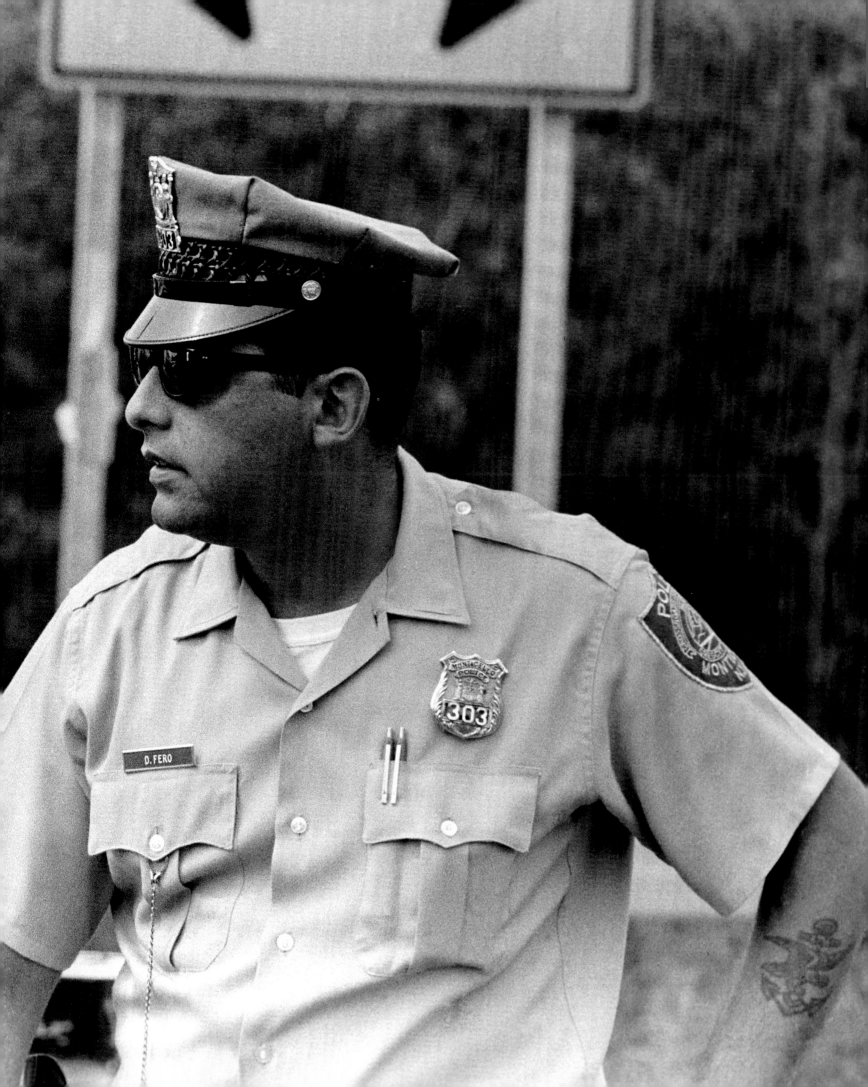

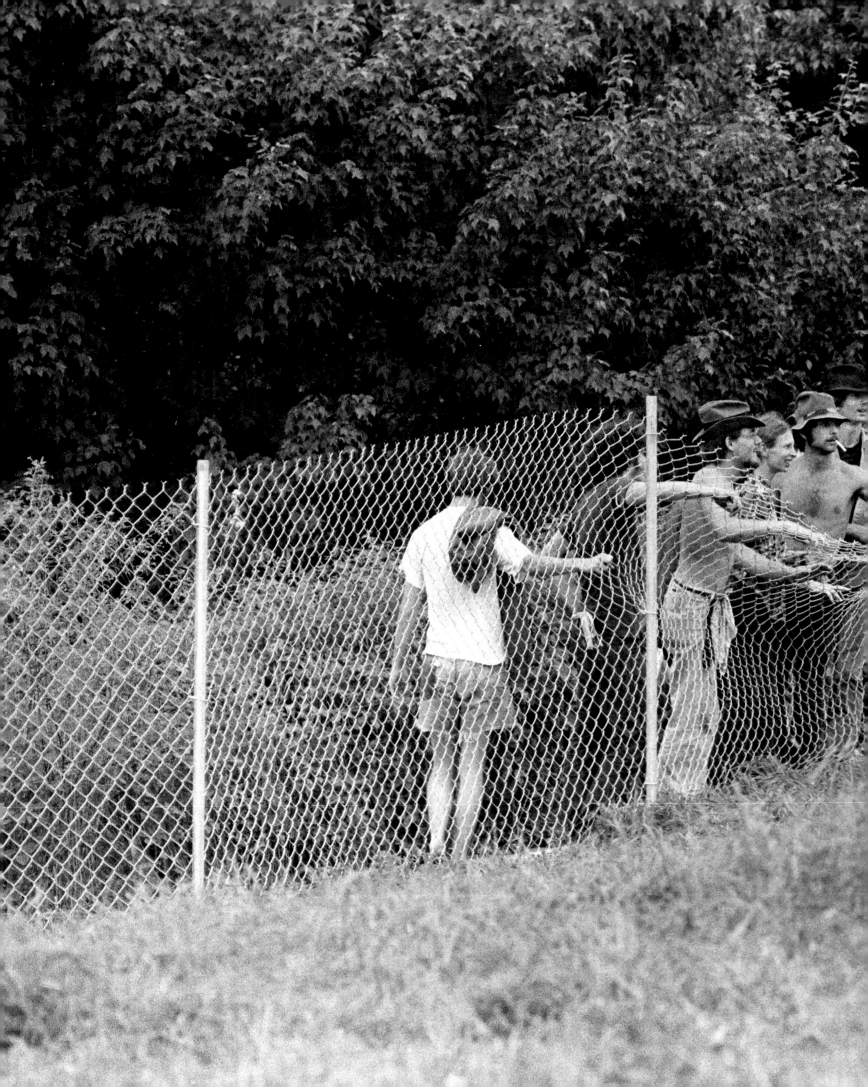

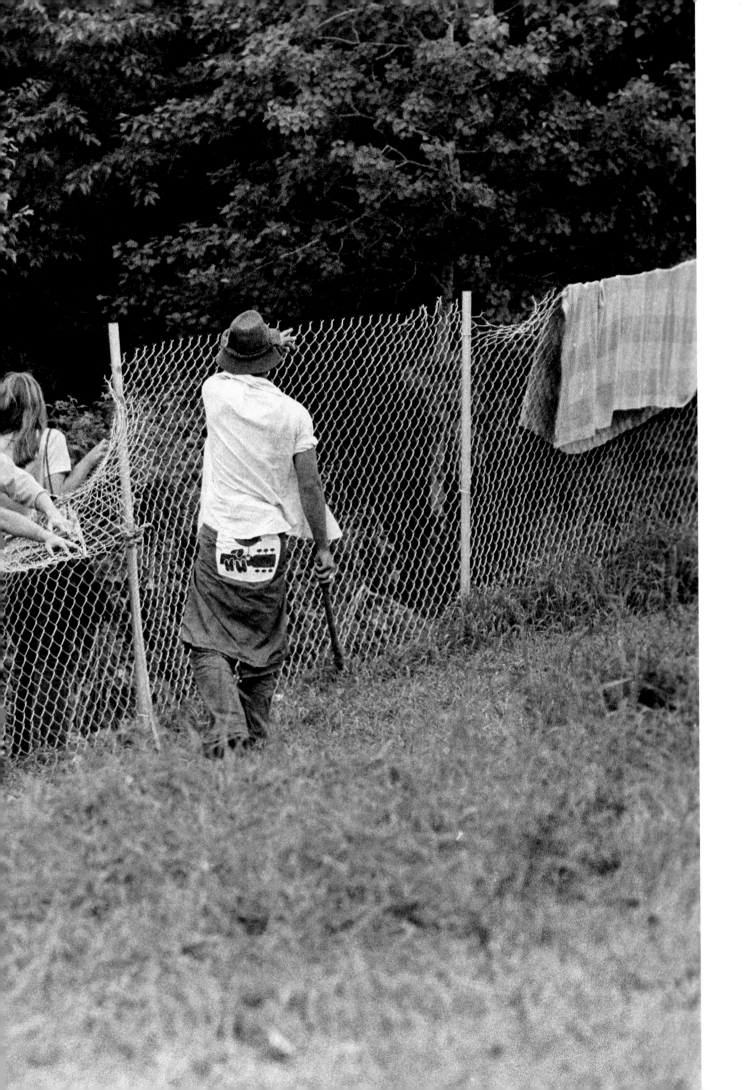

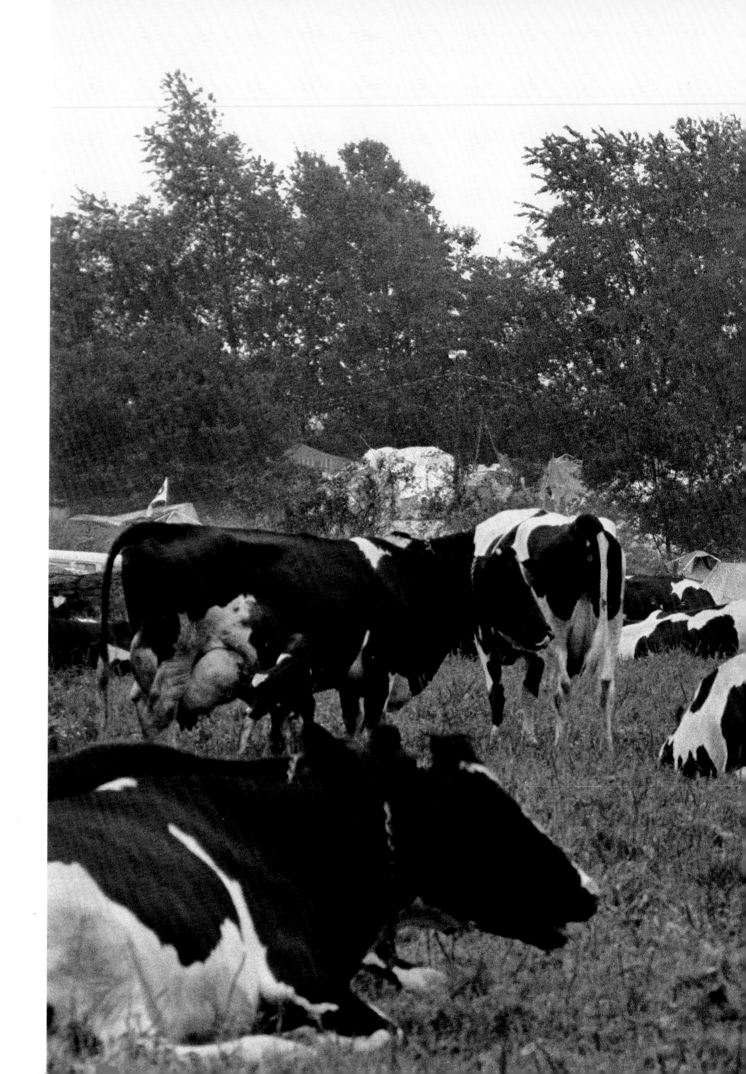

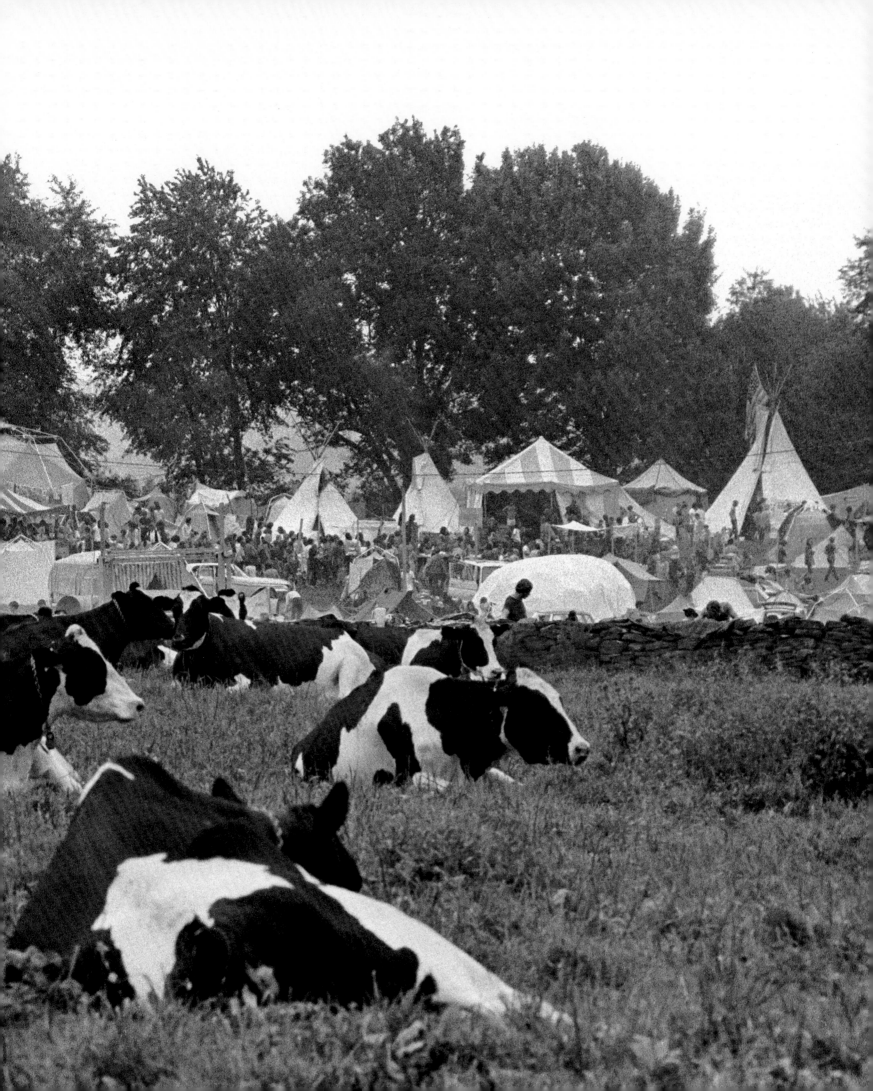

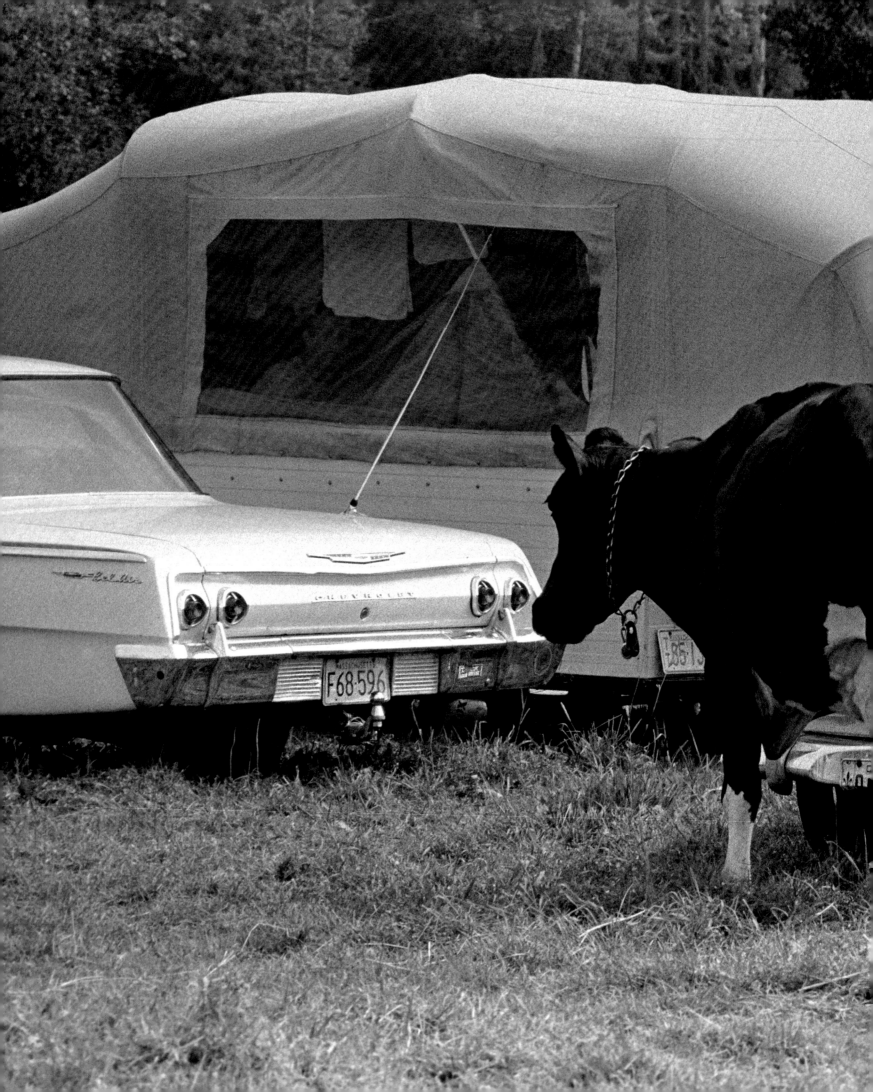

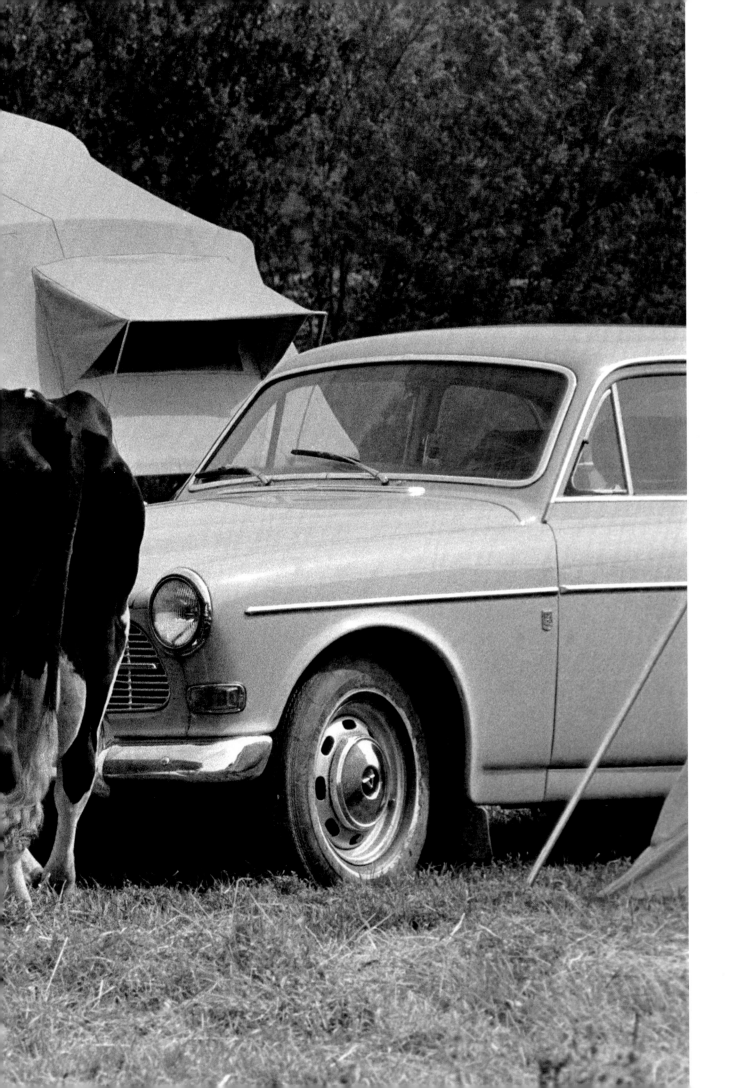

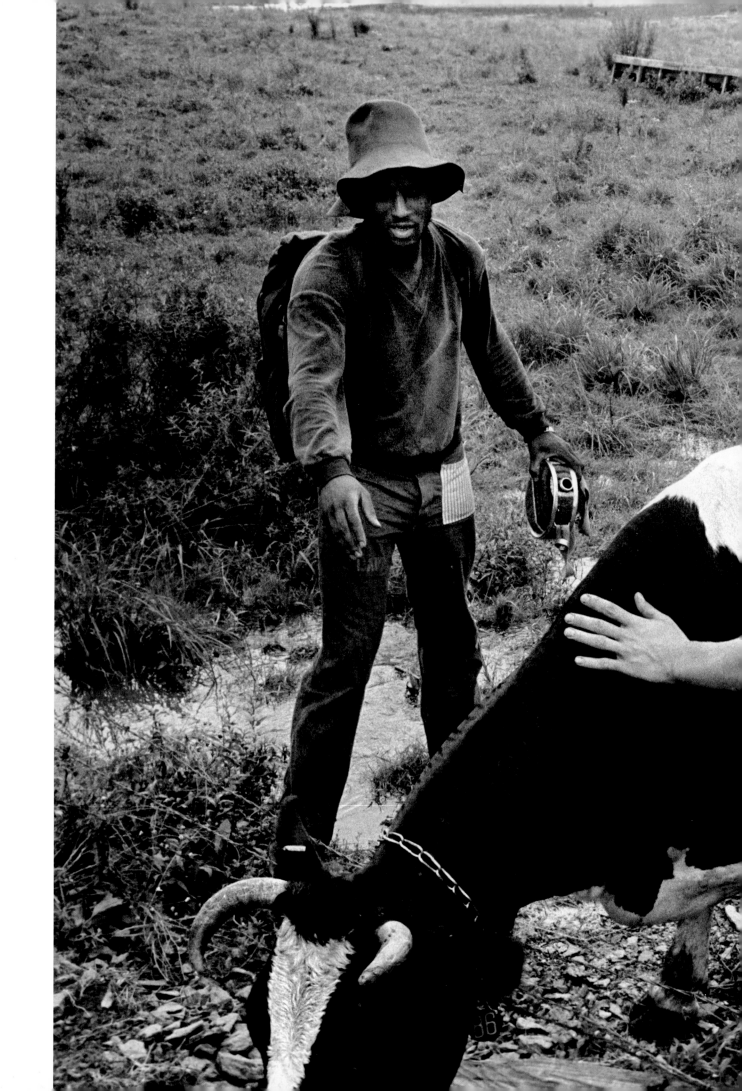

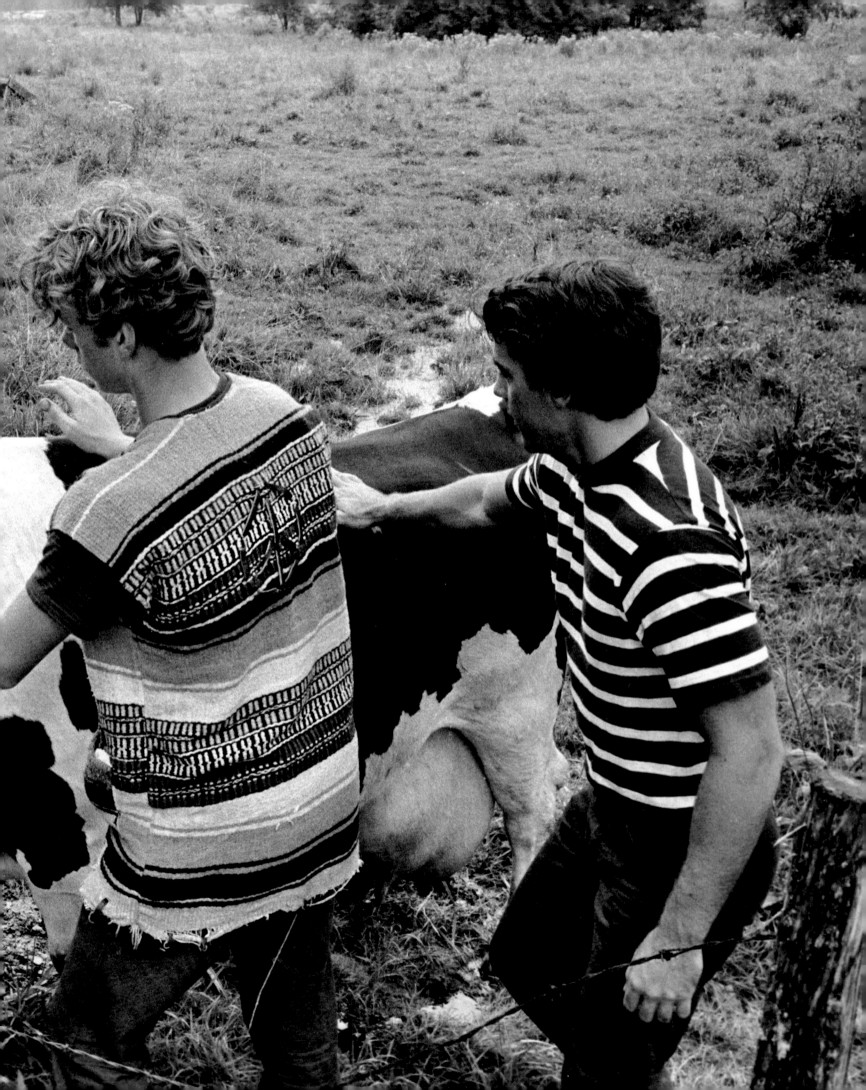

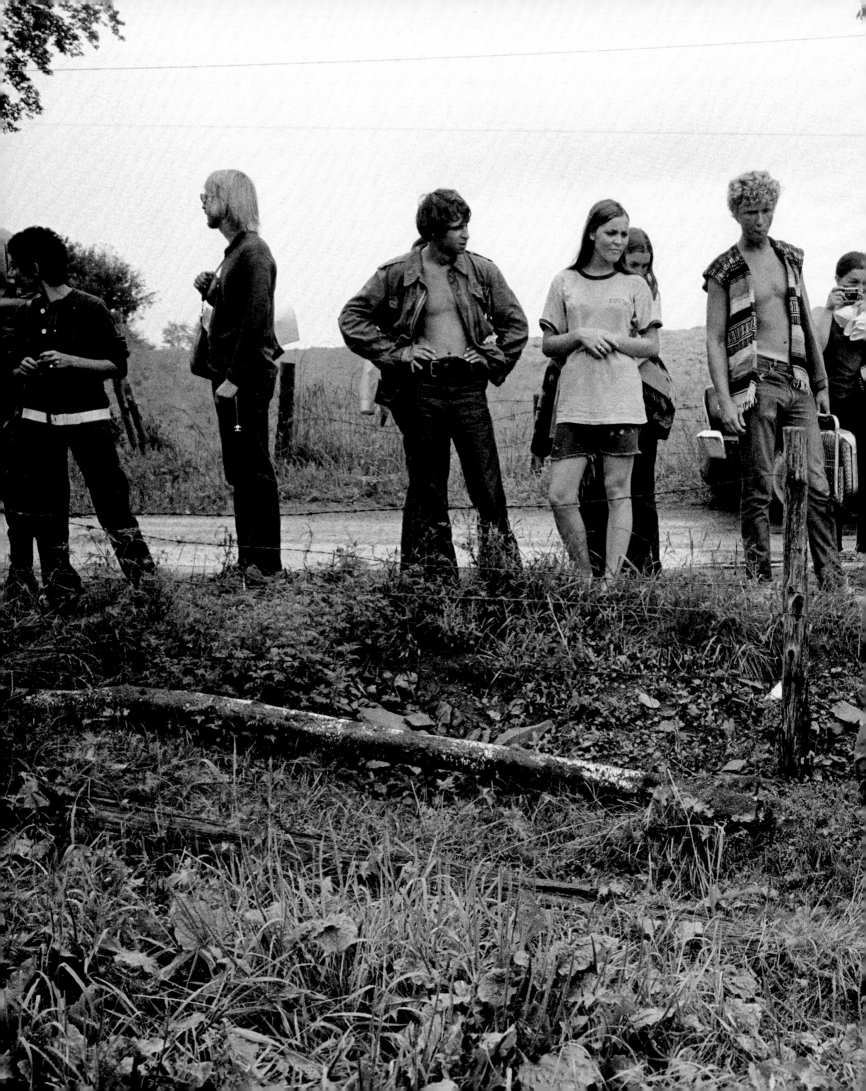

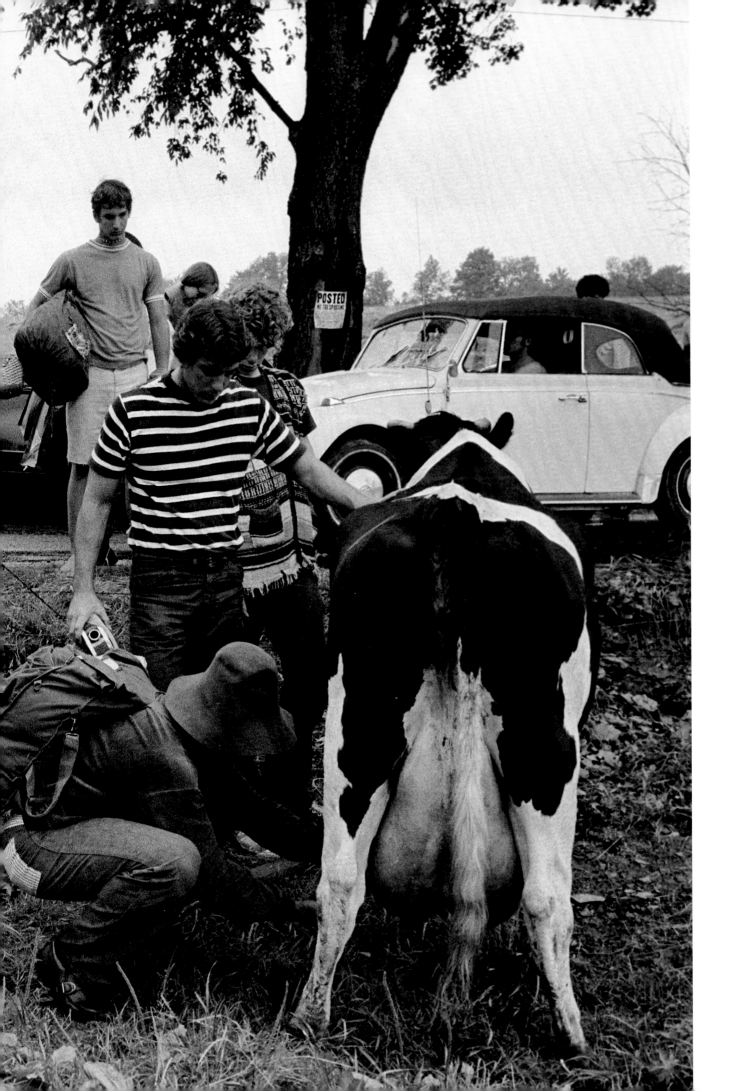

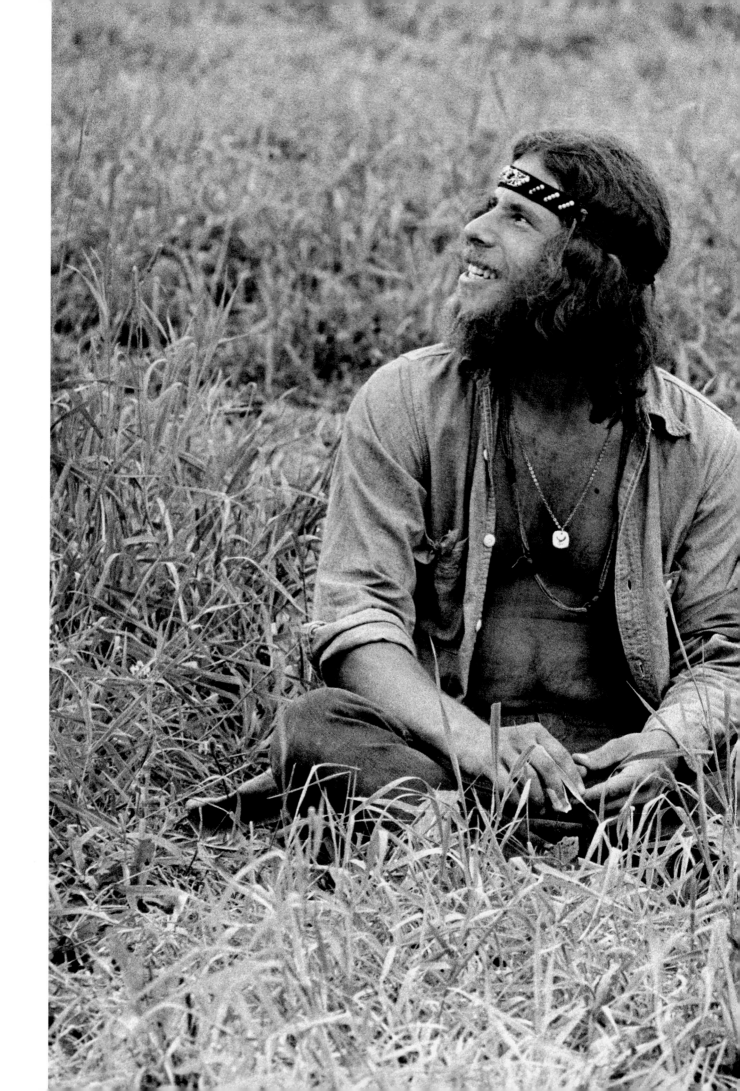

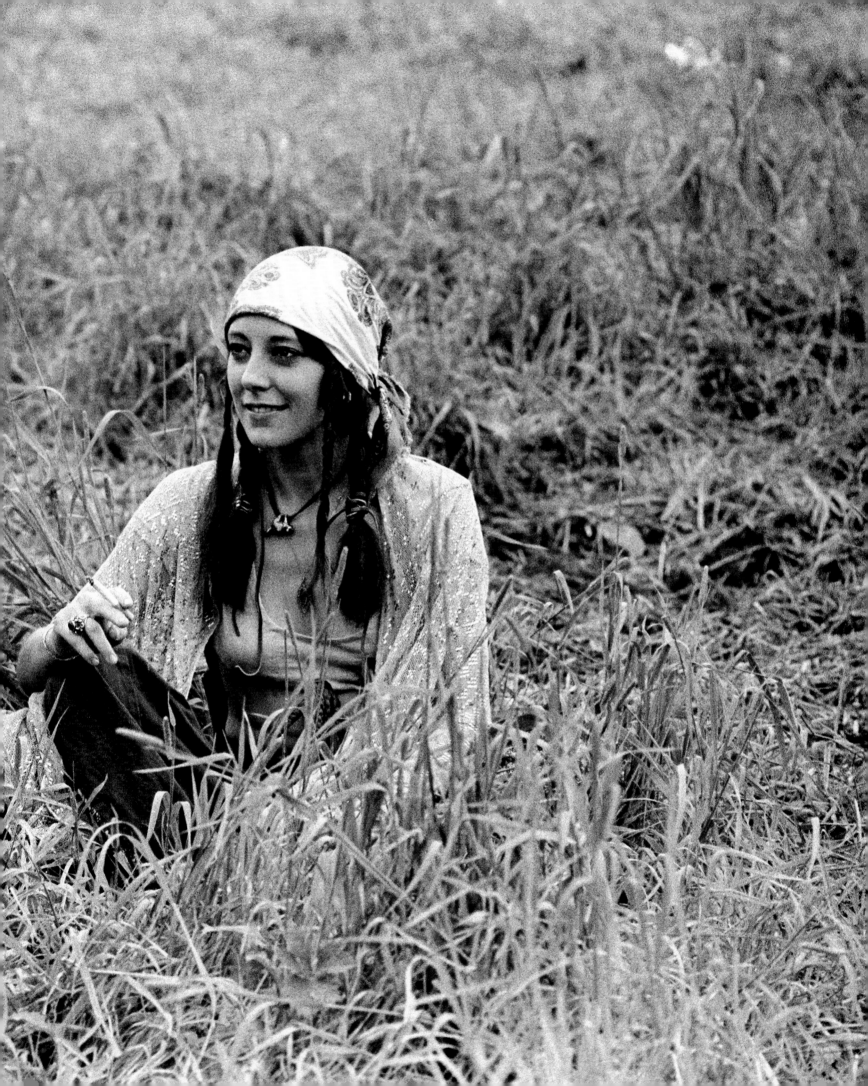

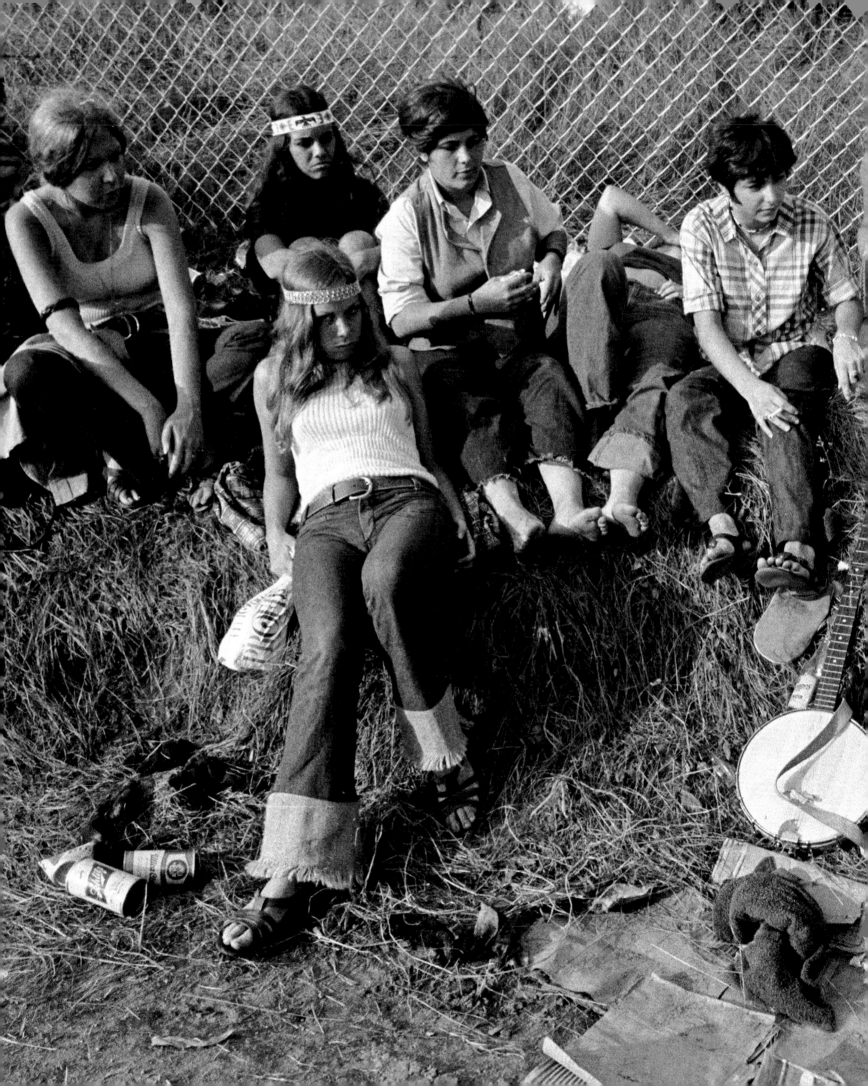

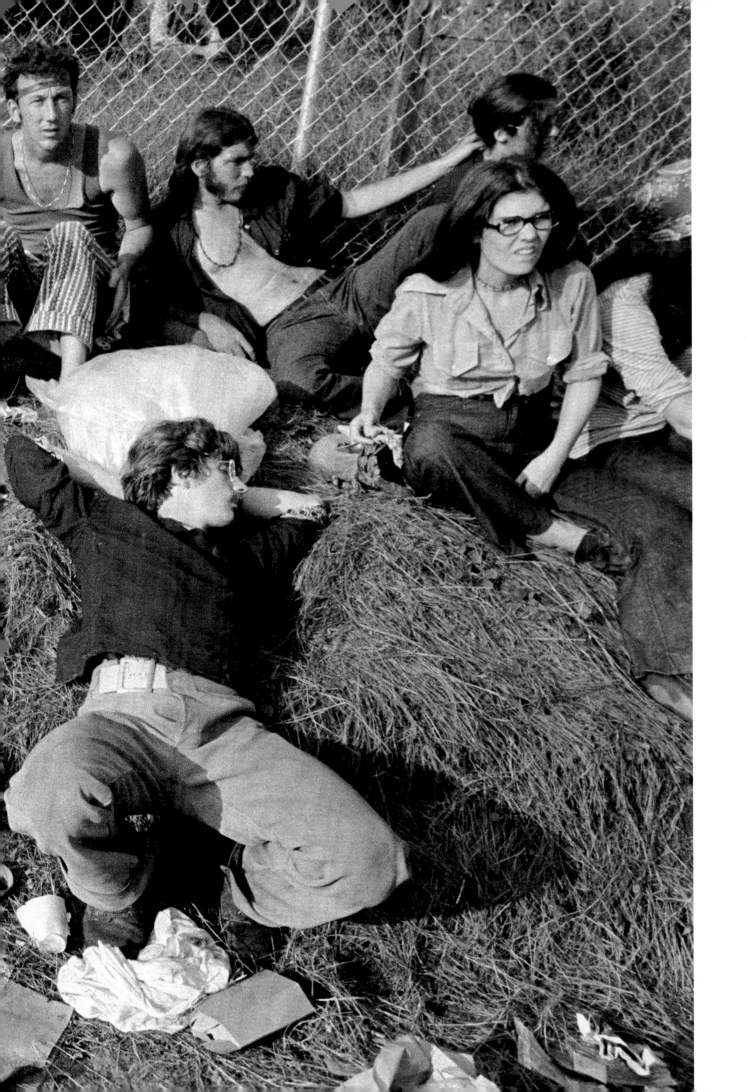

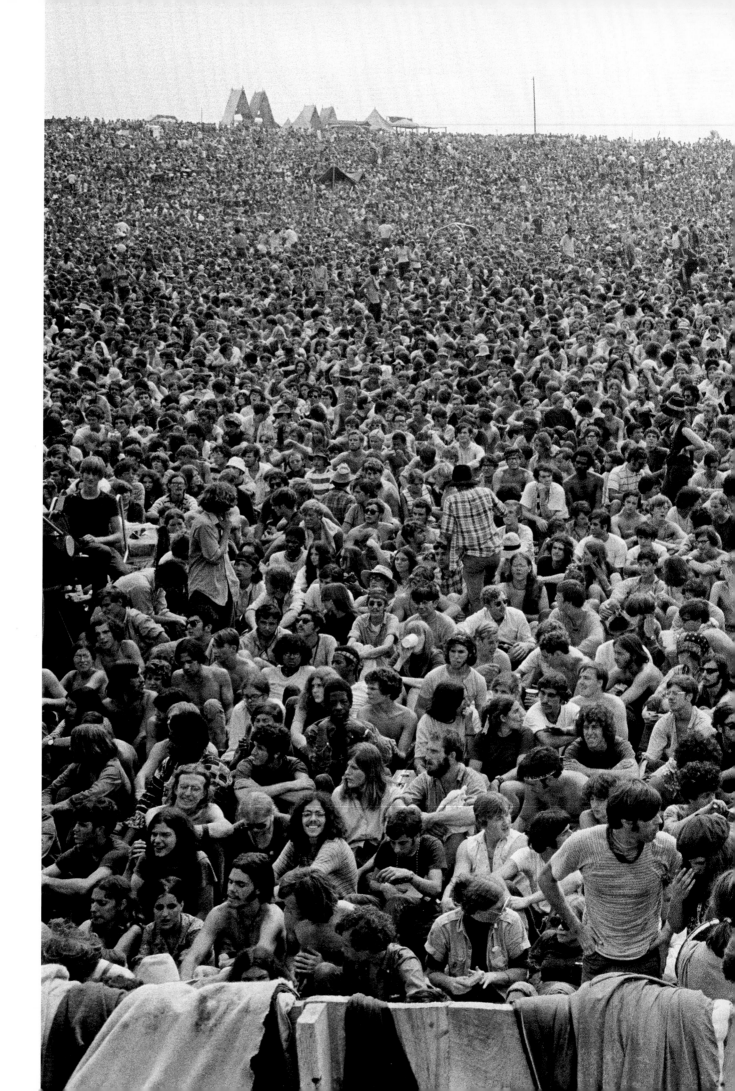

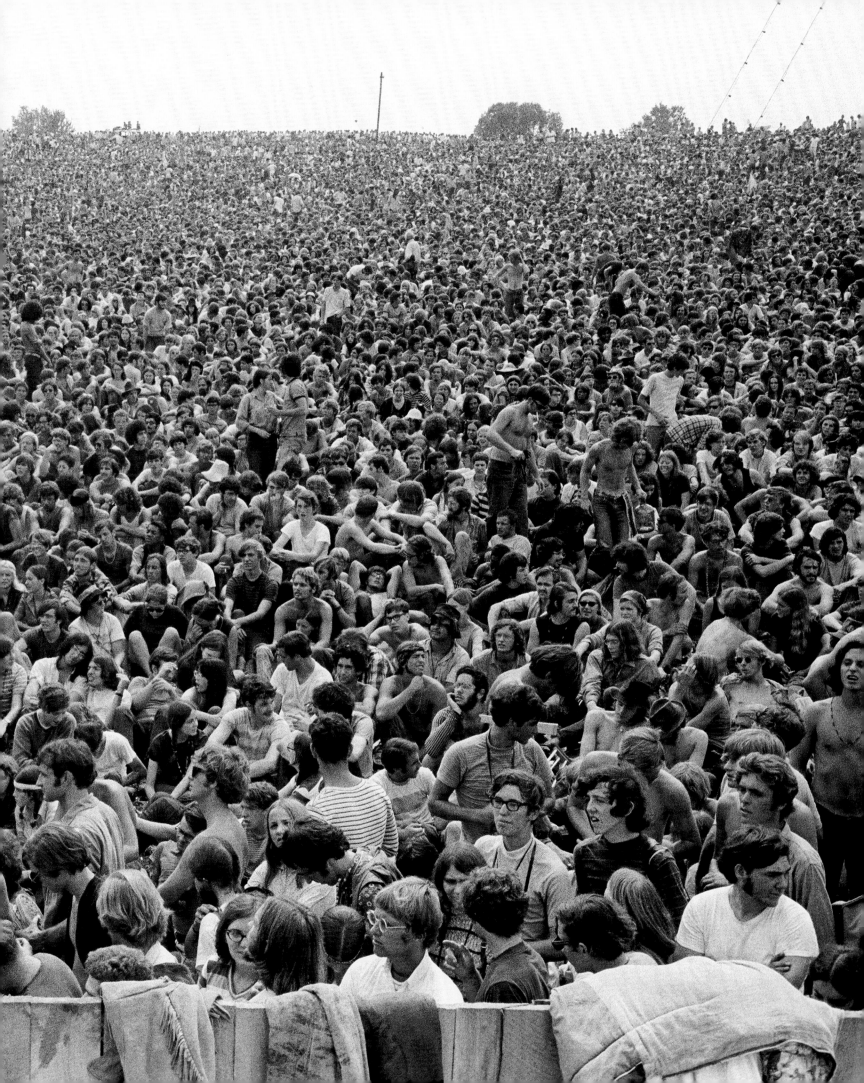

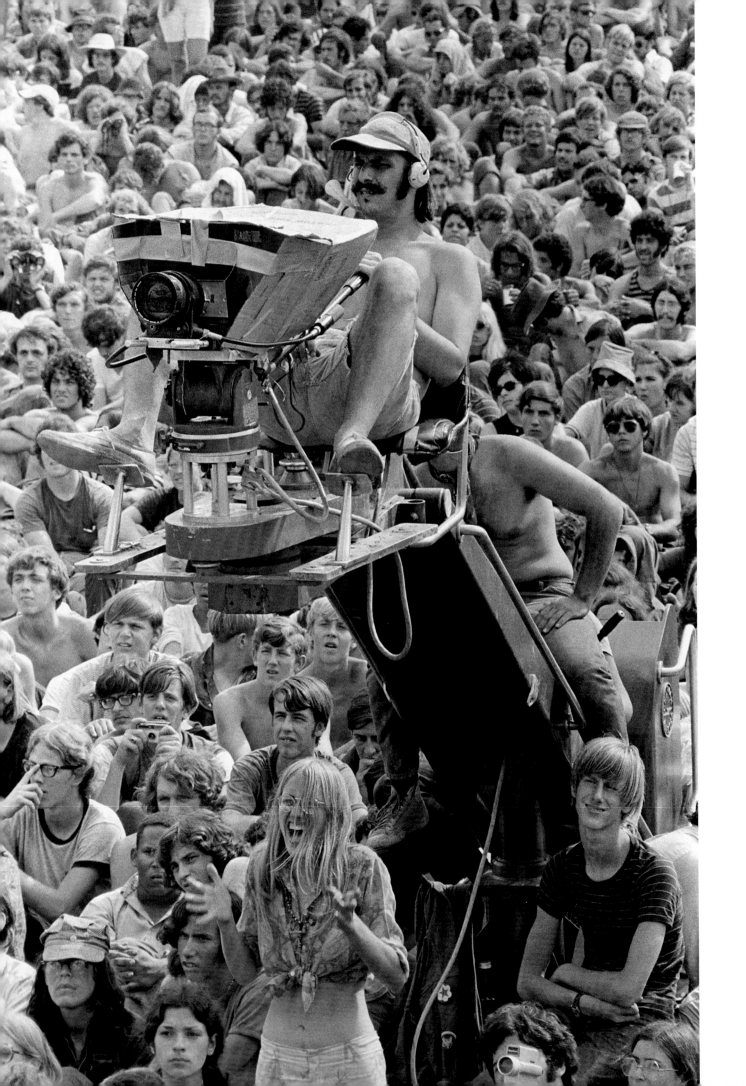

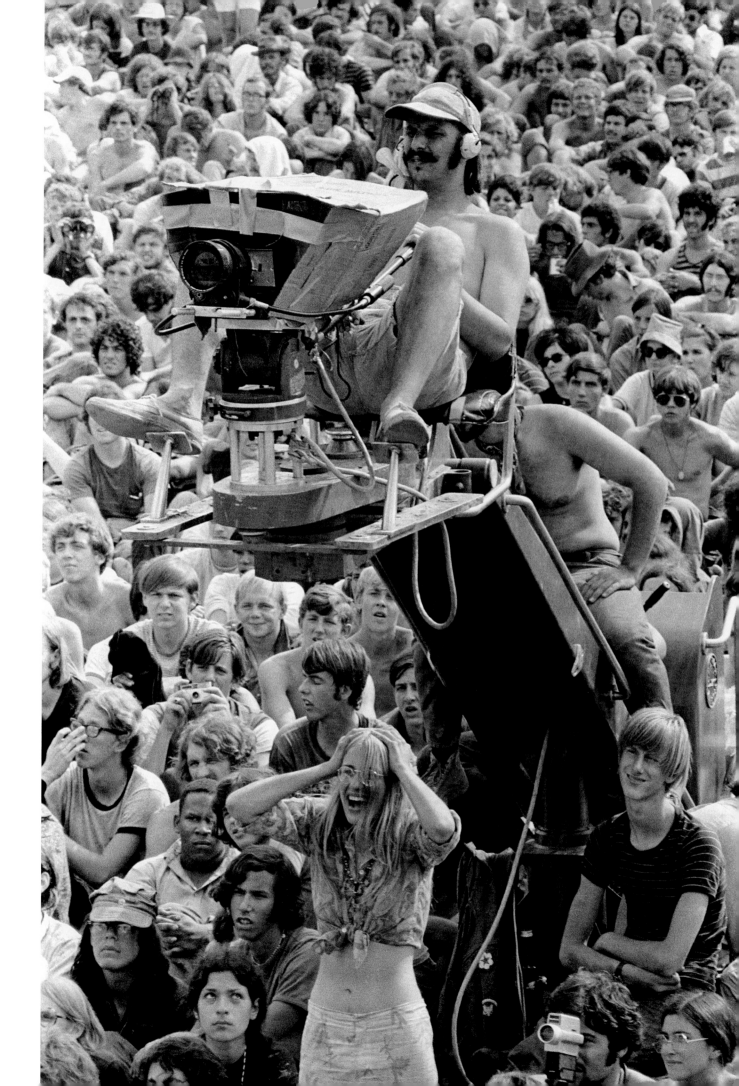

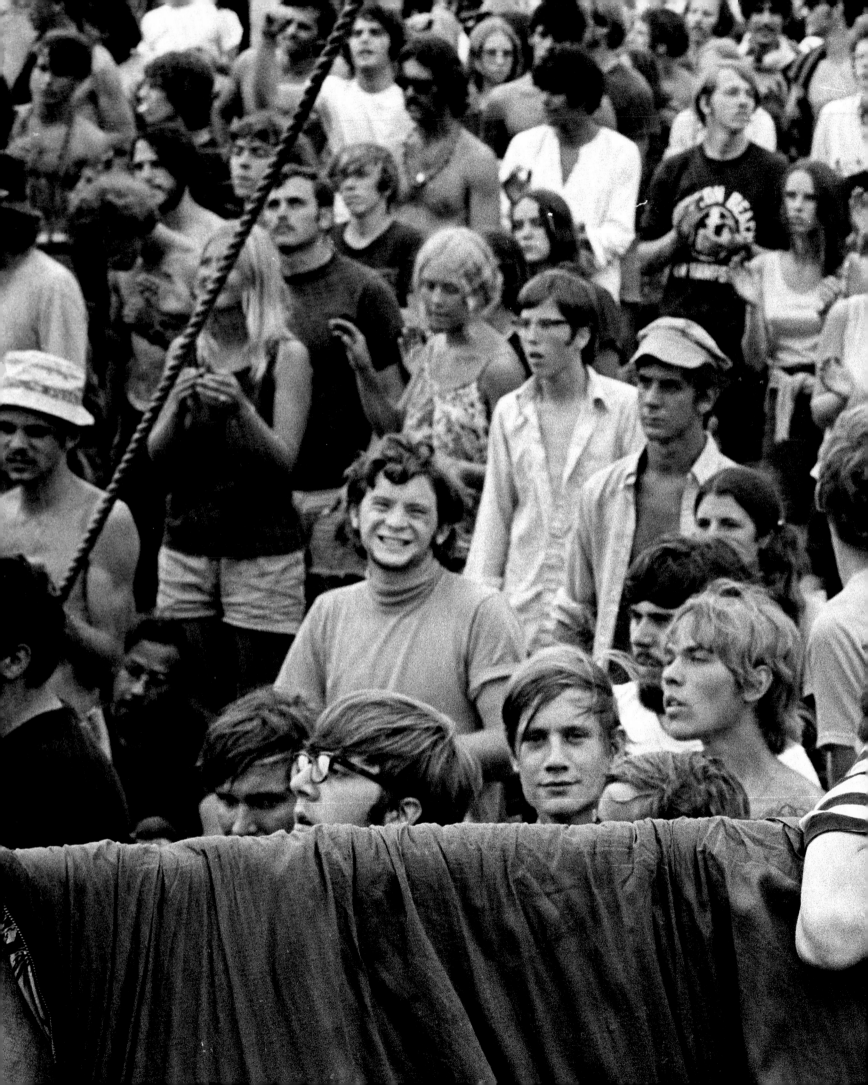

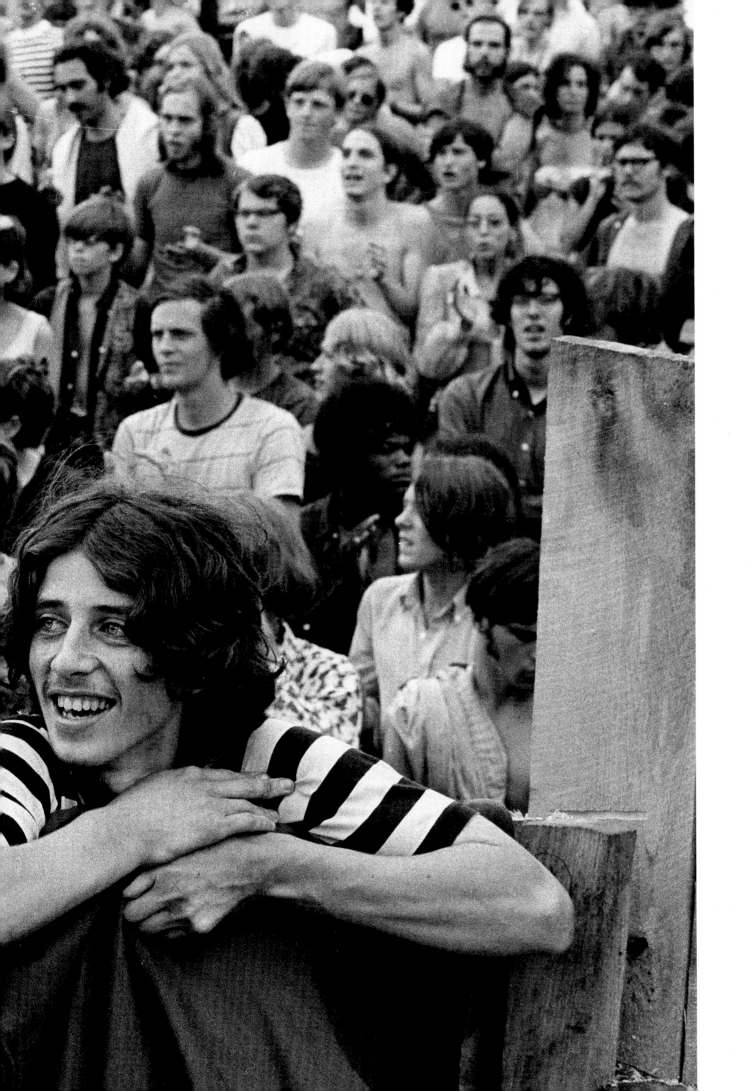

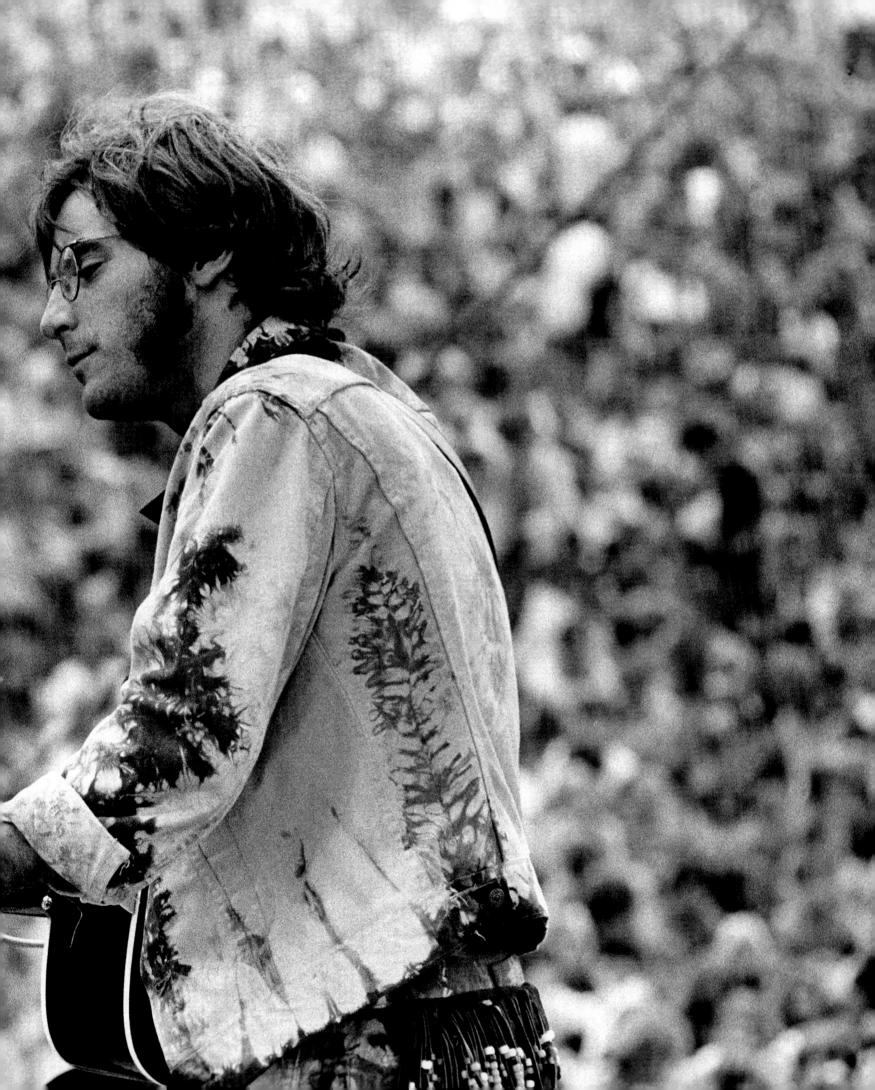

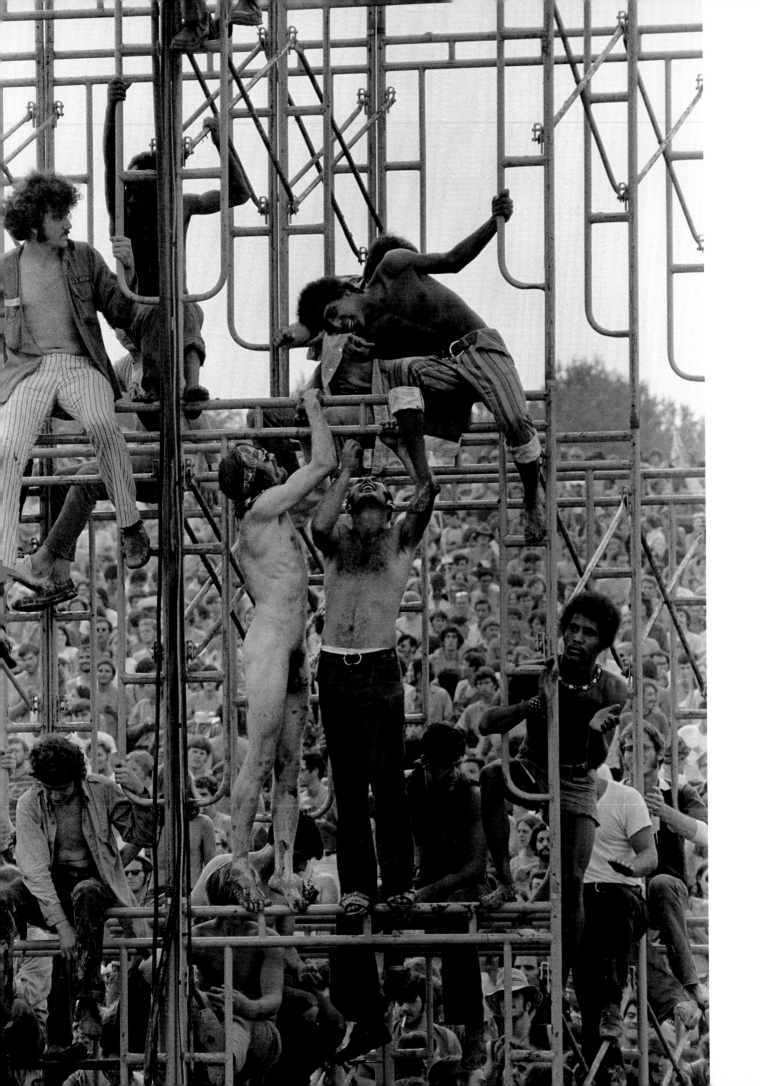

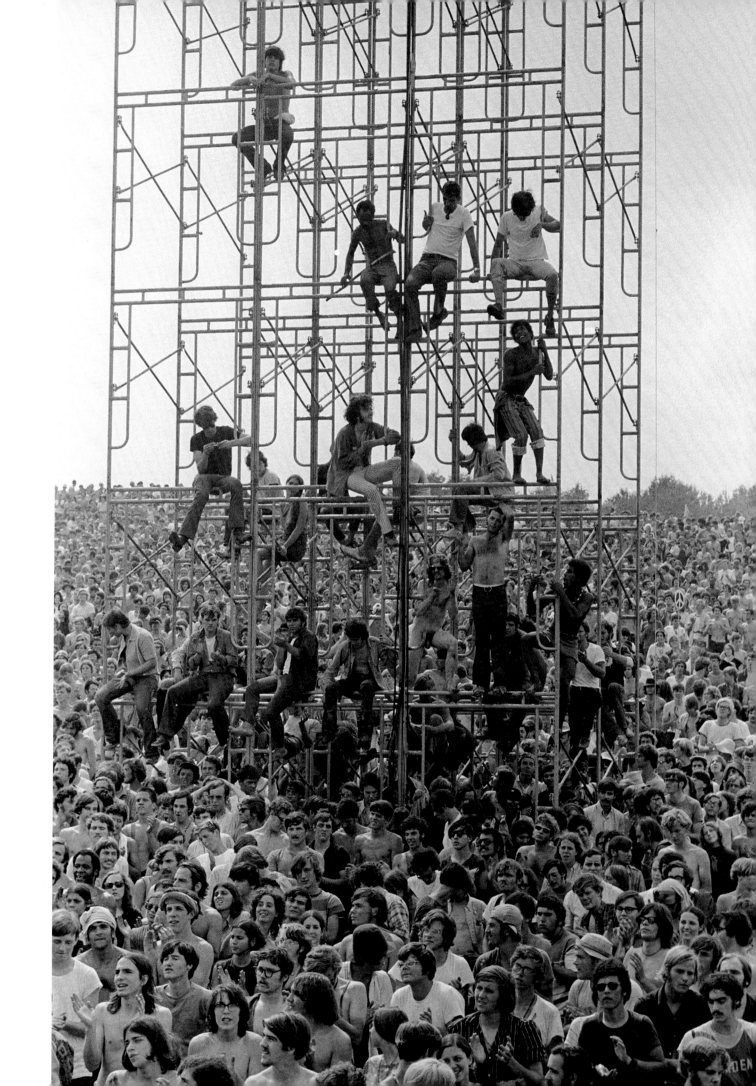

"

*Woodstock
was a real turning point
in my career,
and since then
my life
has only been
an abundance of blessings
and opportunities.*

"

- Carlos Santana

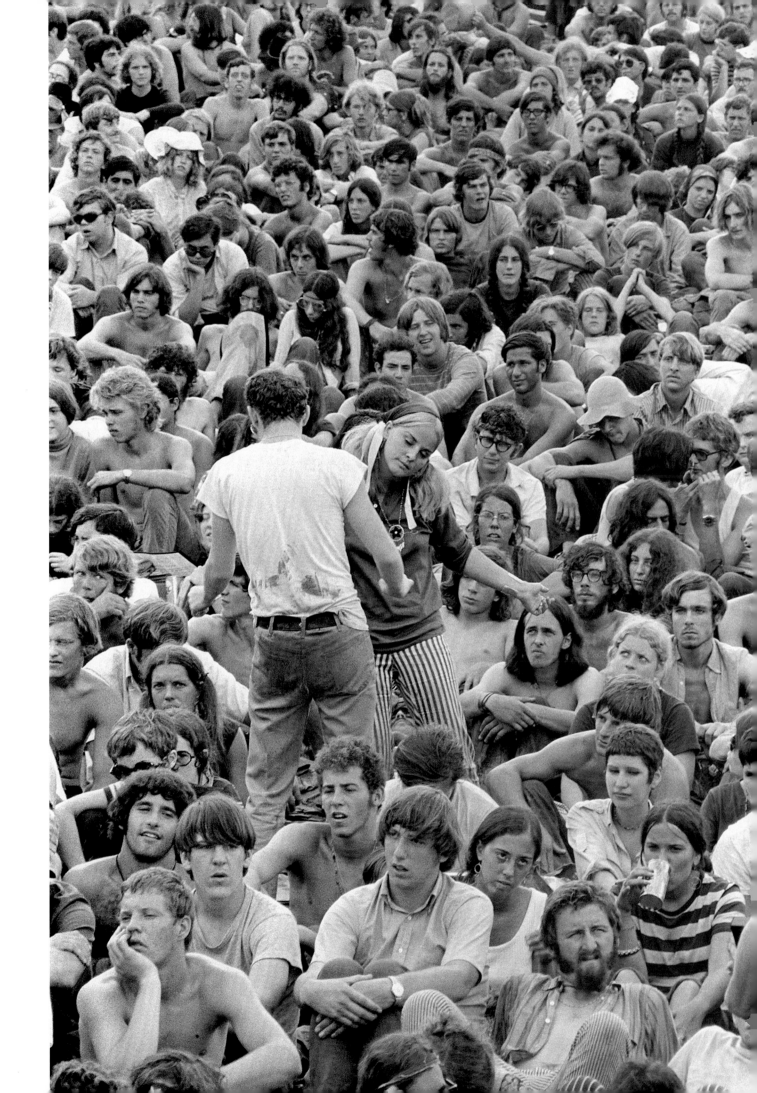

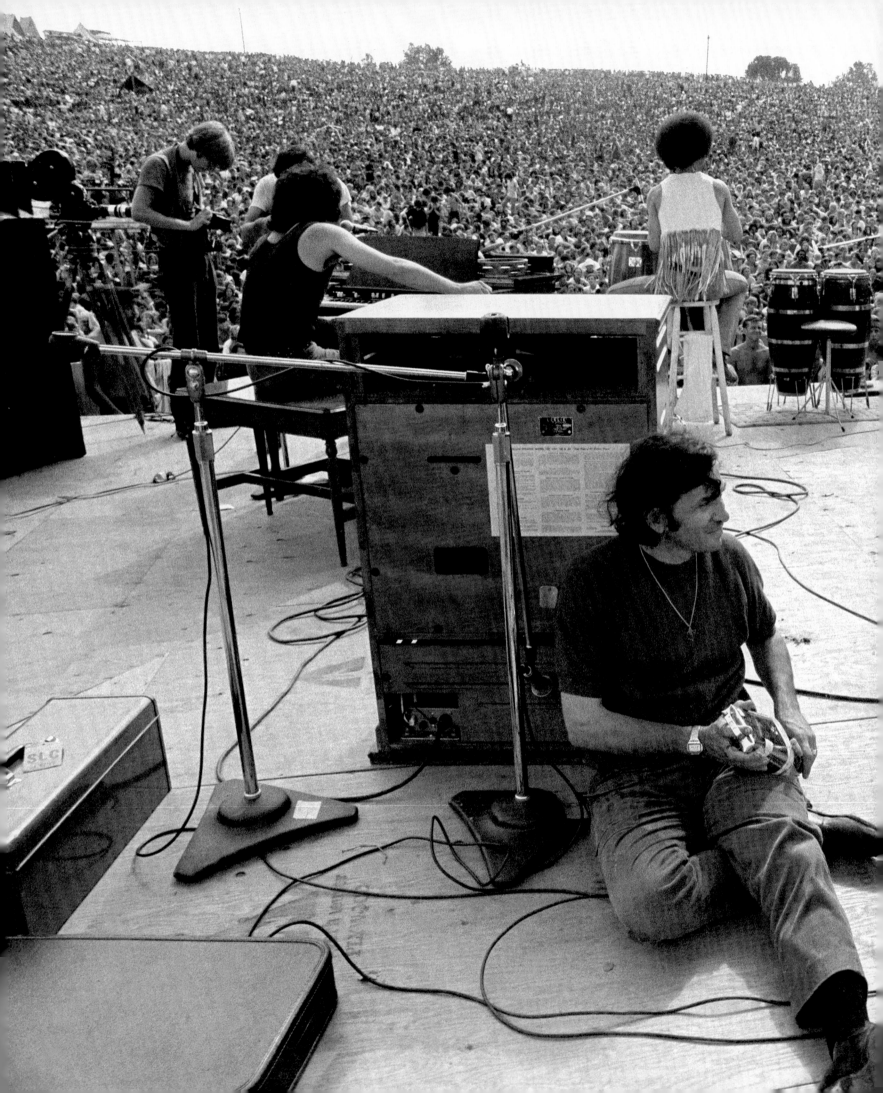

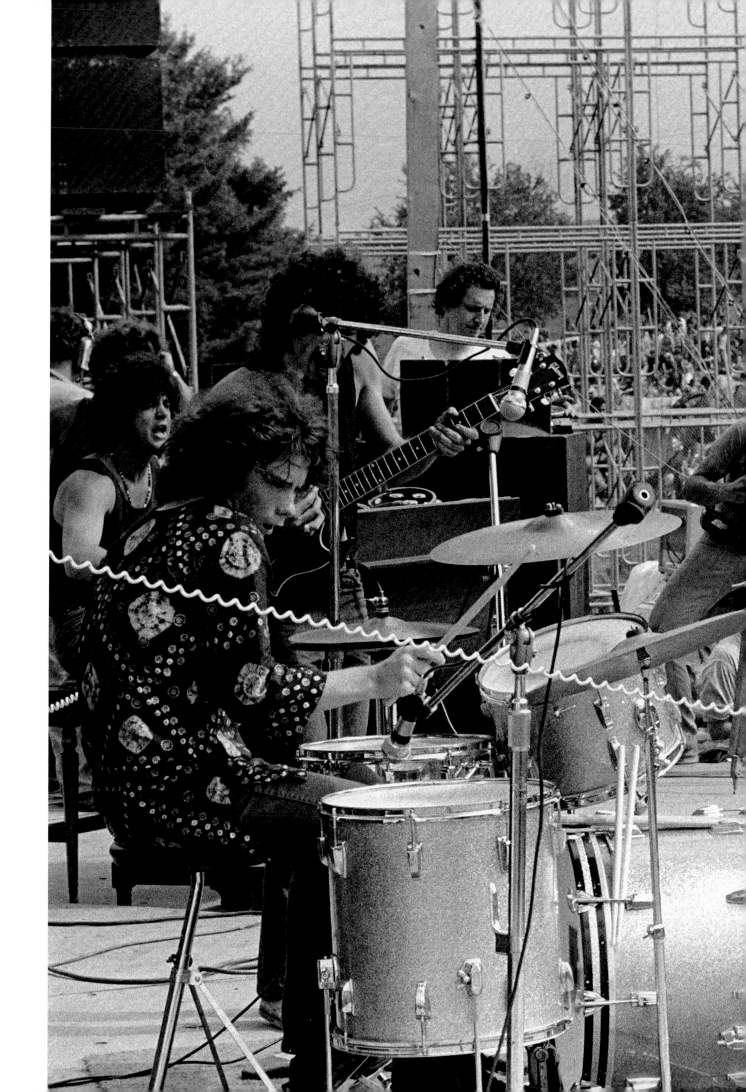

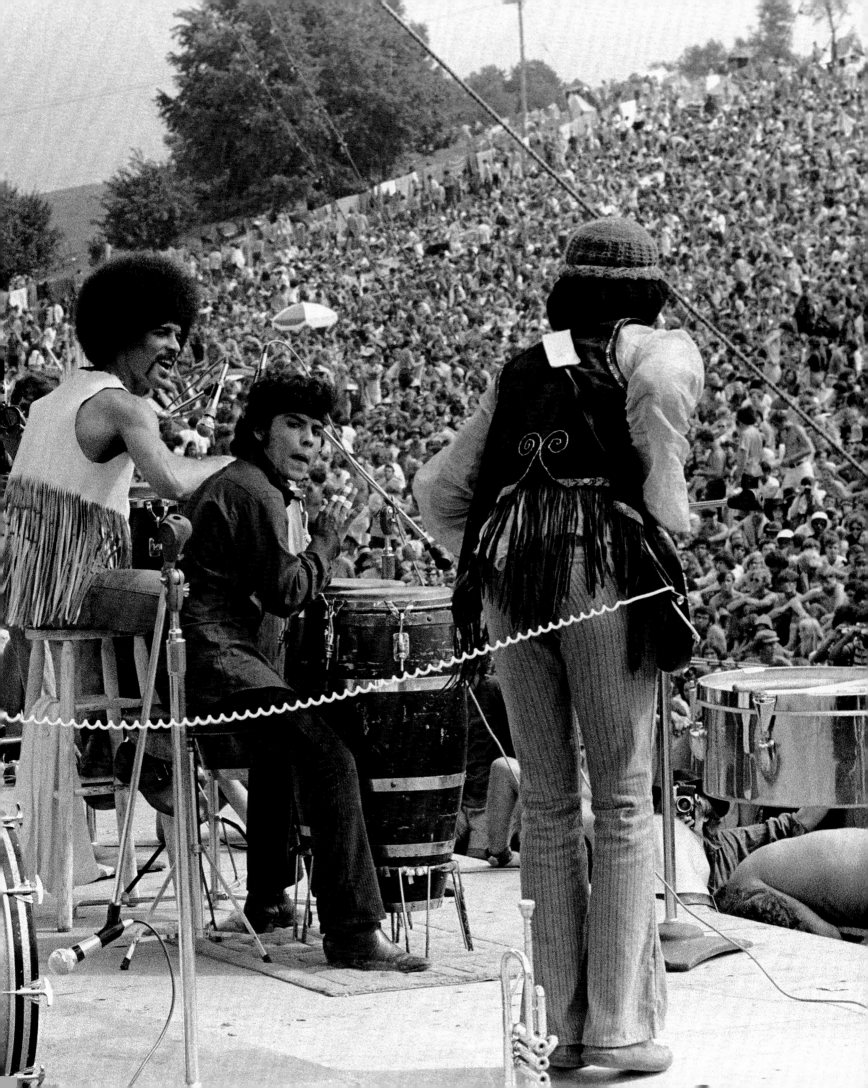

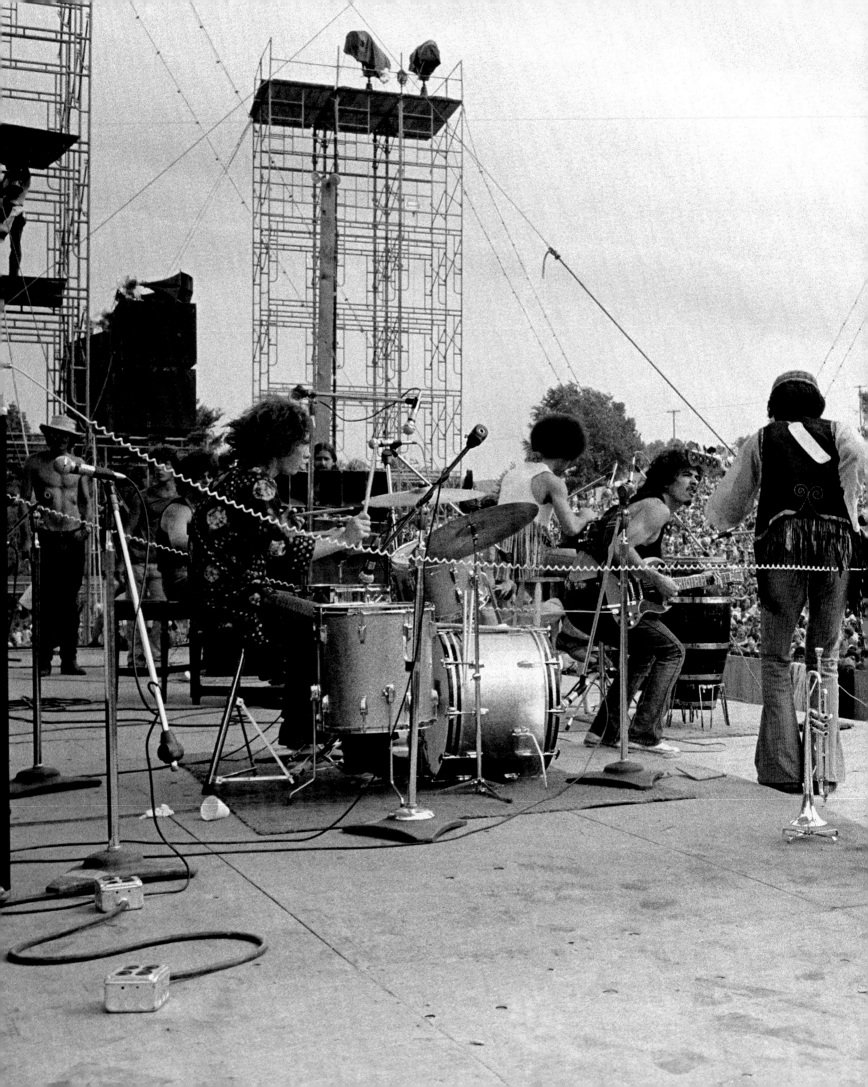

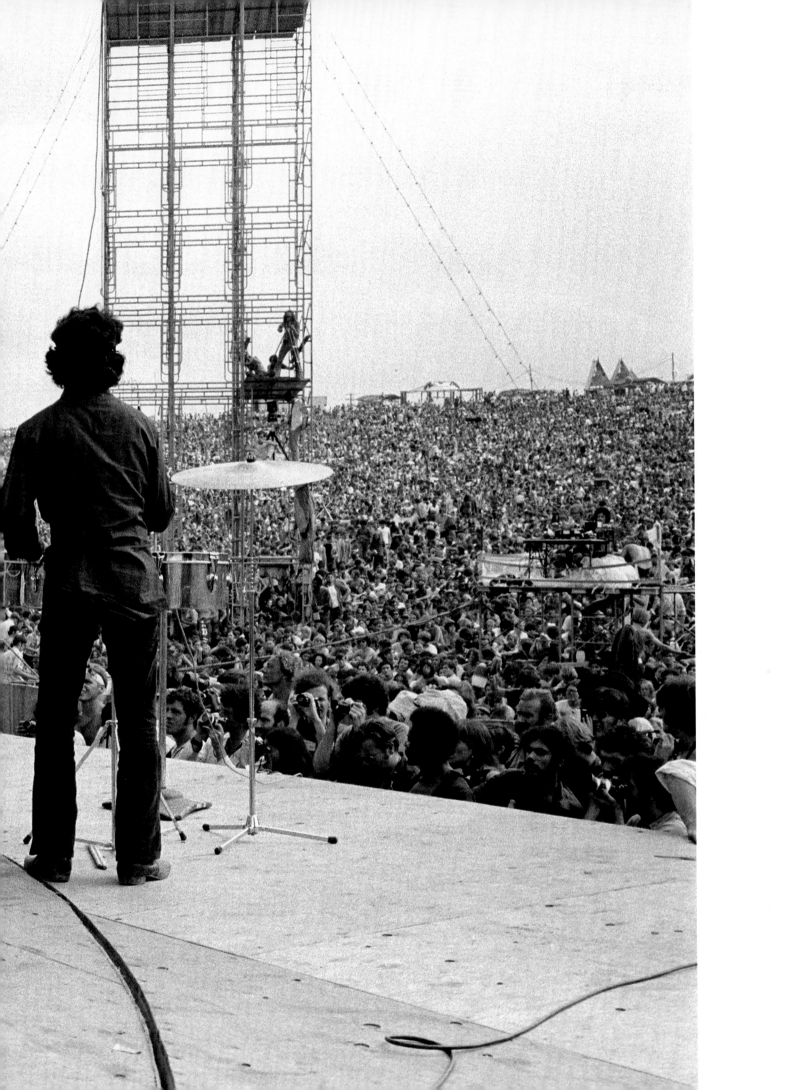

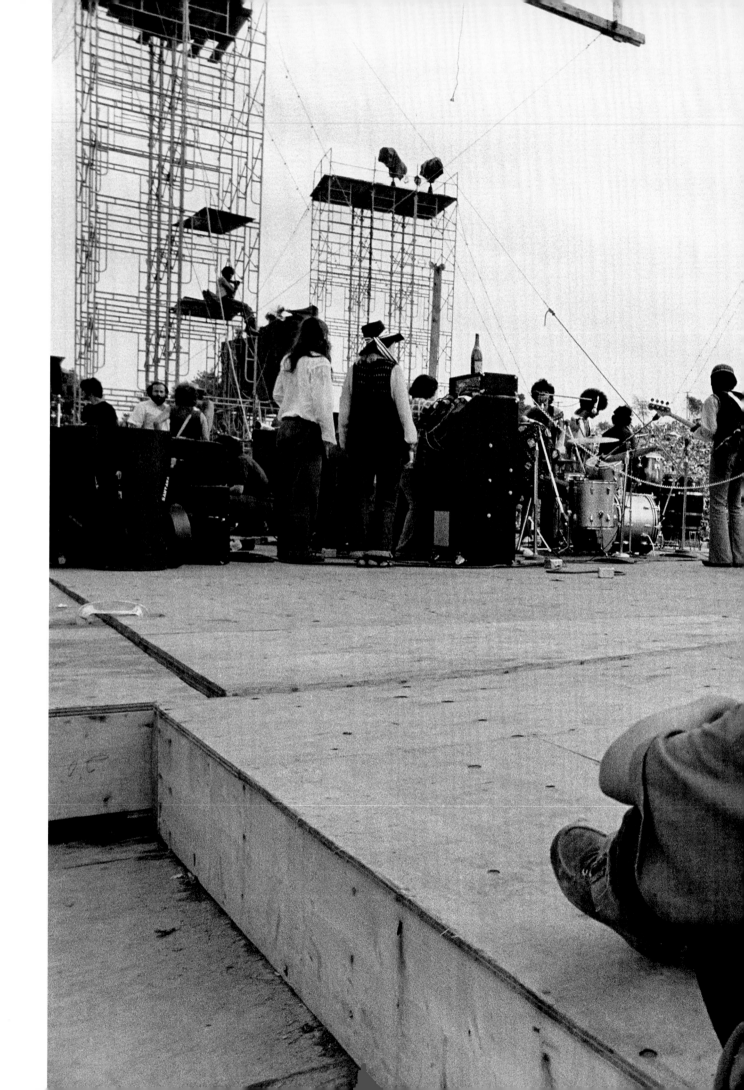

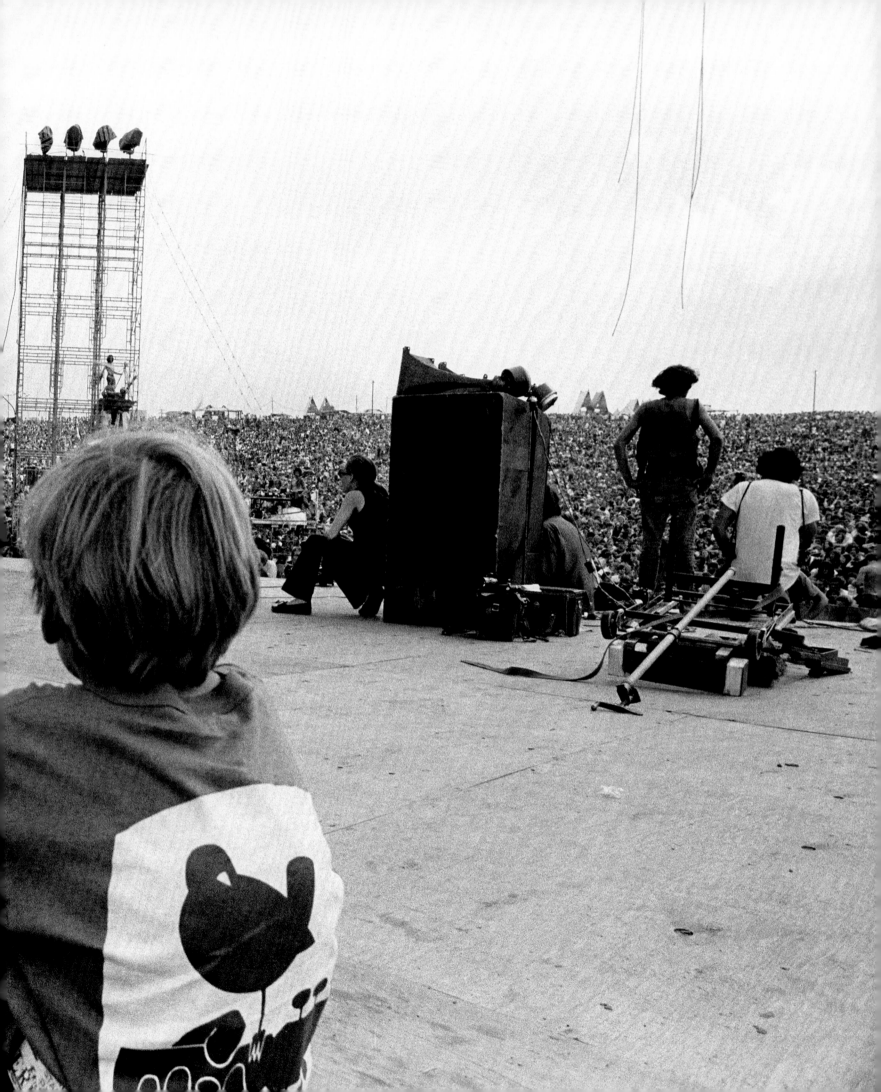

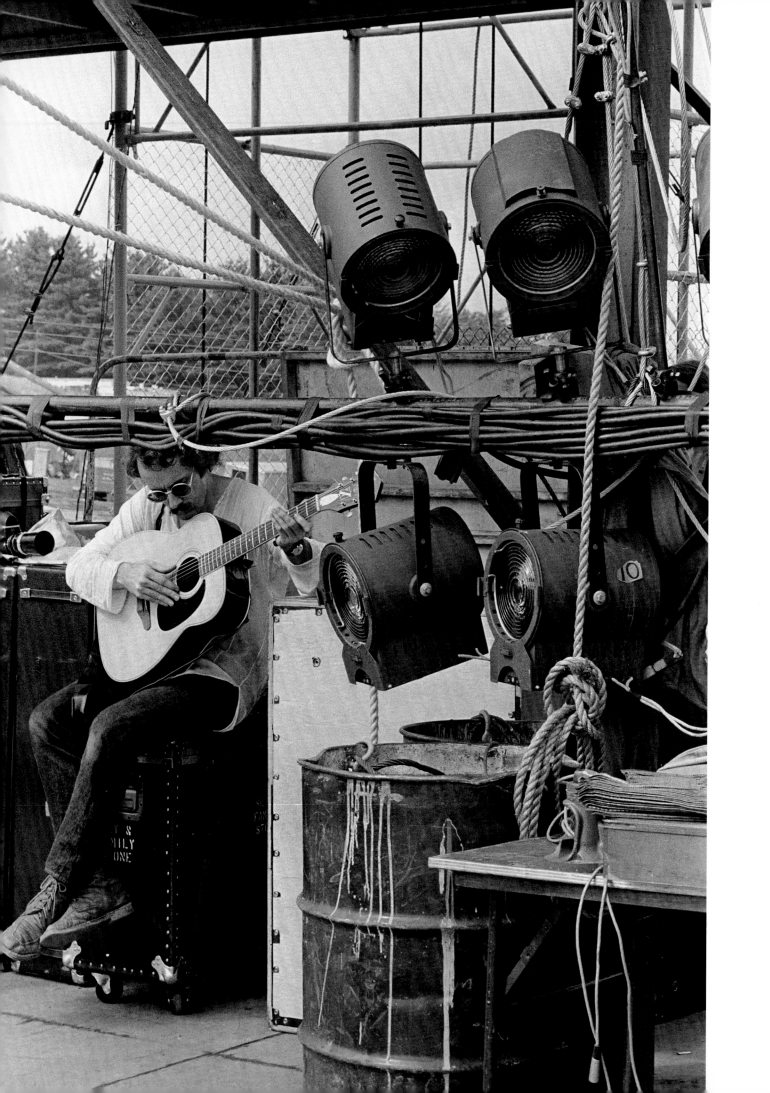

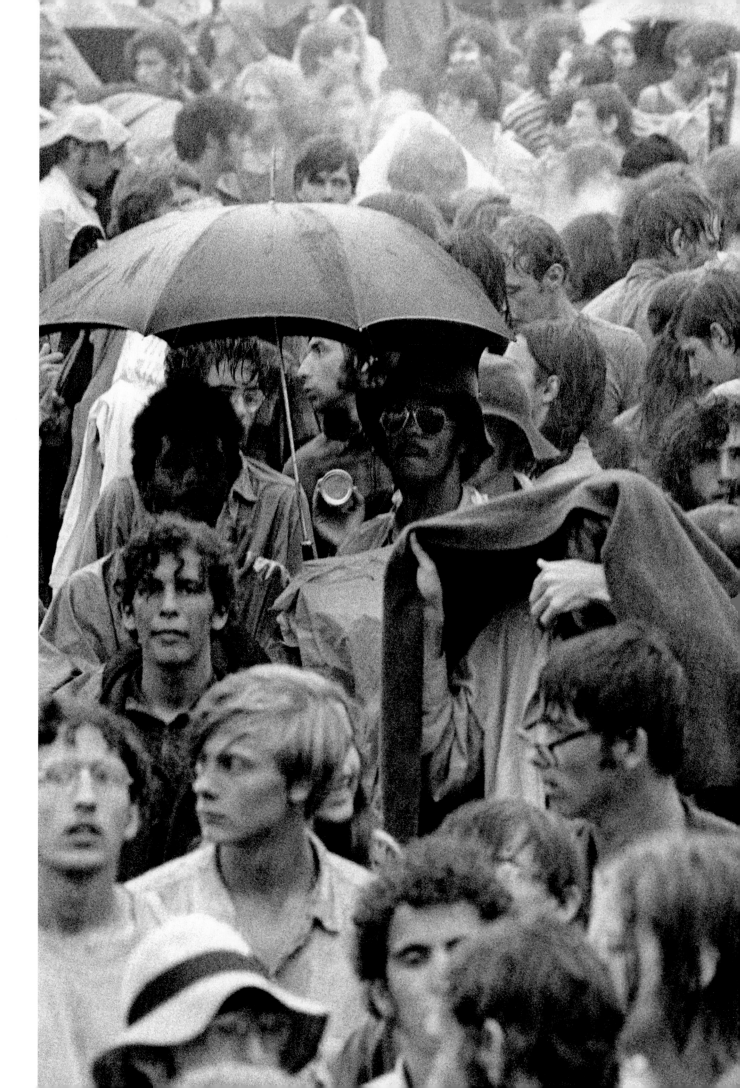

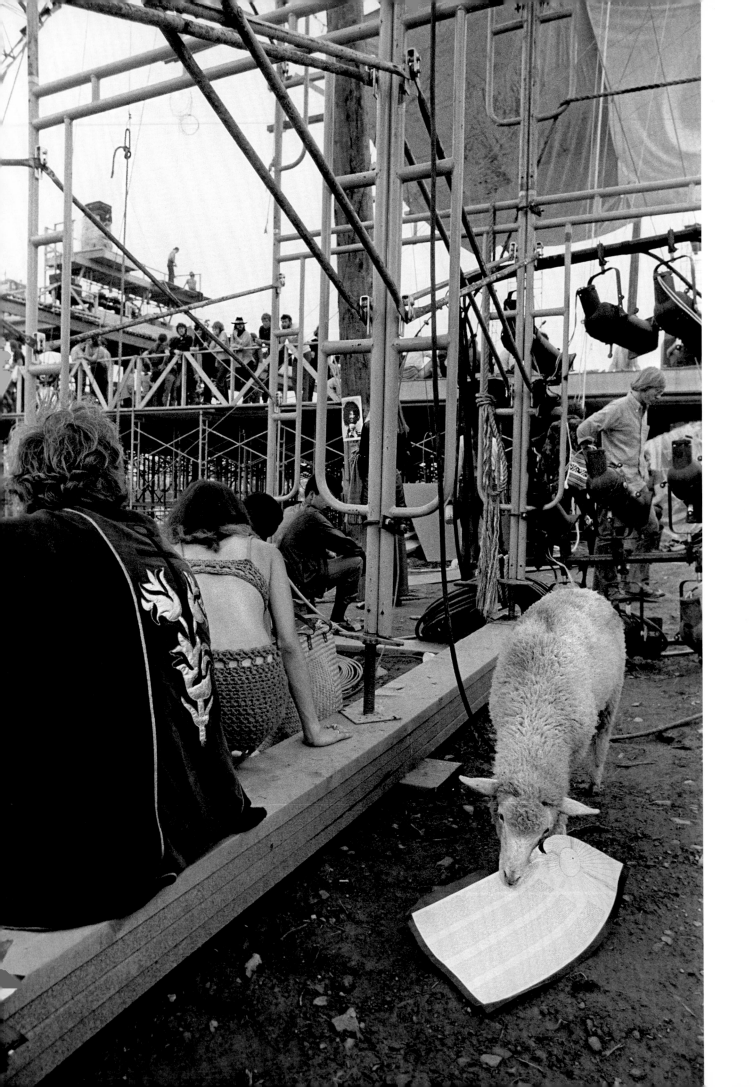

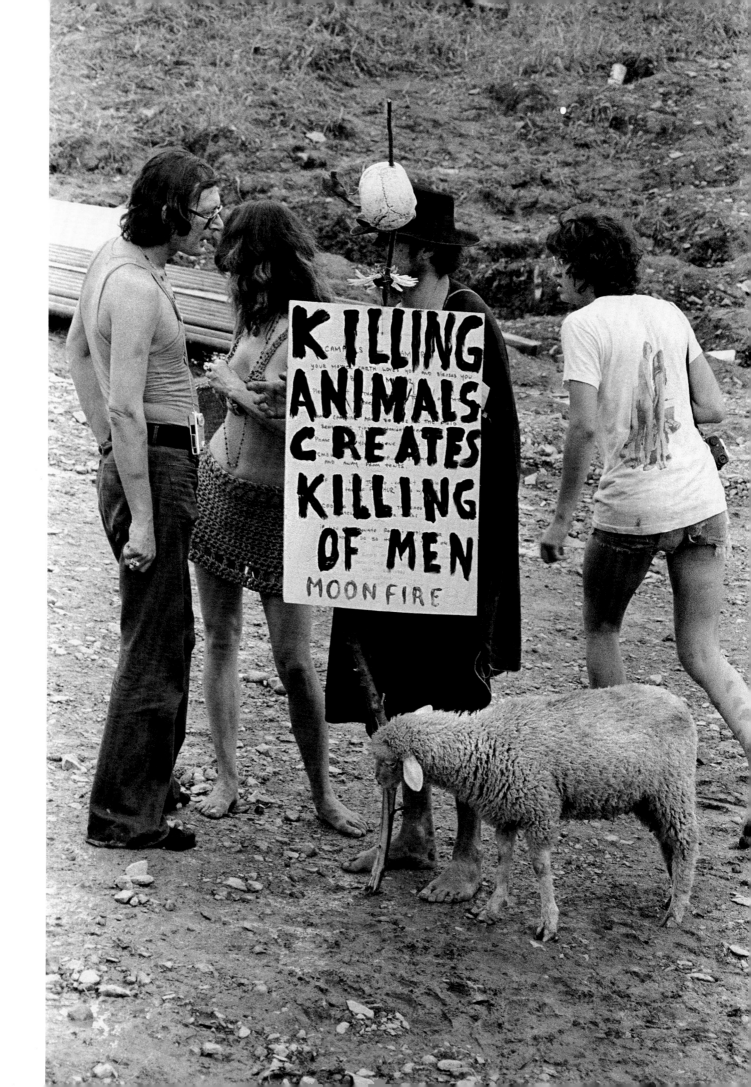

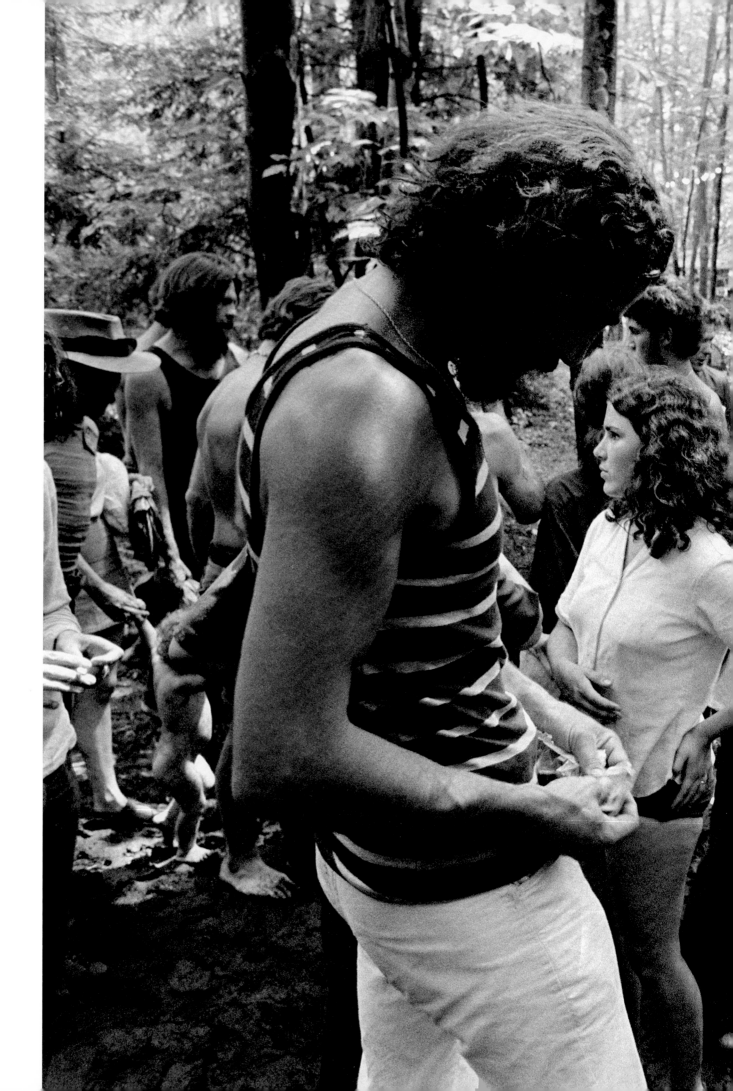

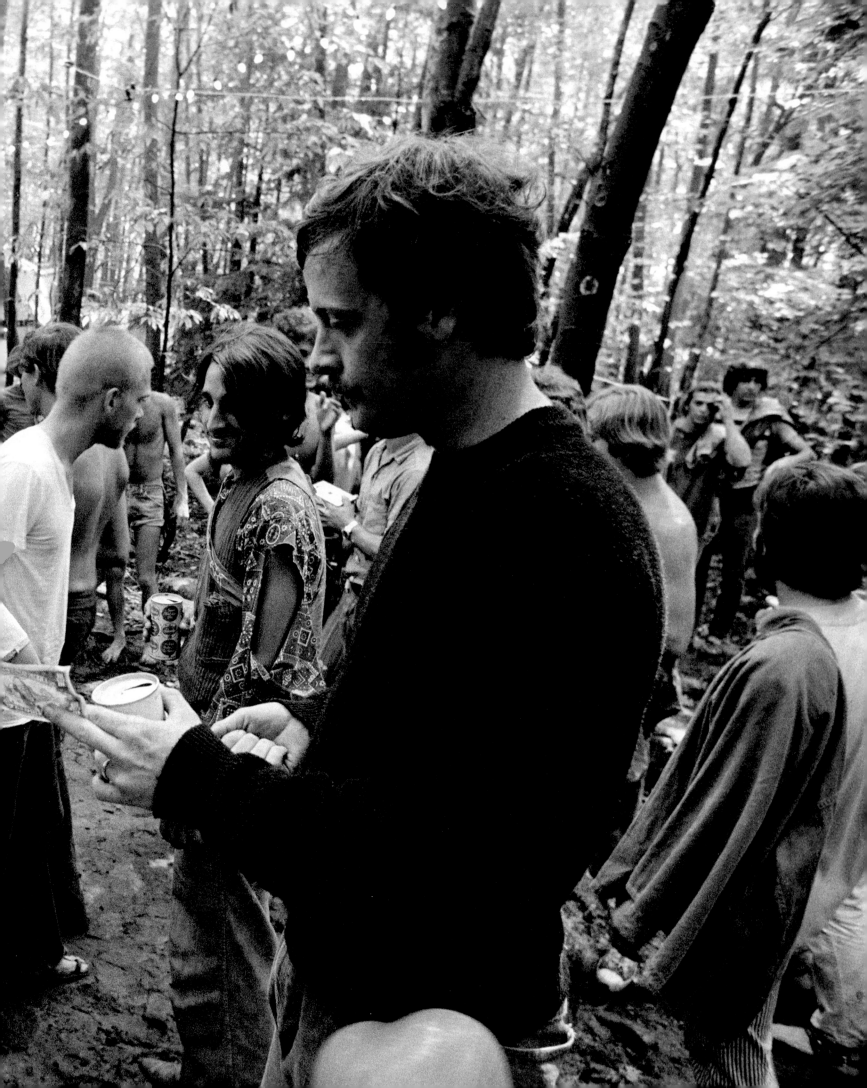

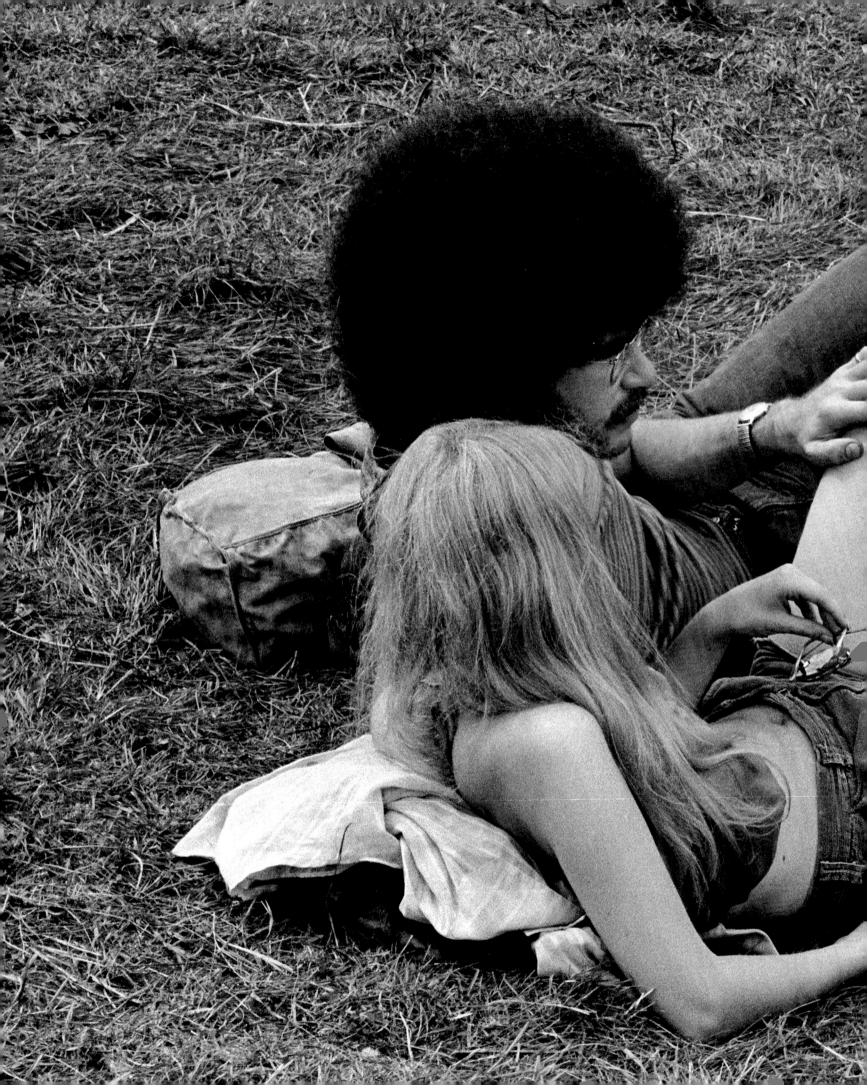

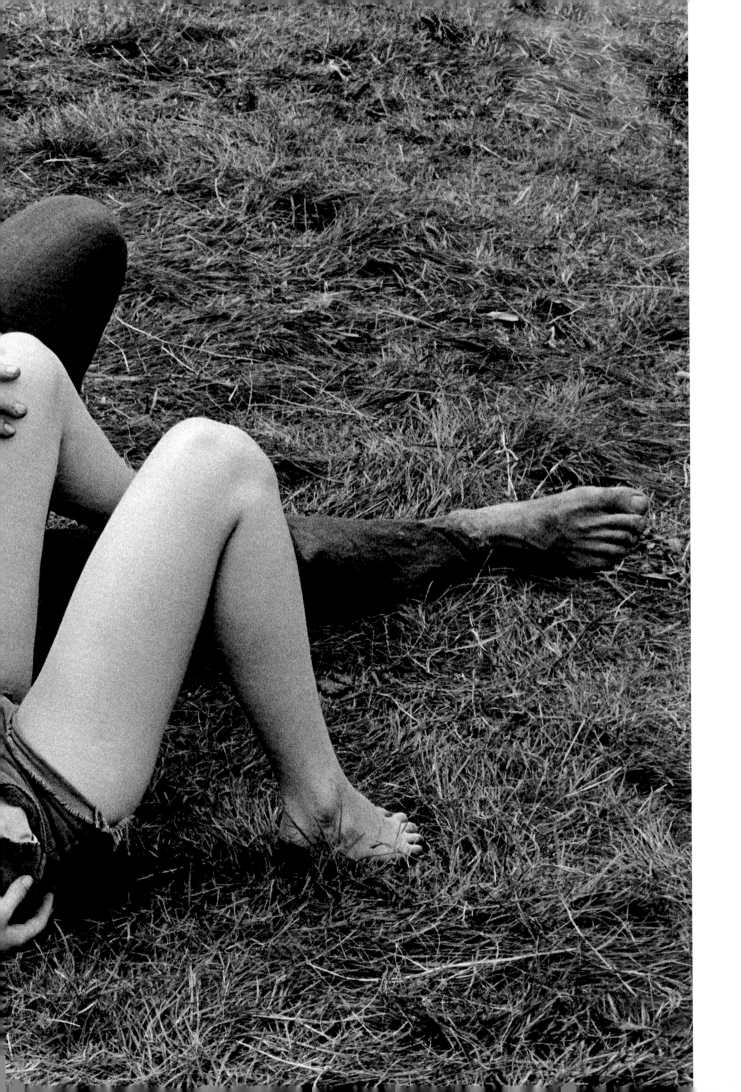

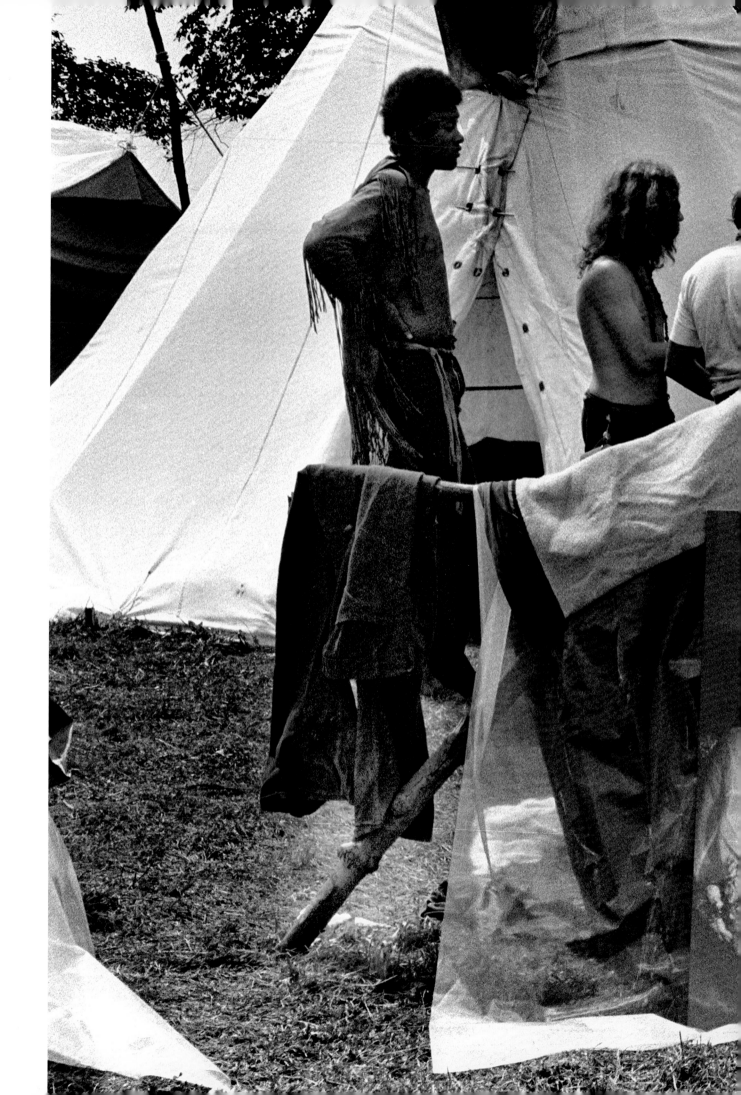

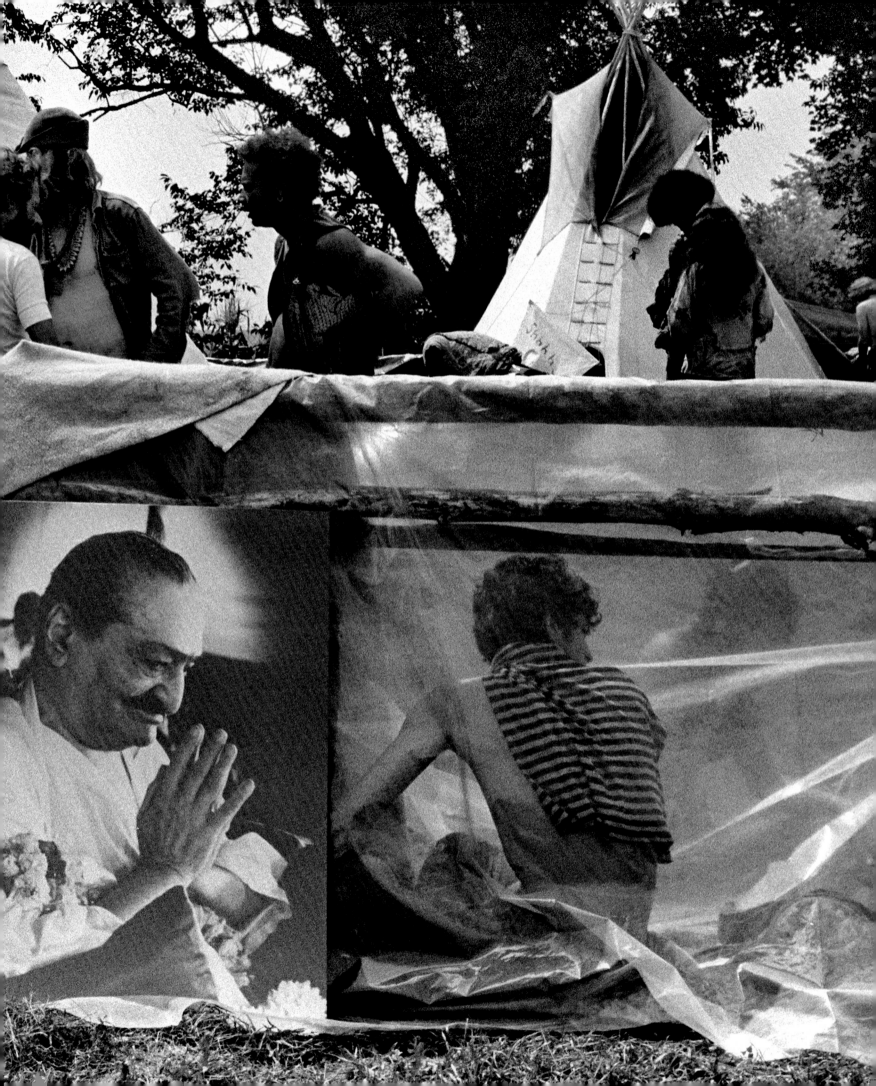

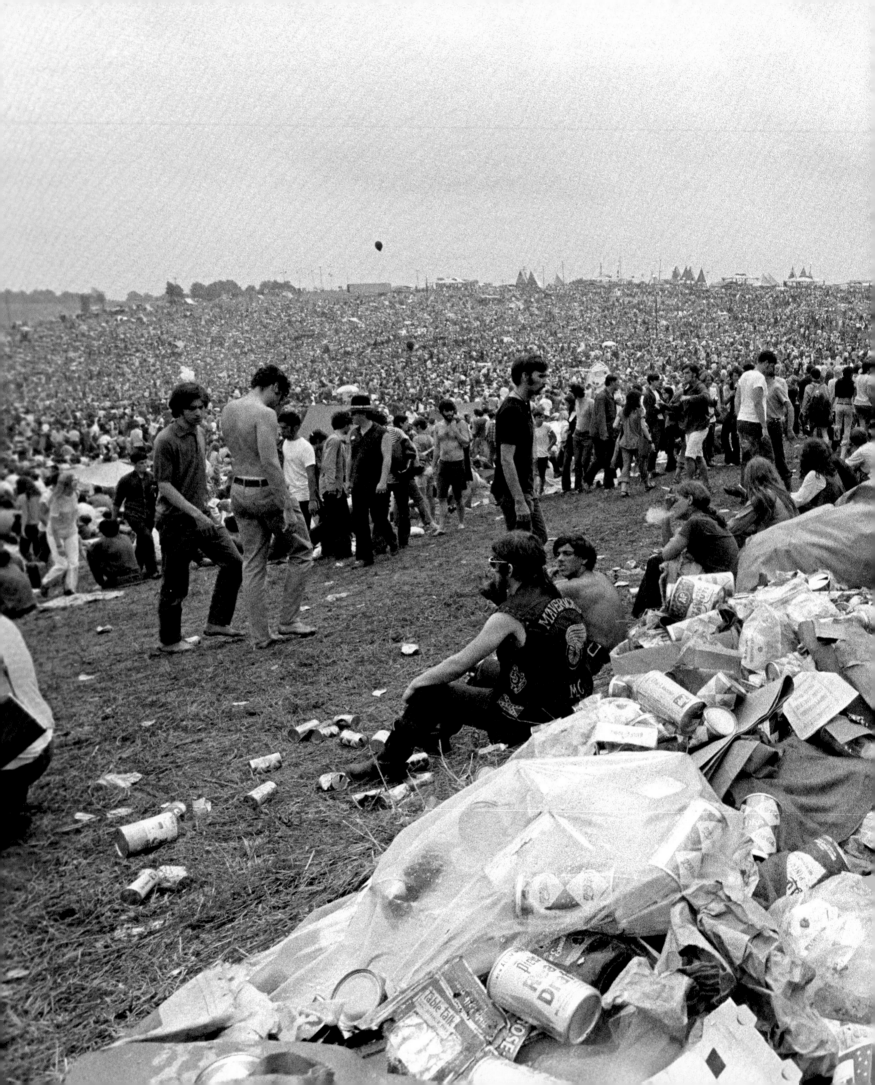

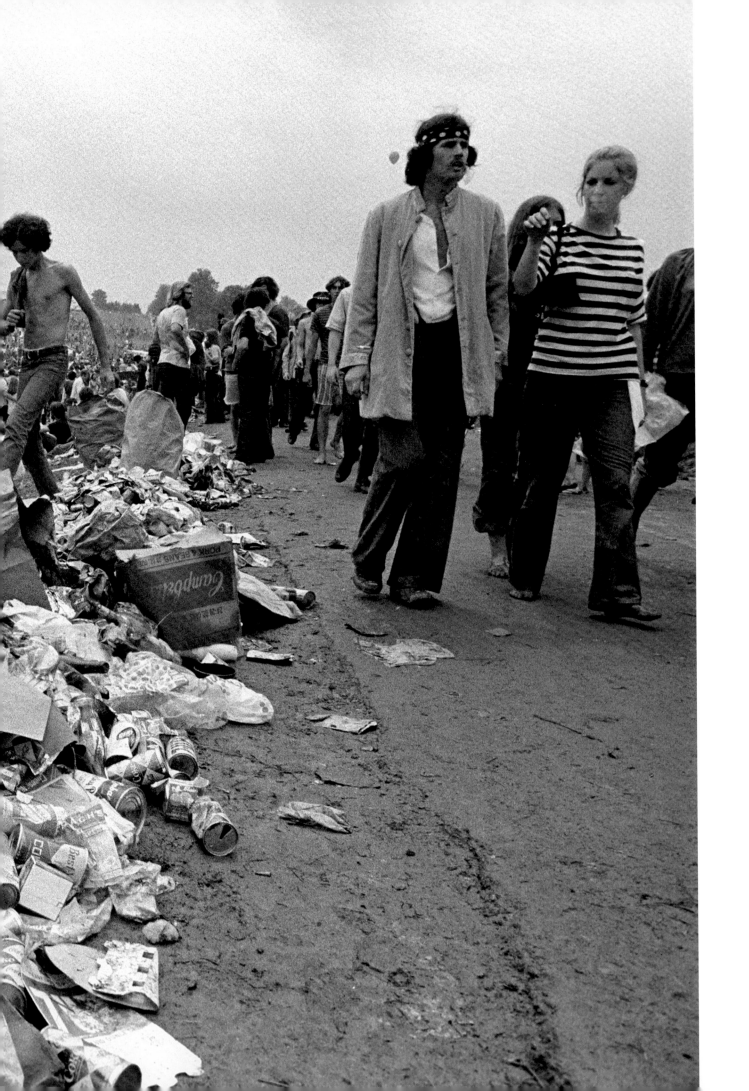

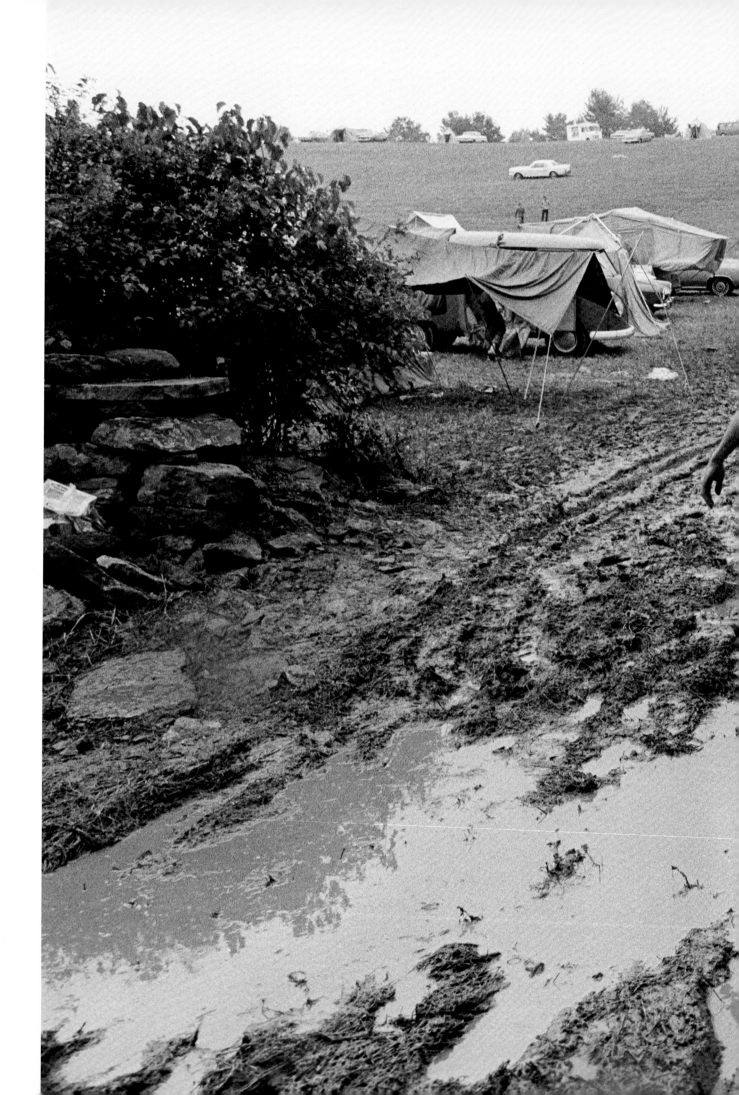

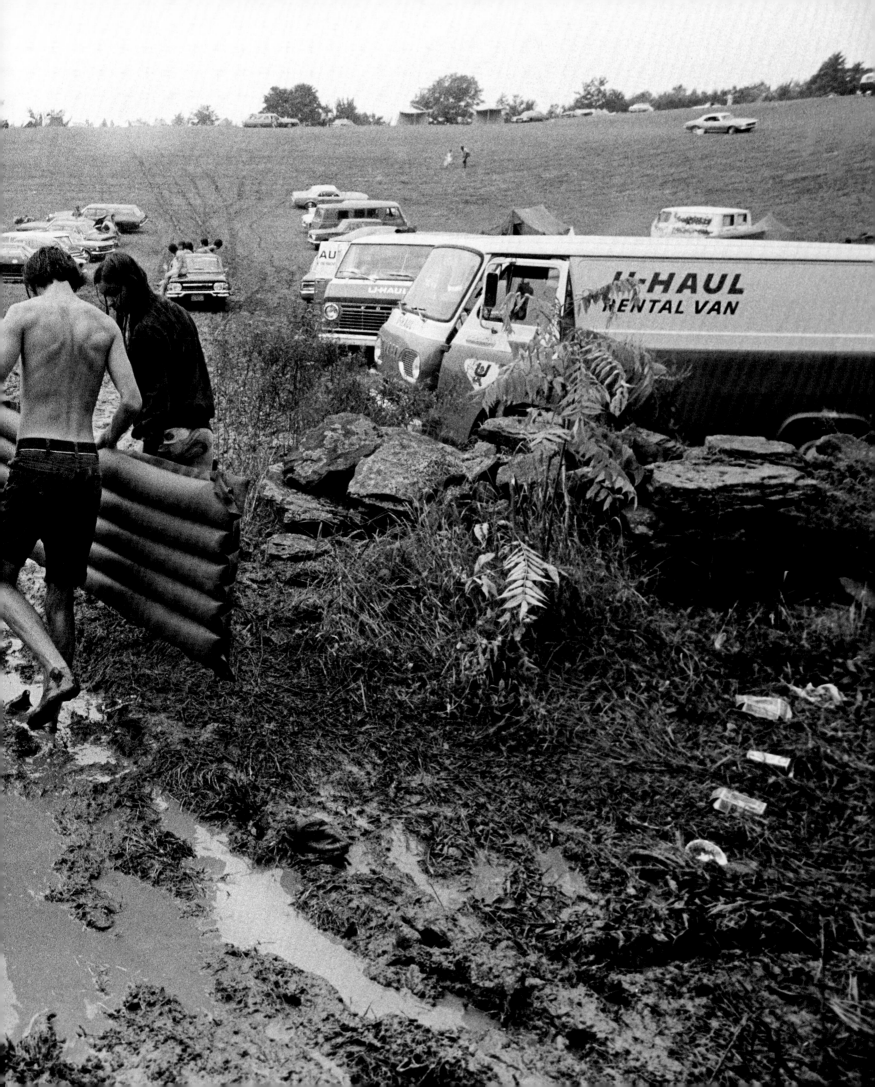

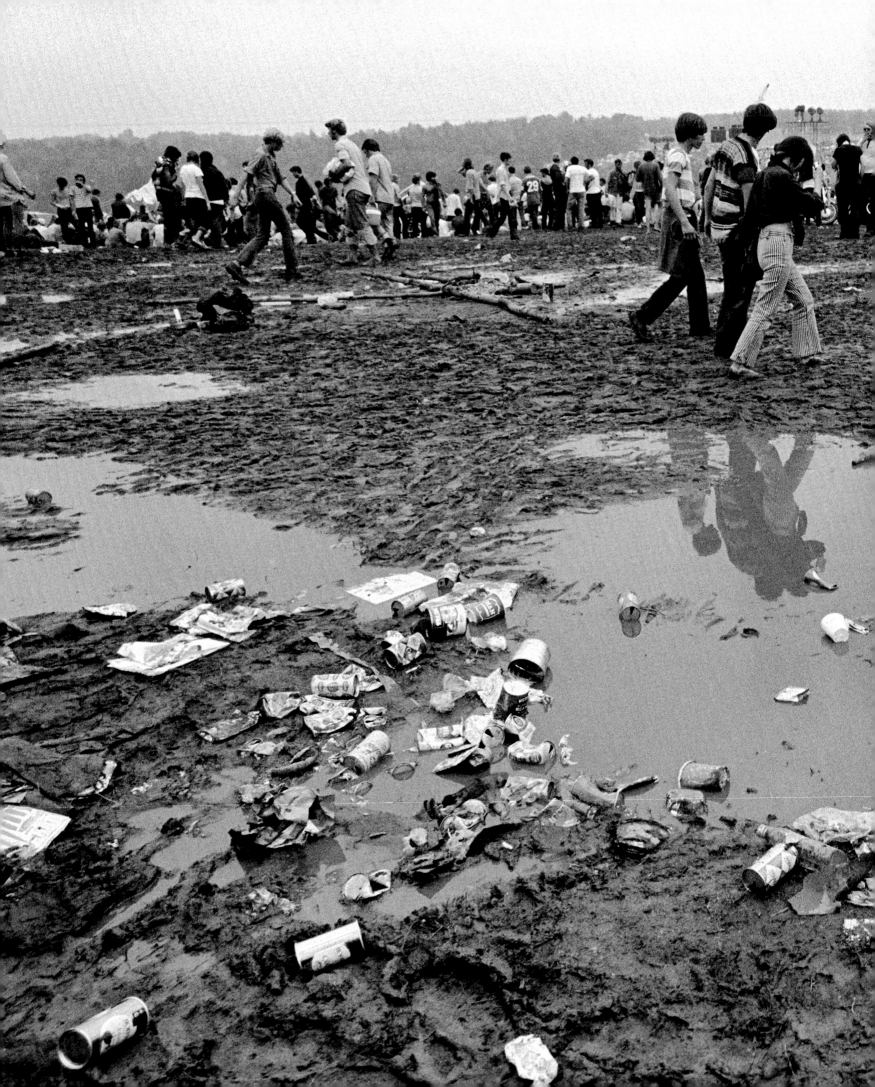

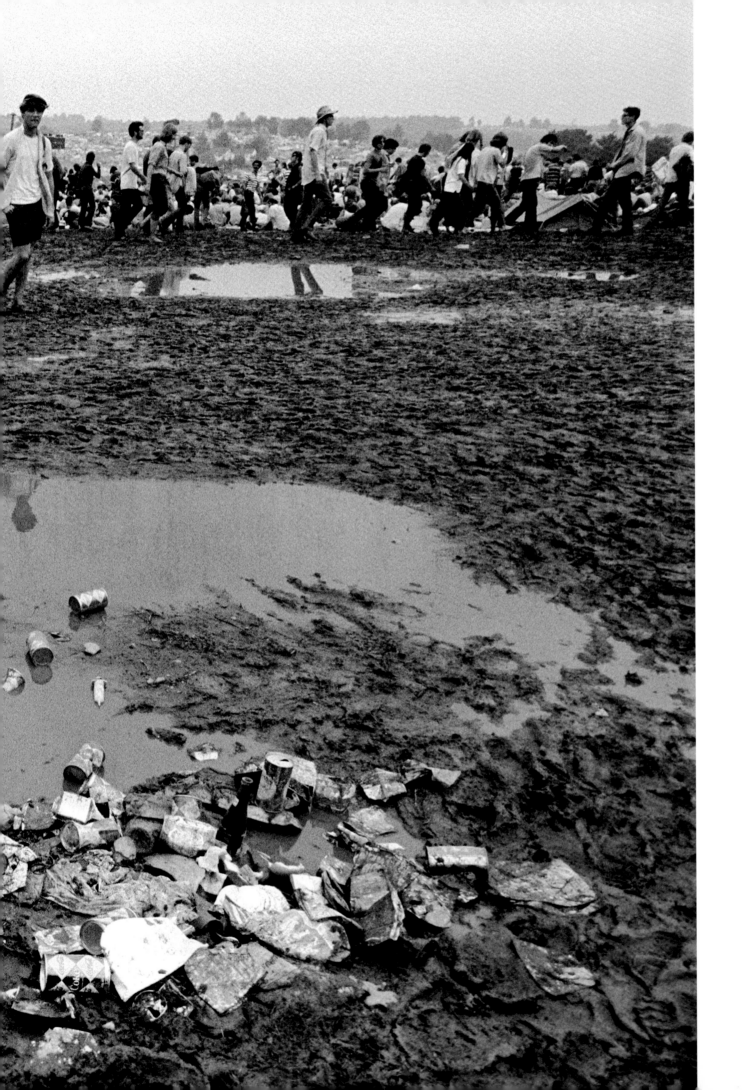

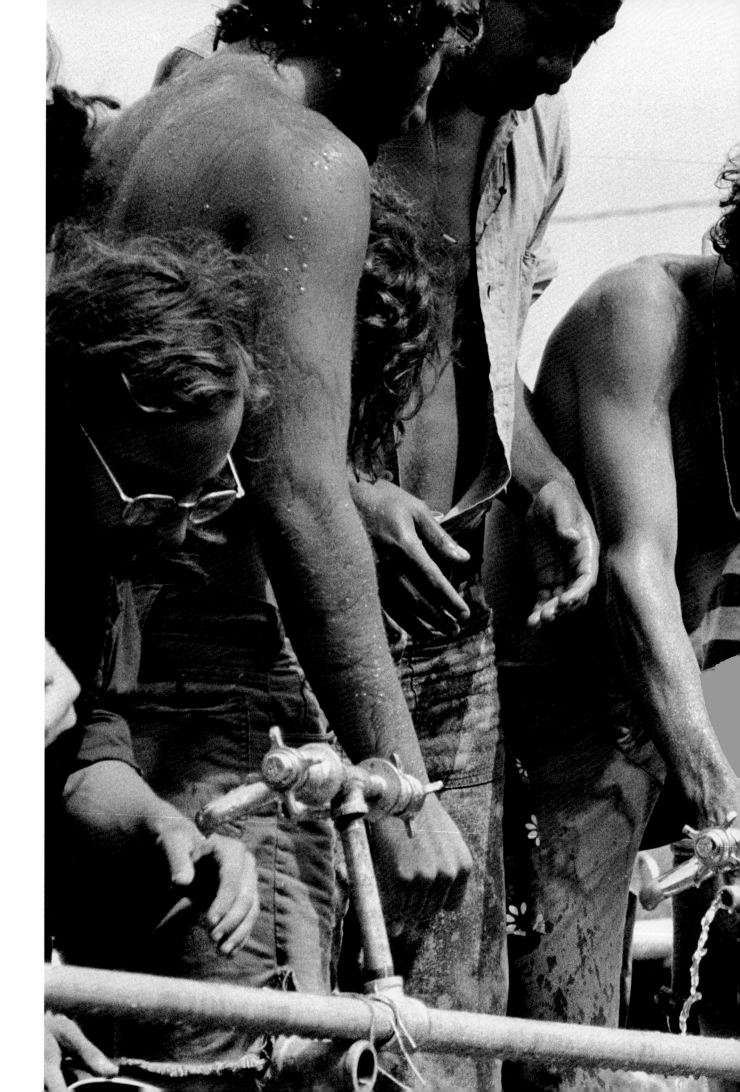

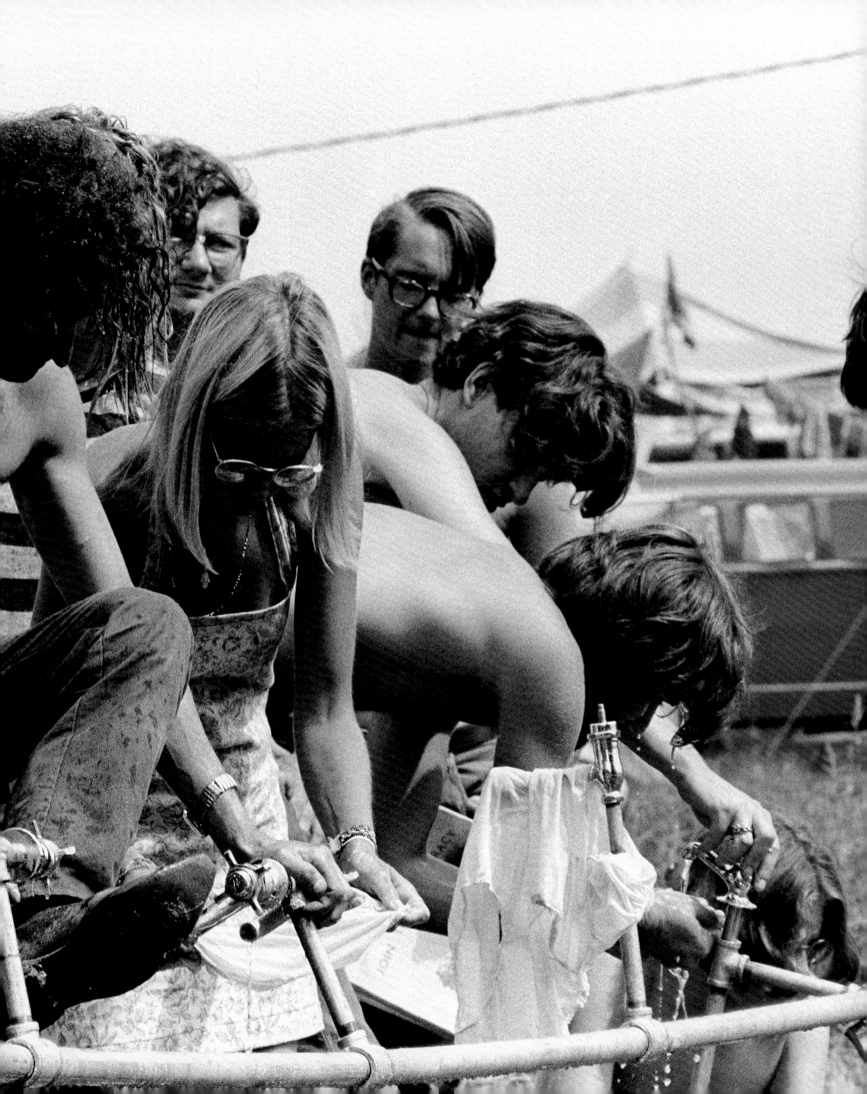

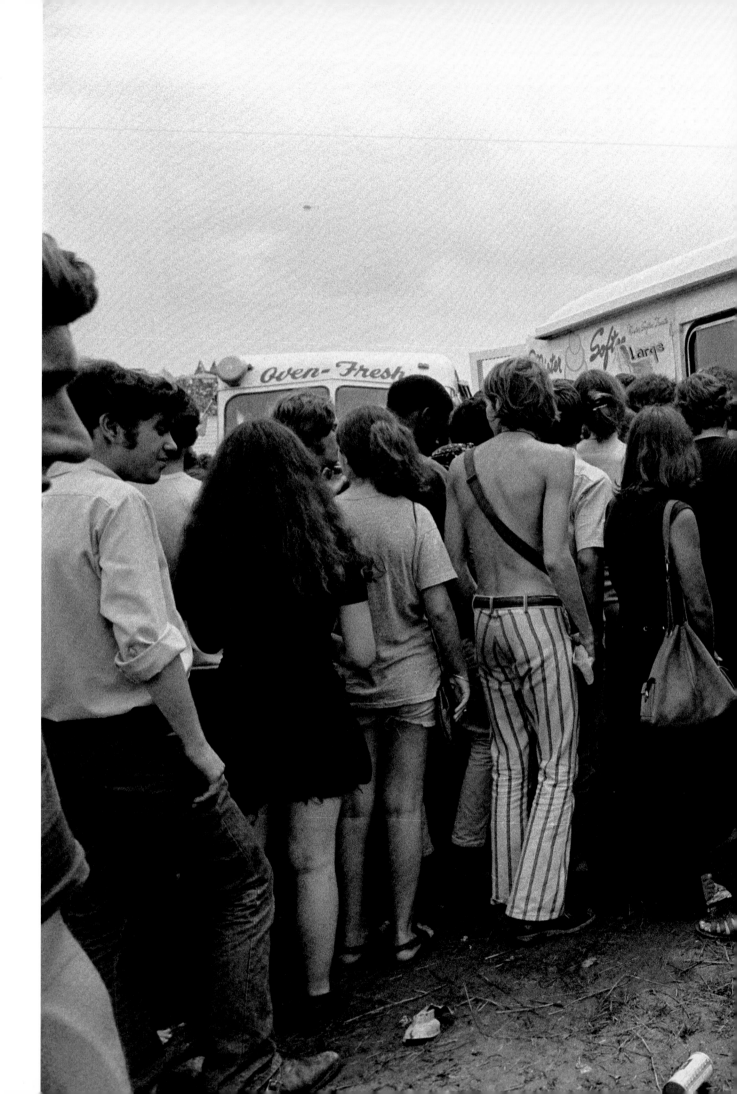

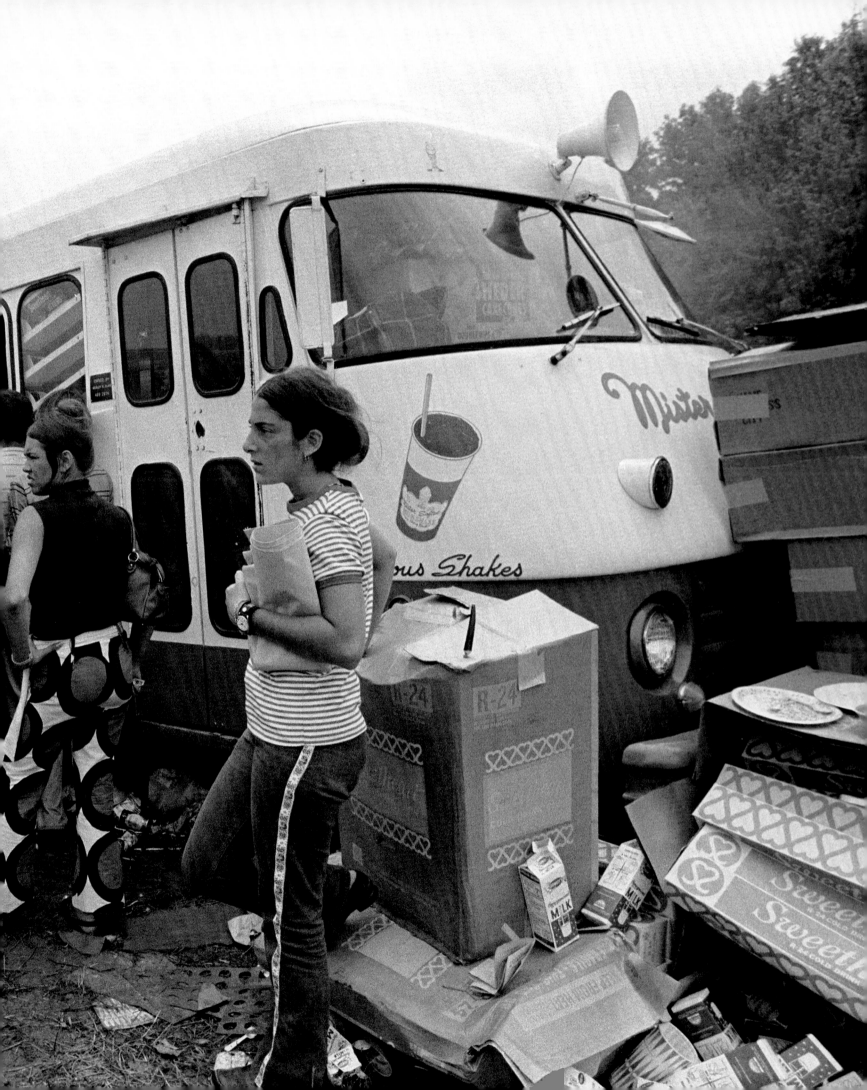

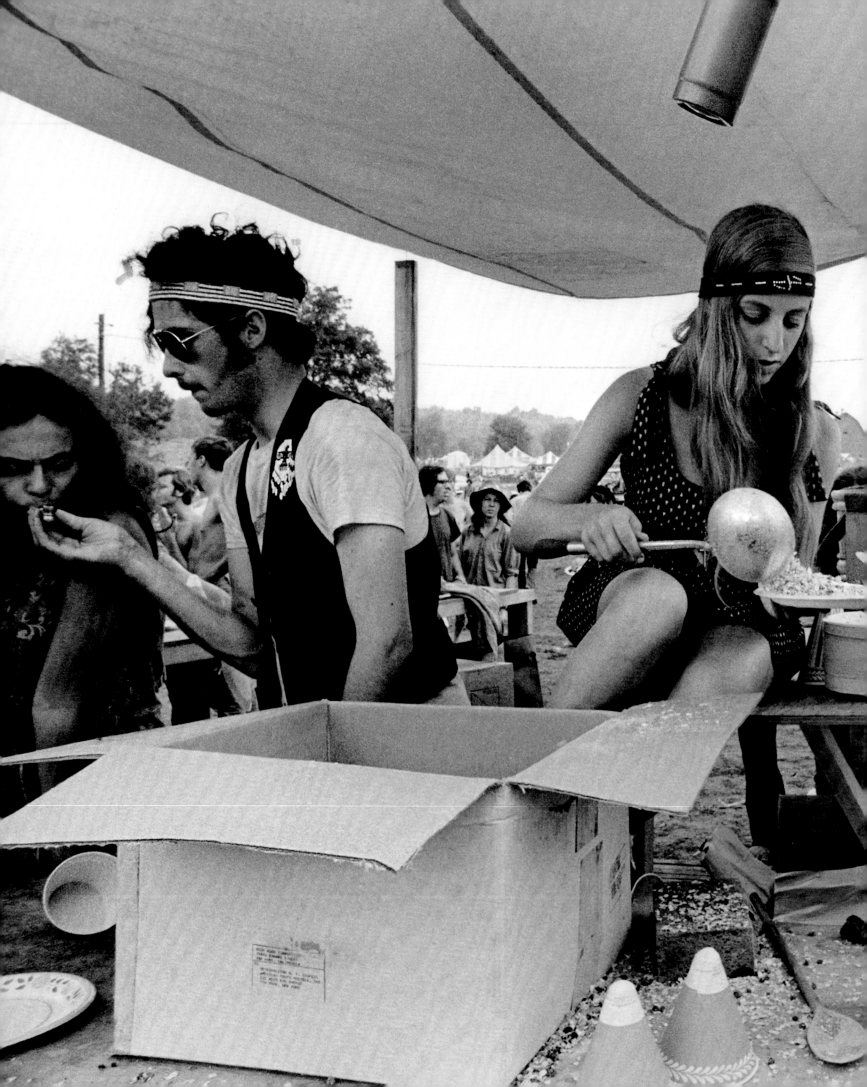

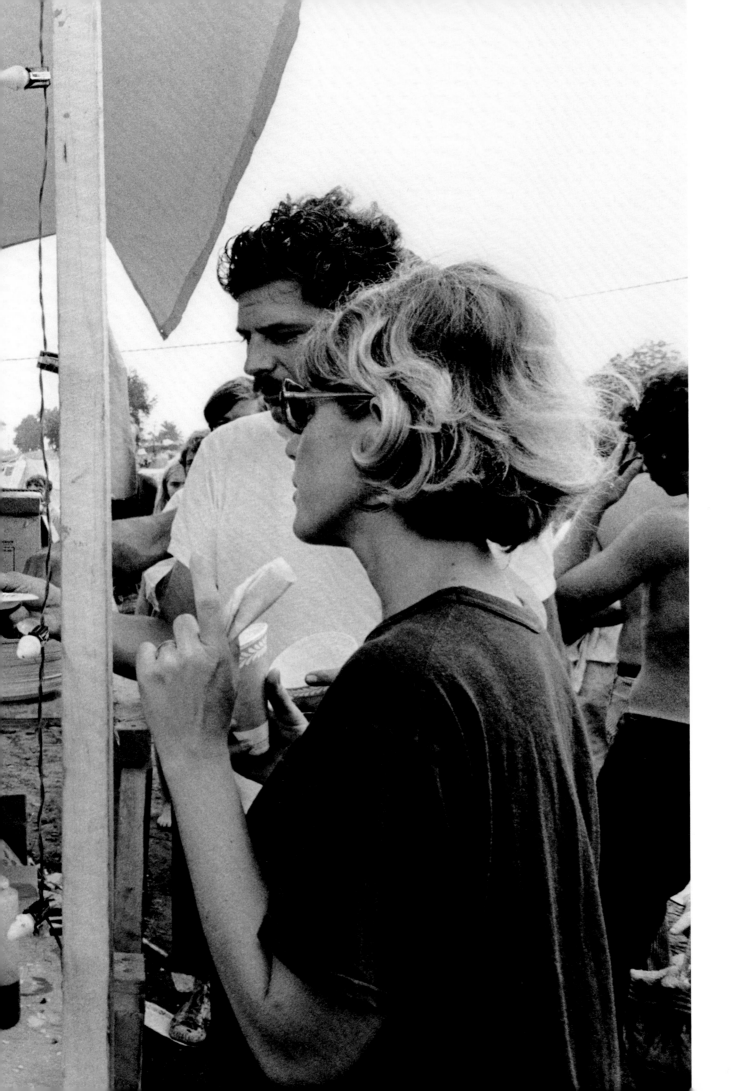

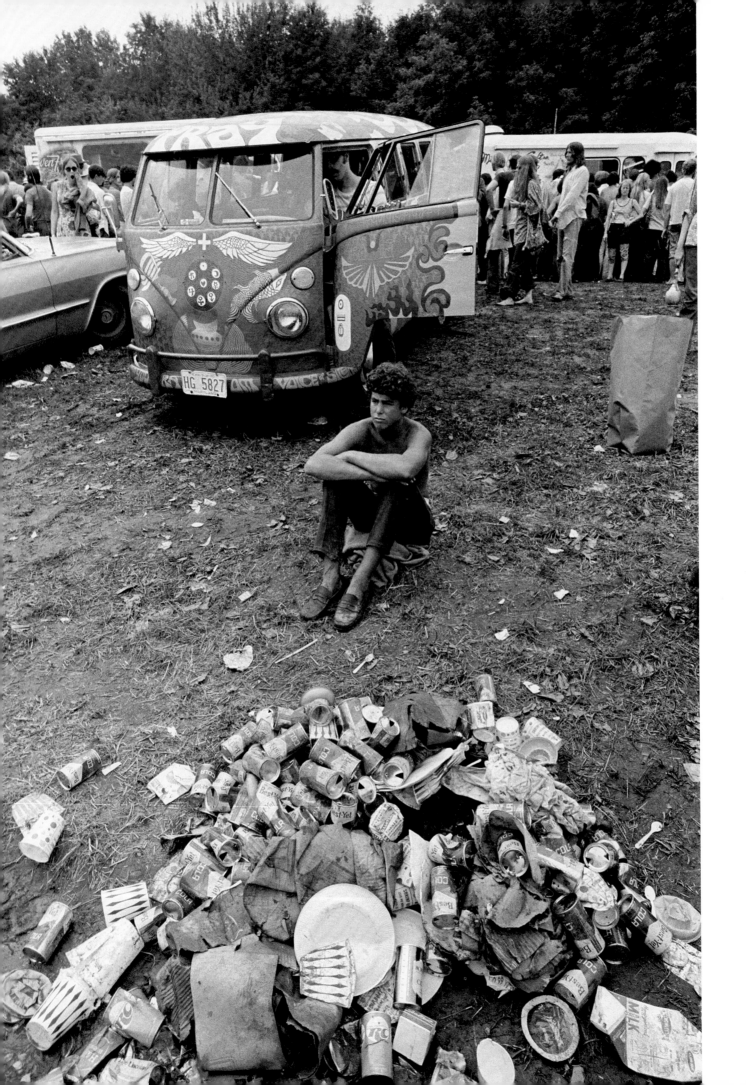

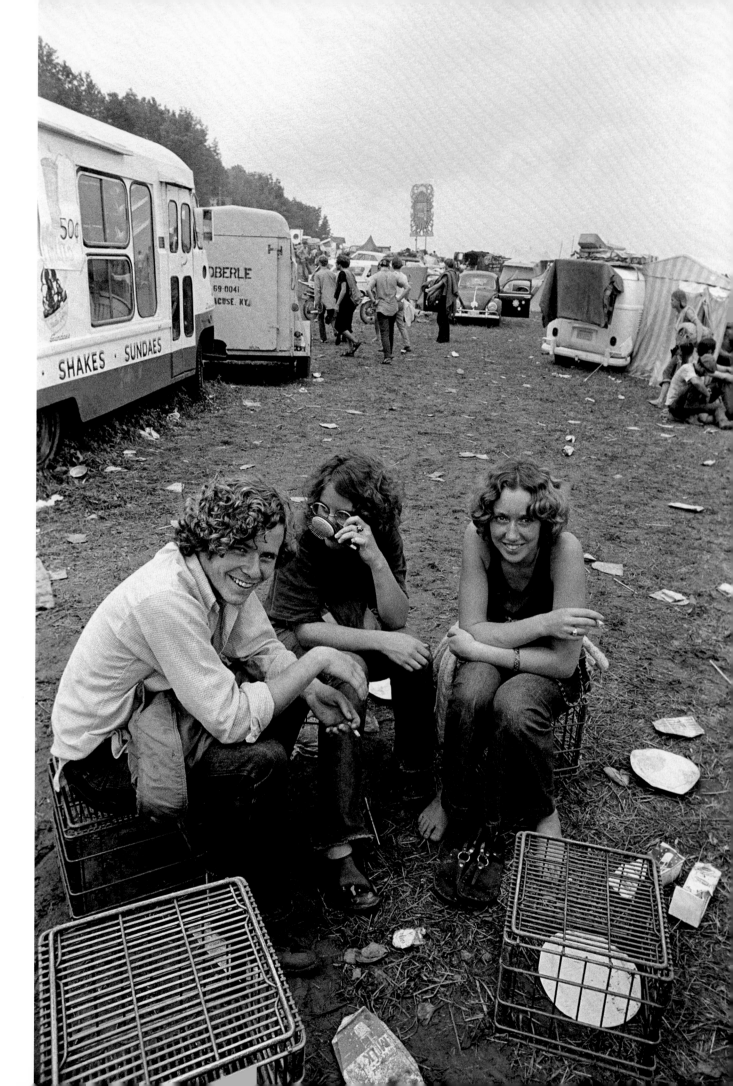

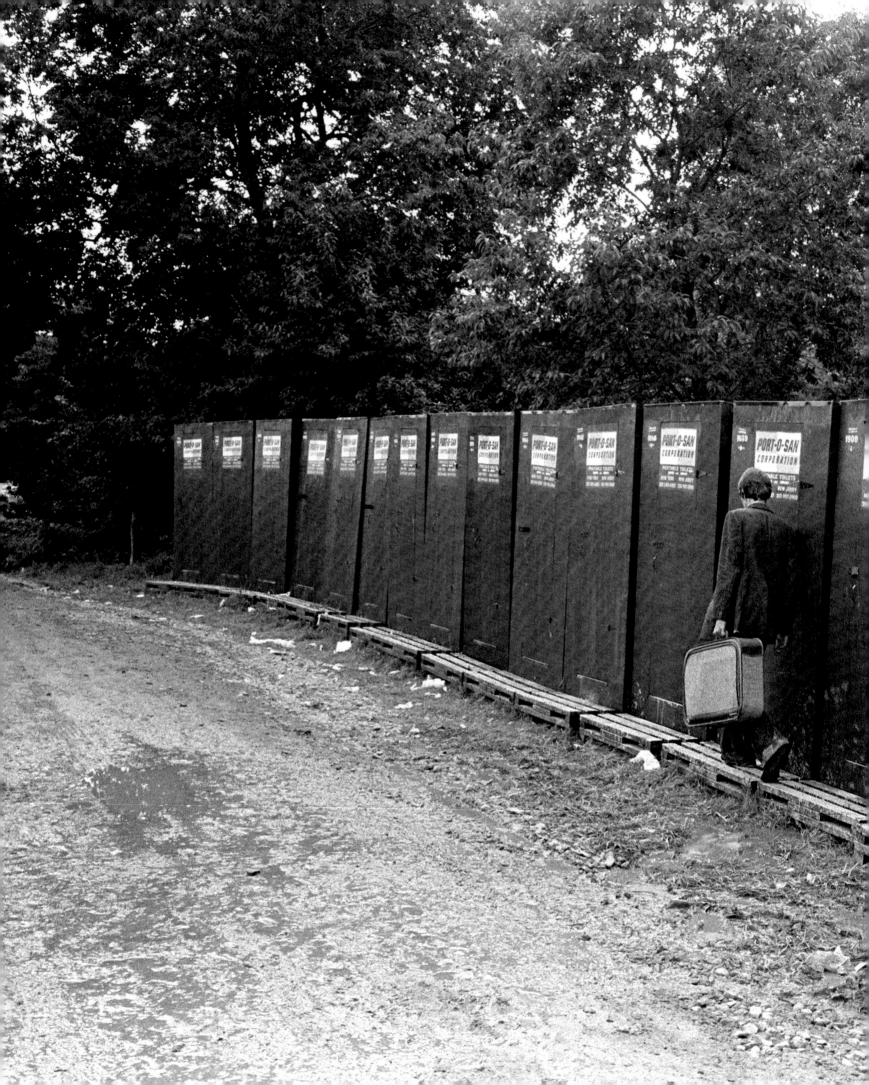

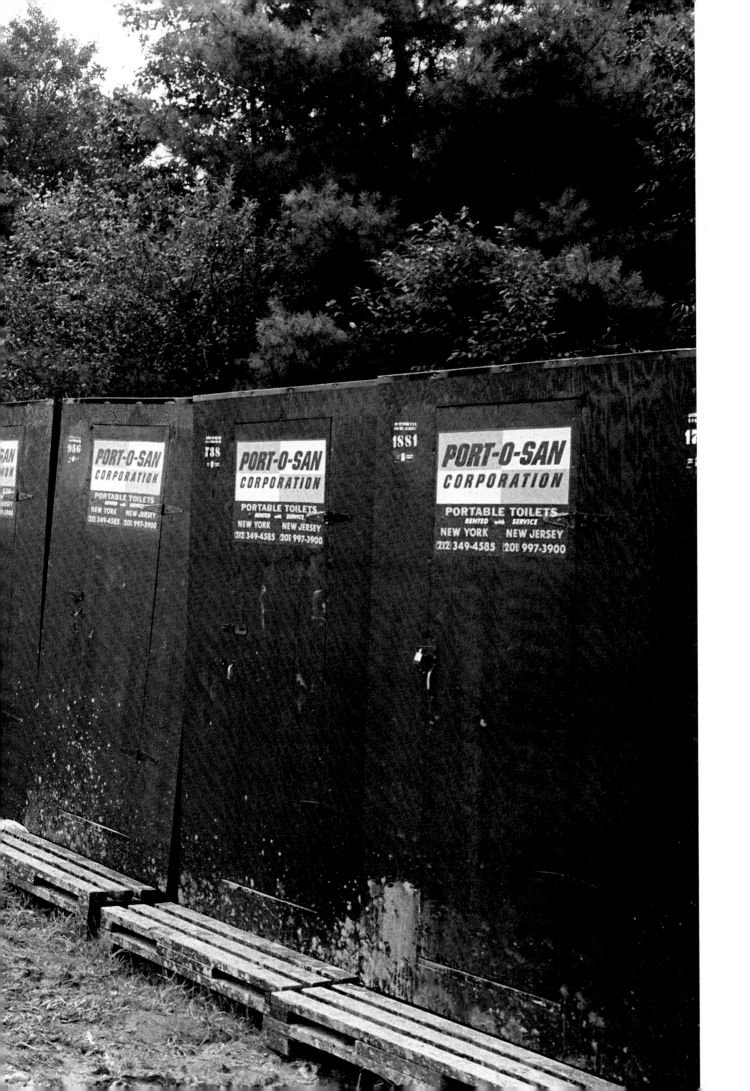

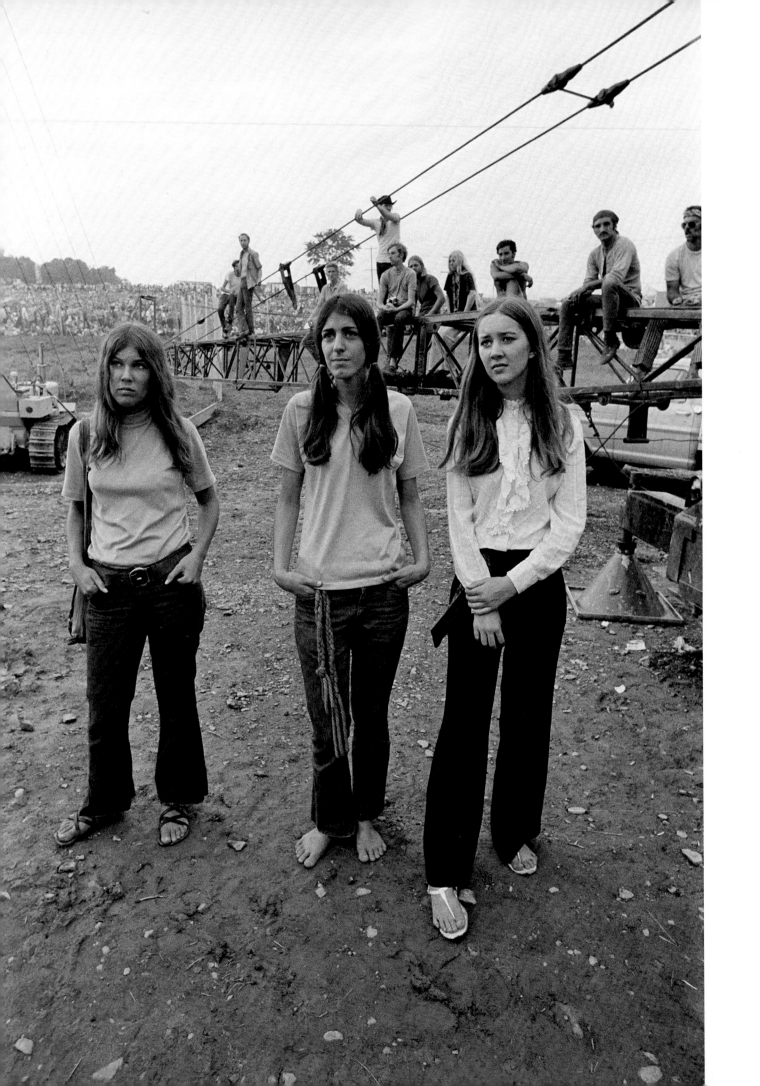

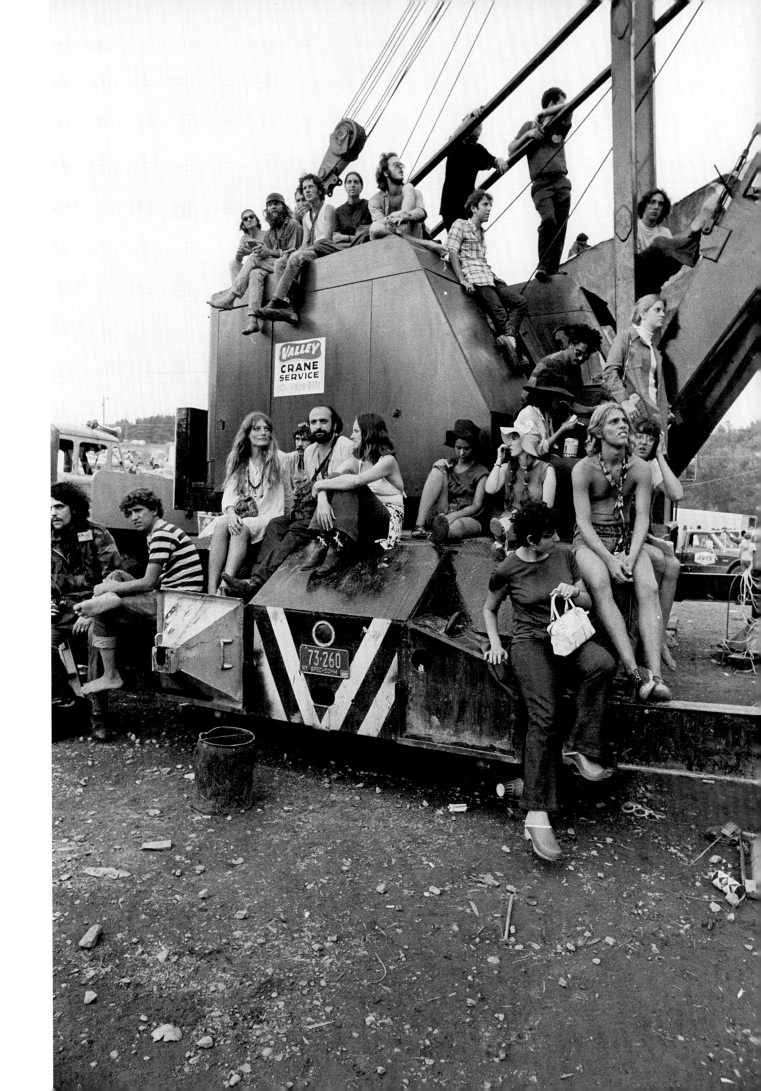

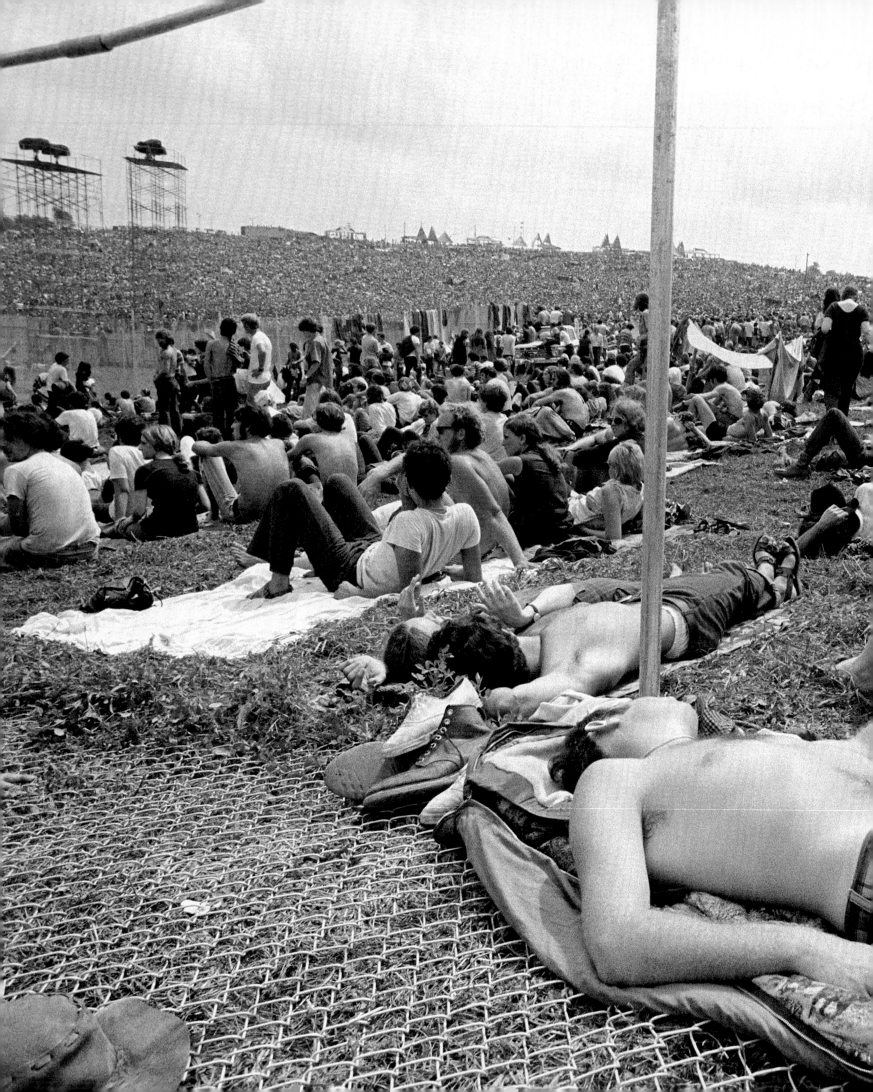

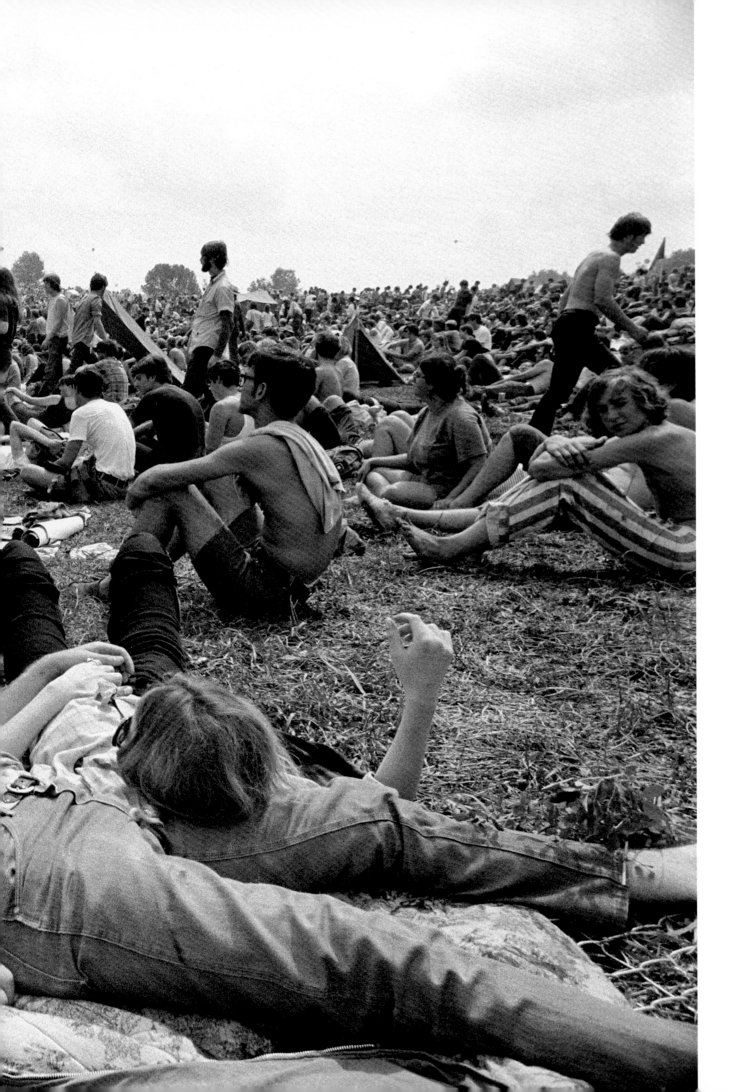

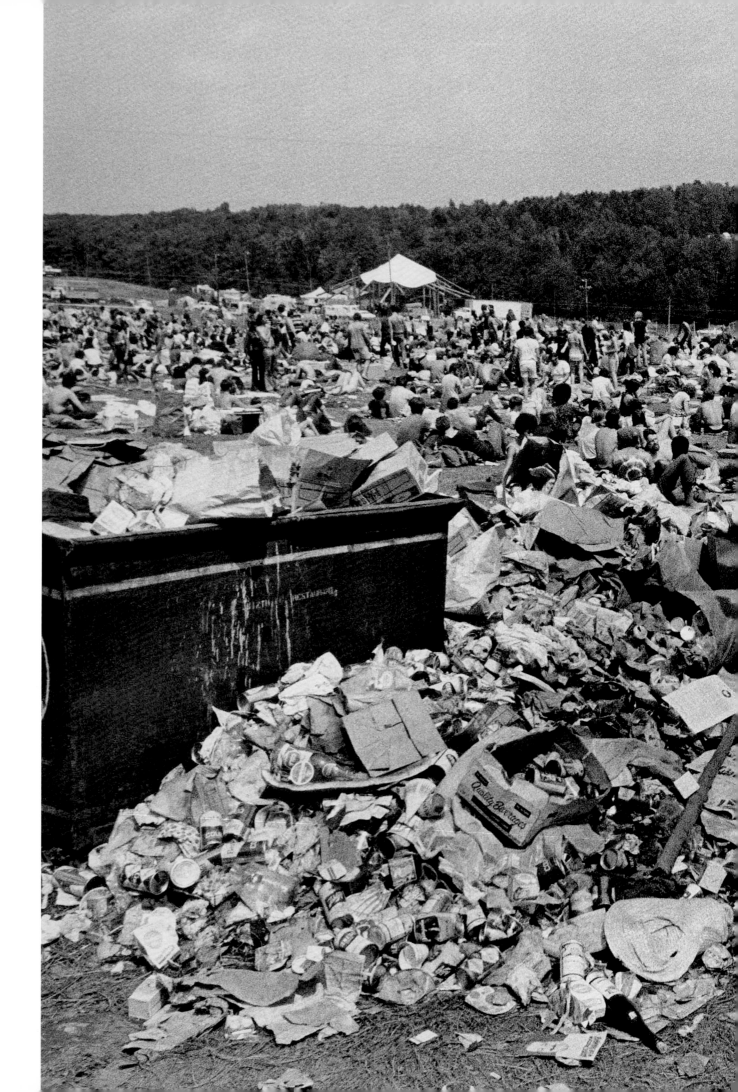

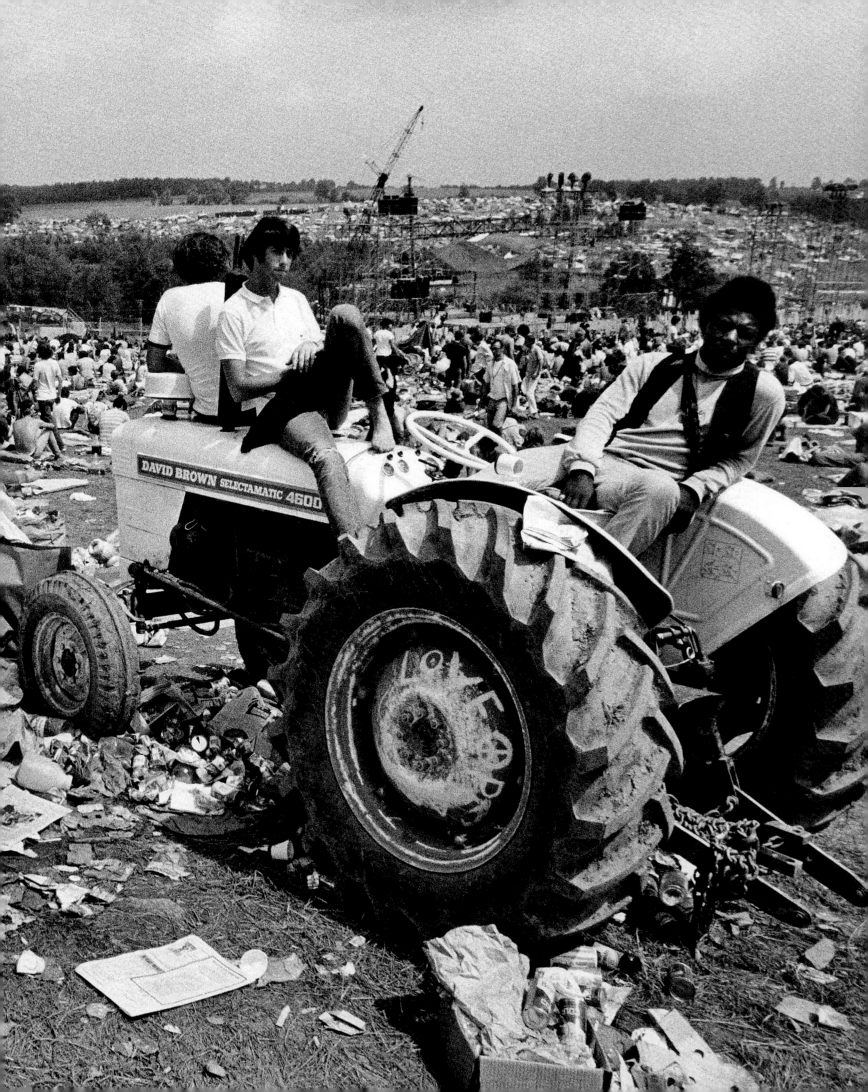

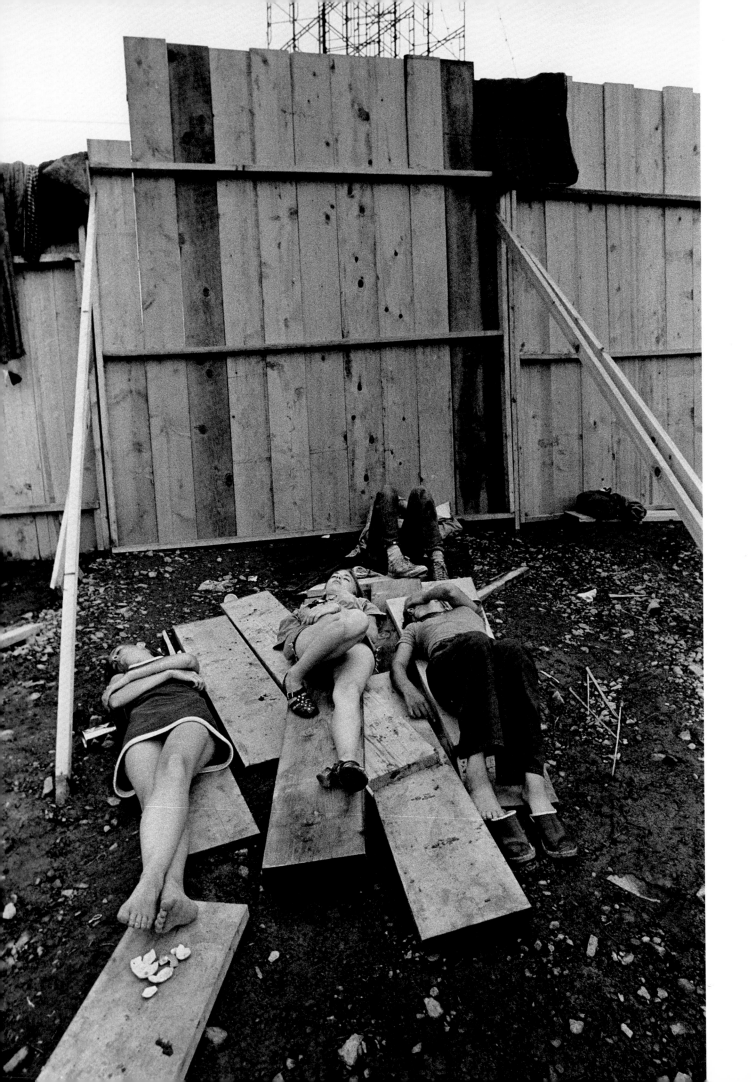

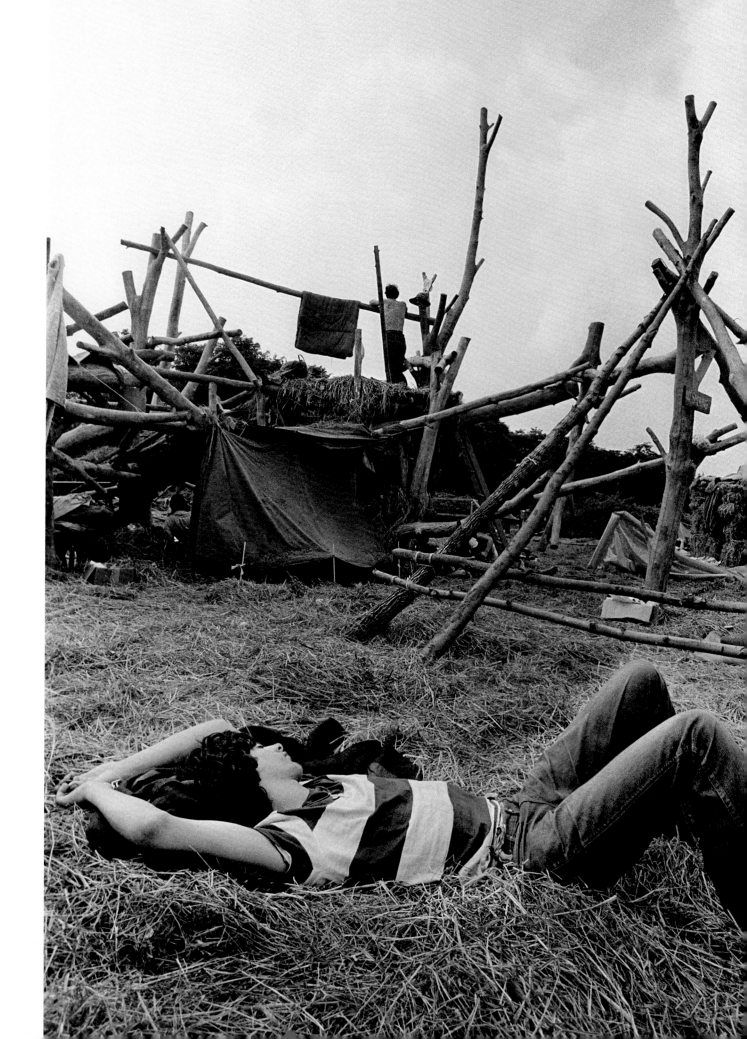

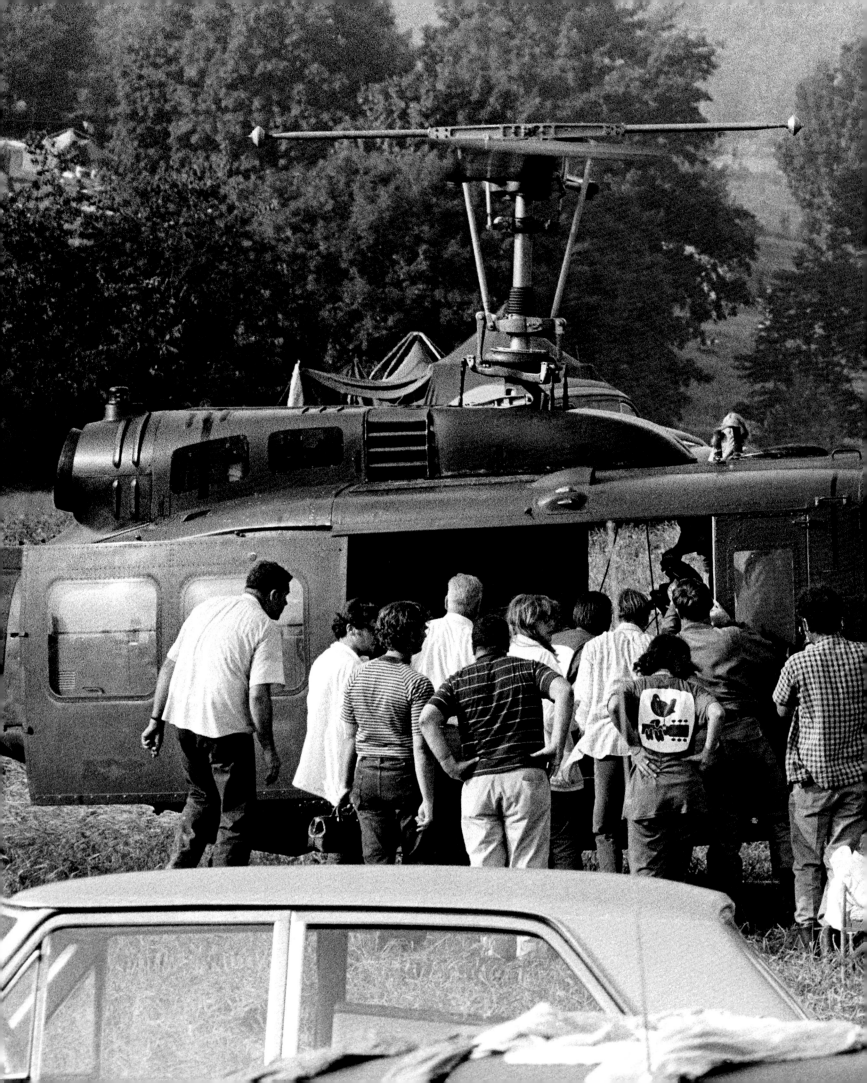

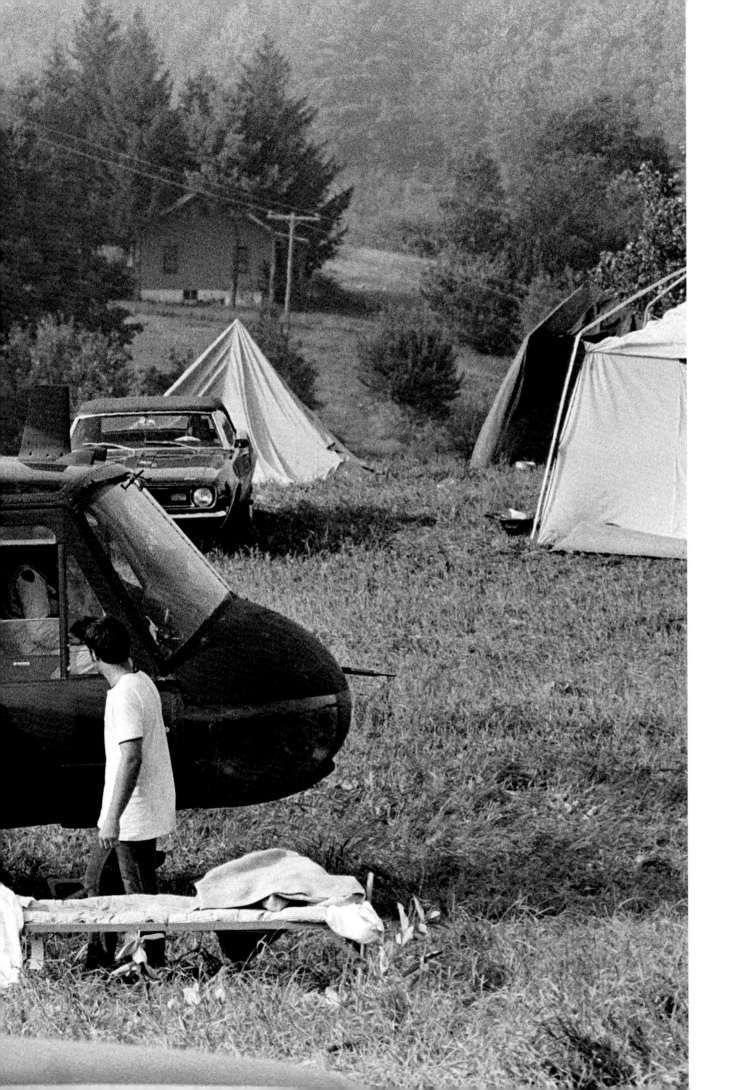

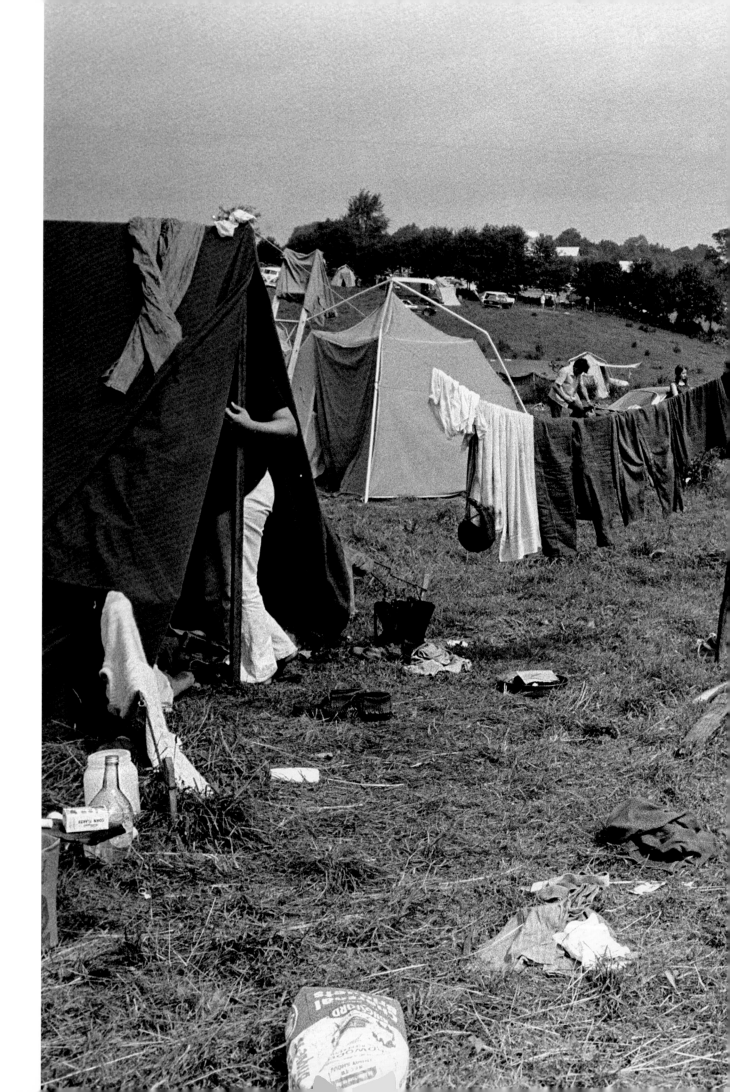

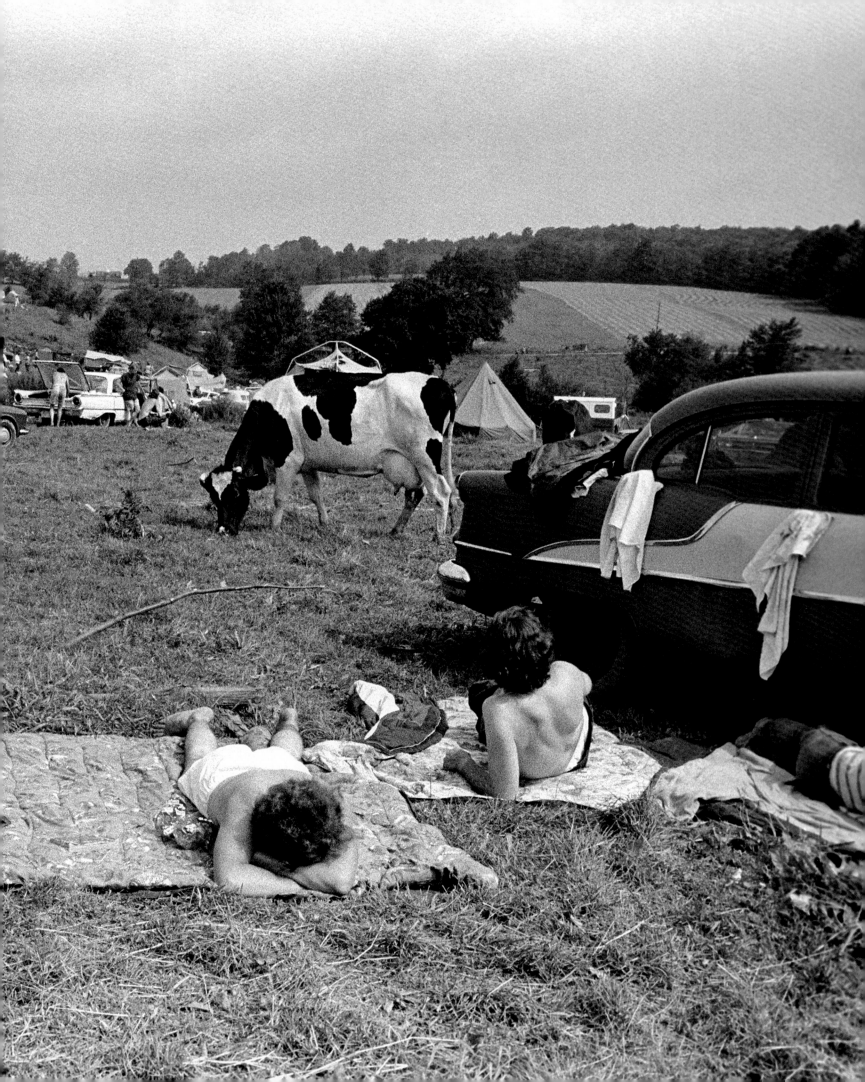

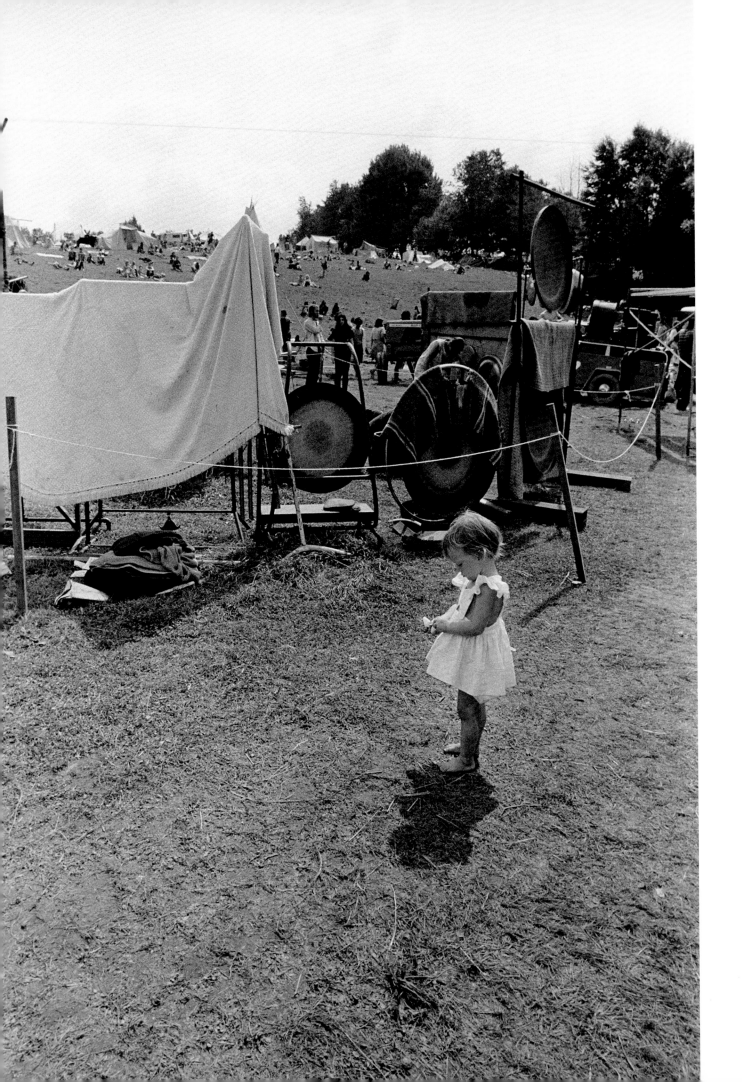

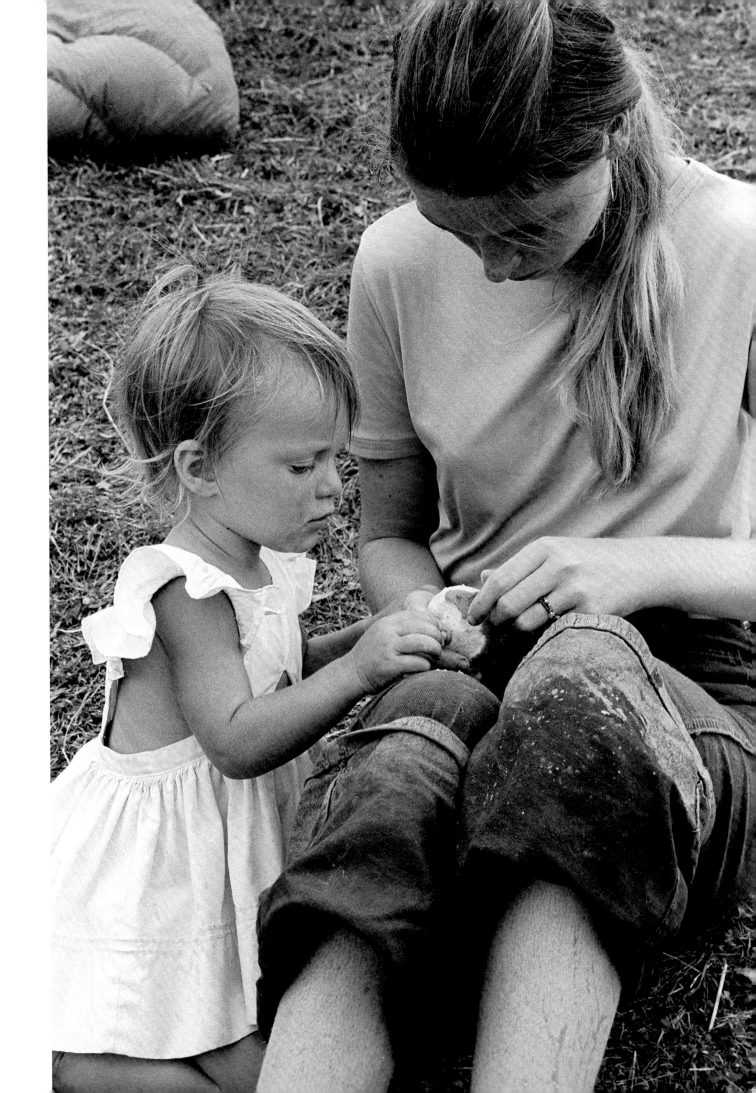

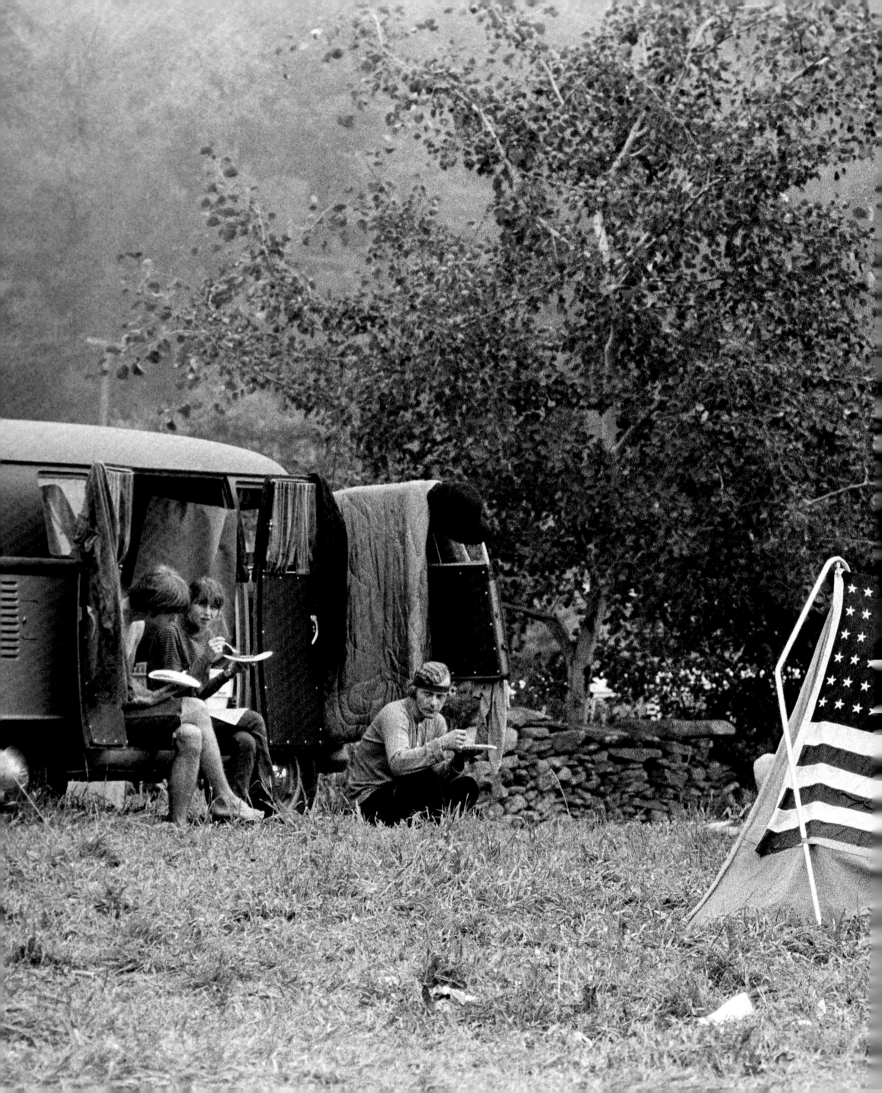

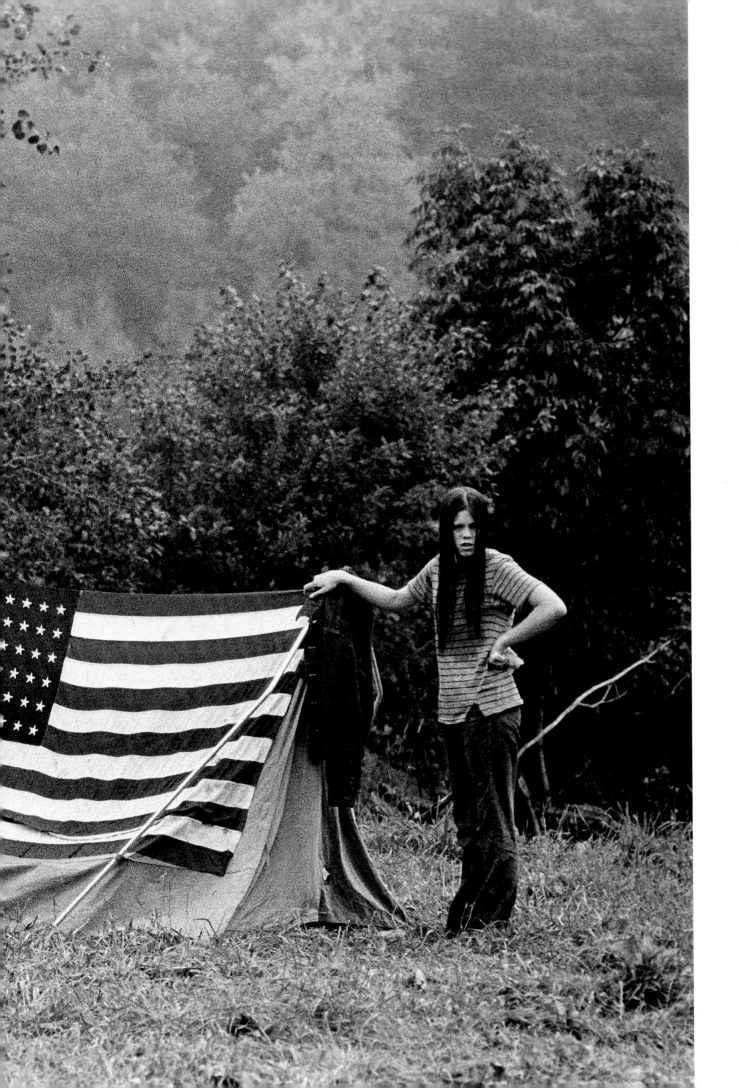

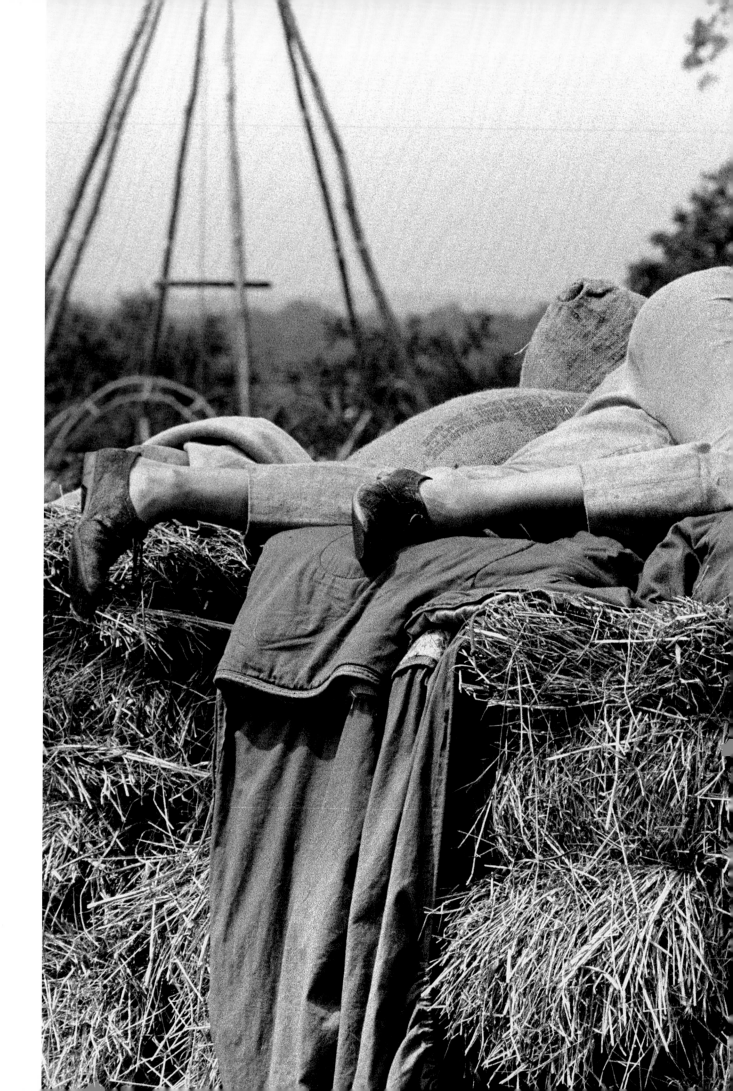

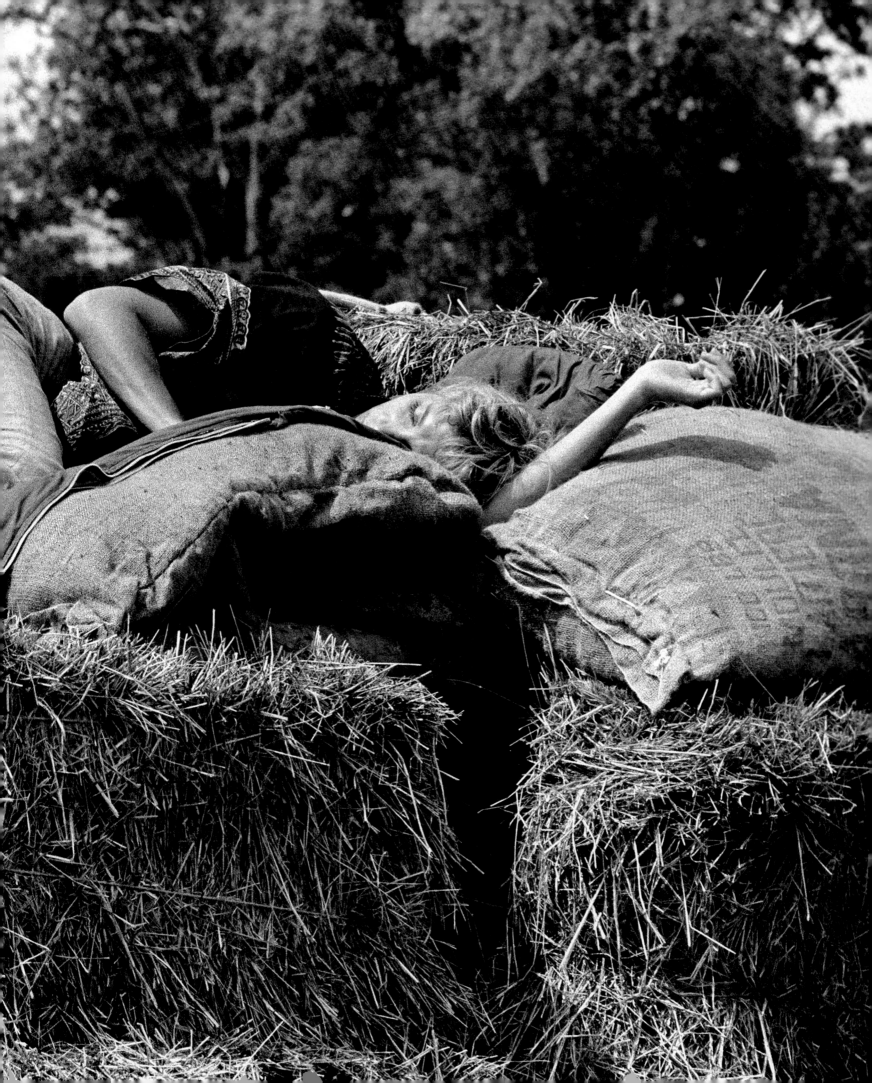

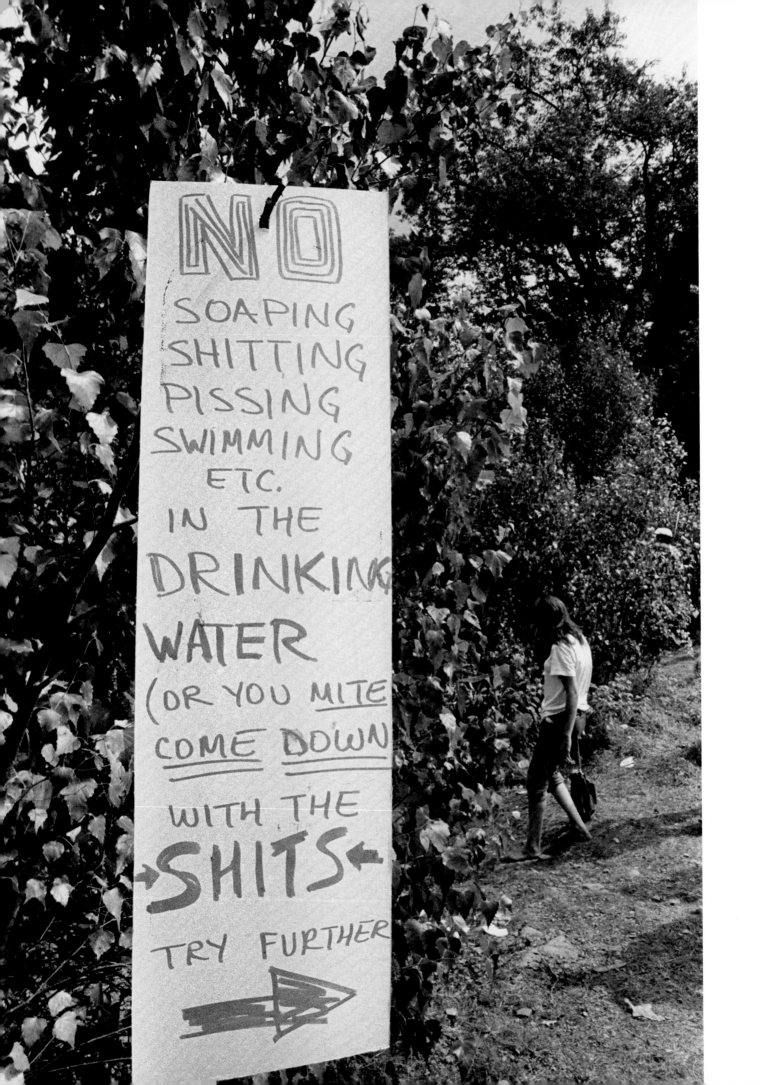

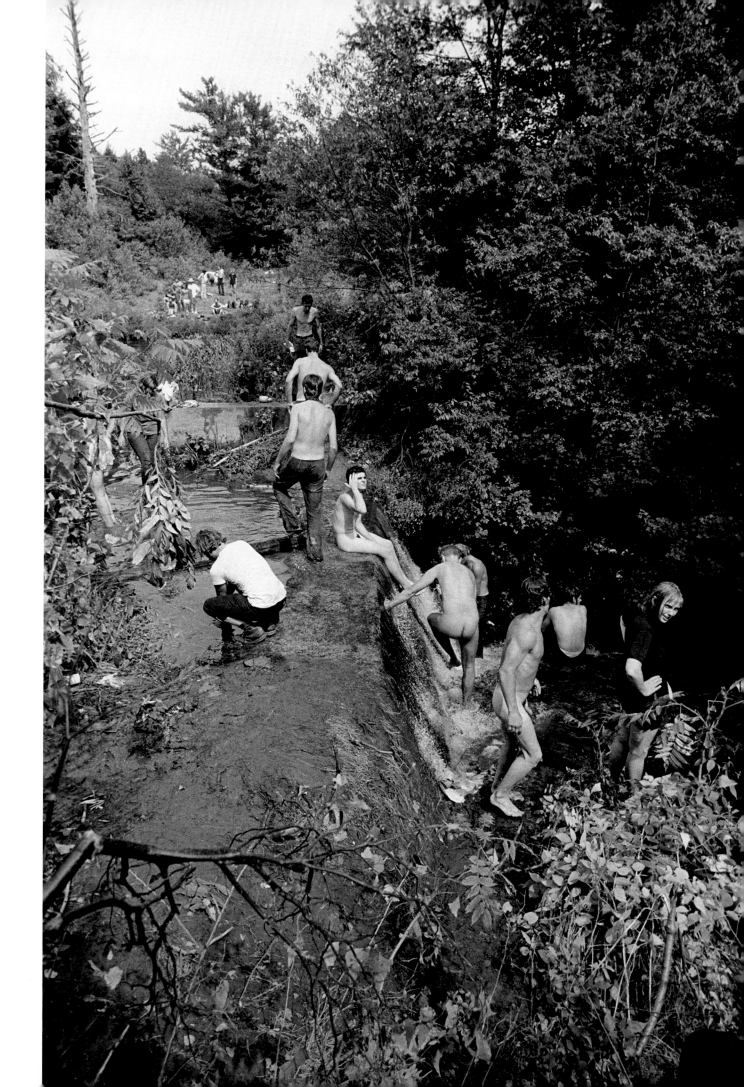

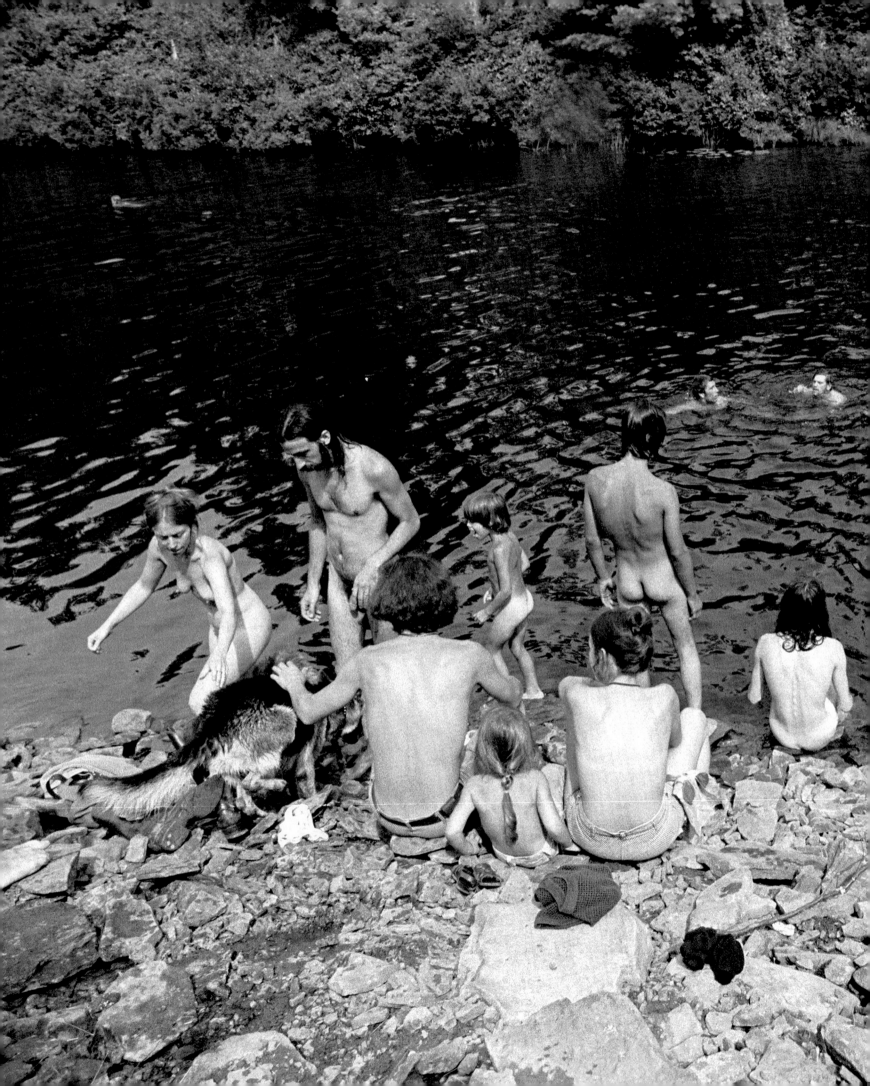

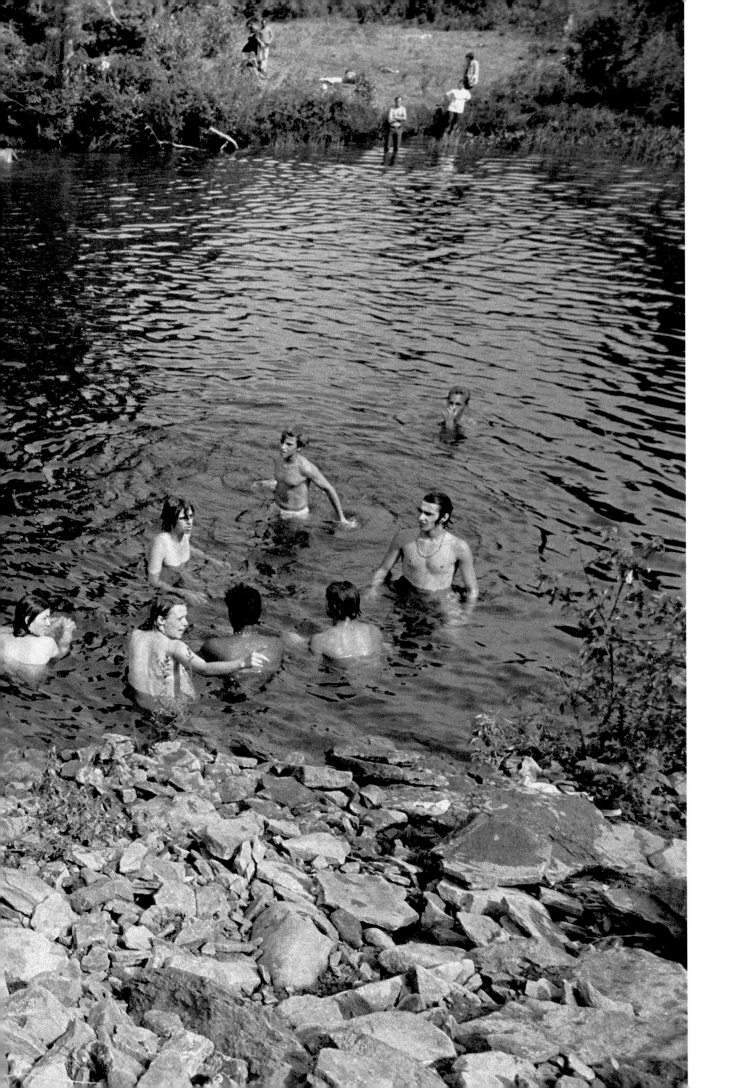

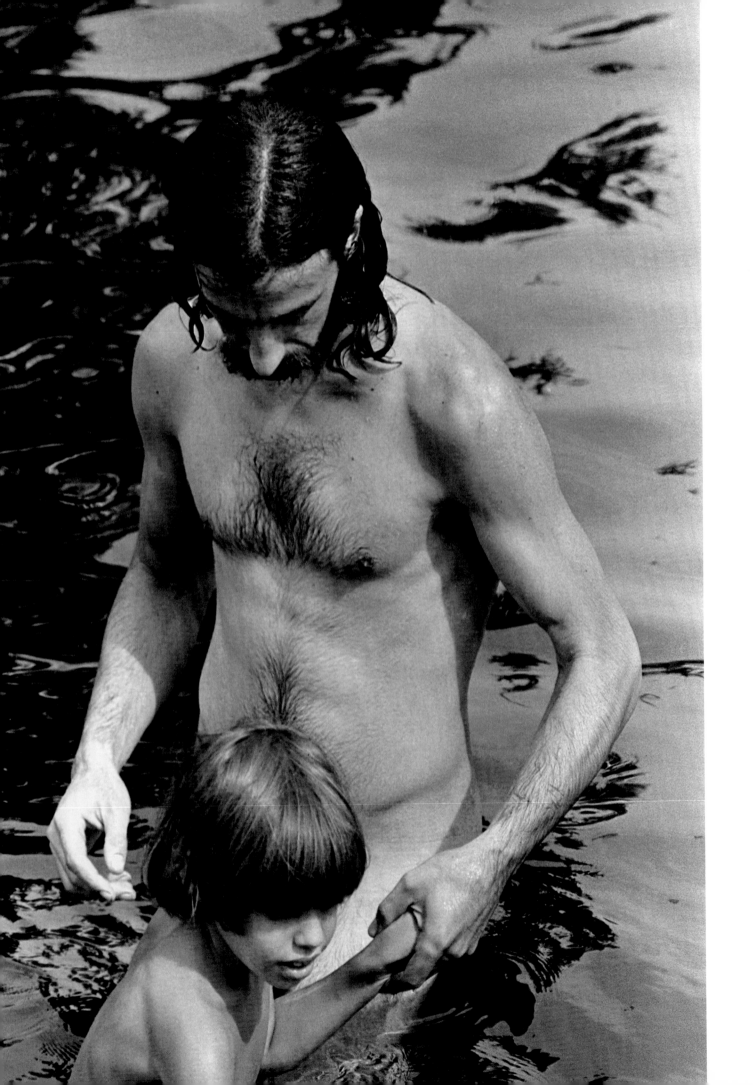

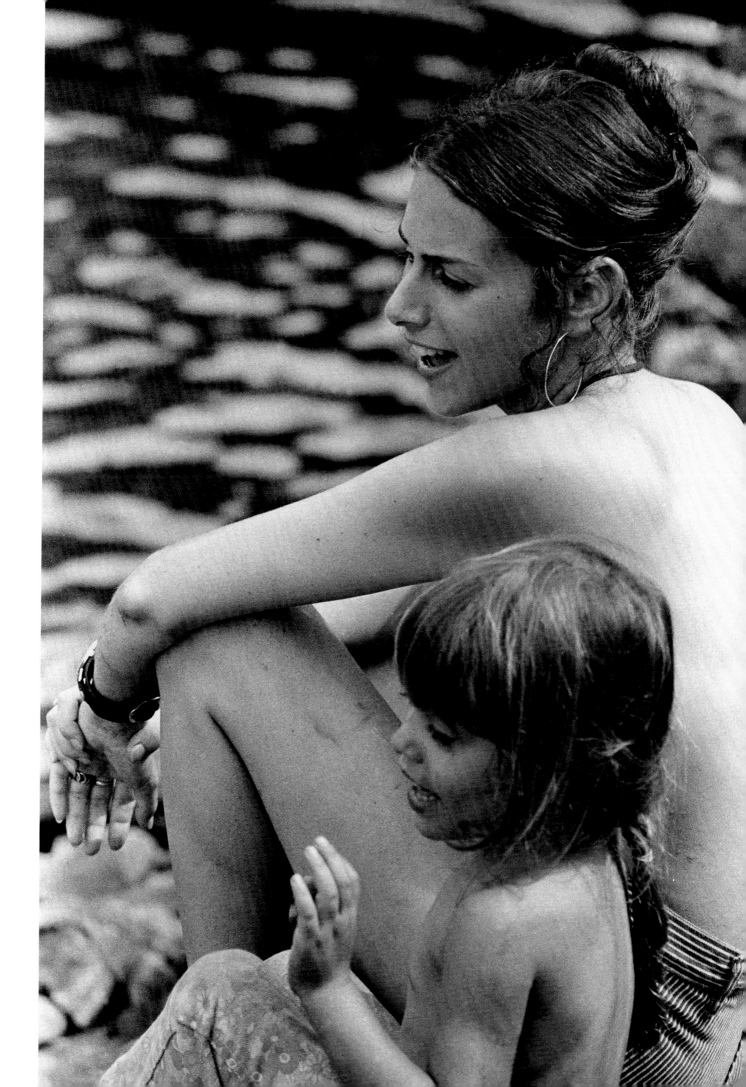

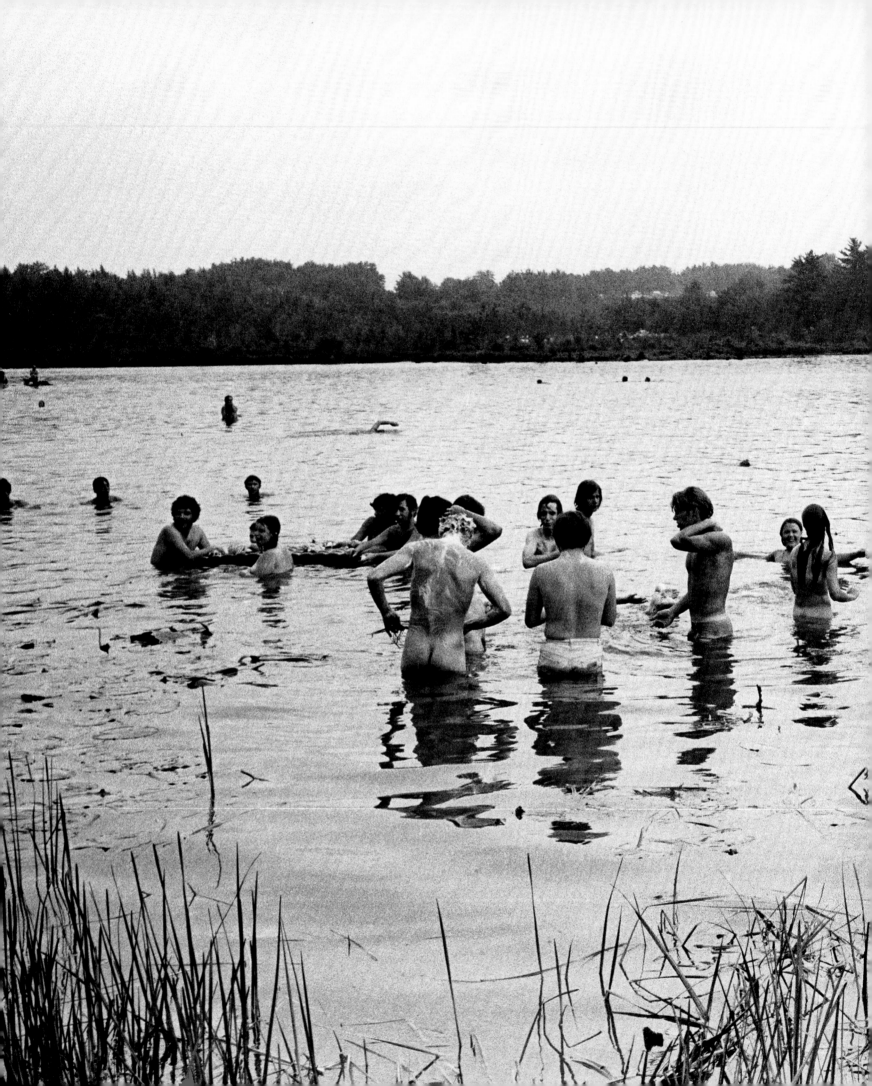

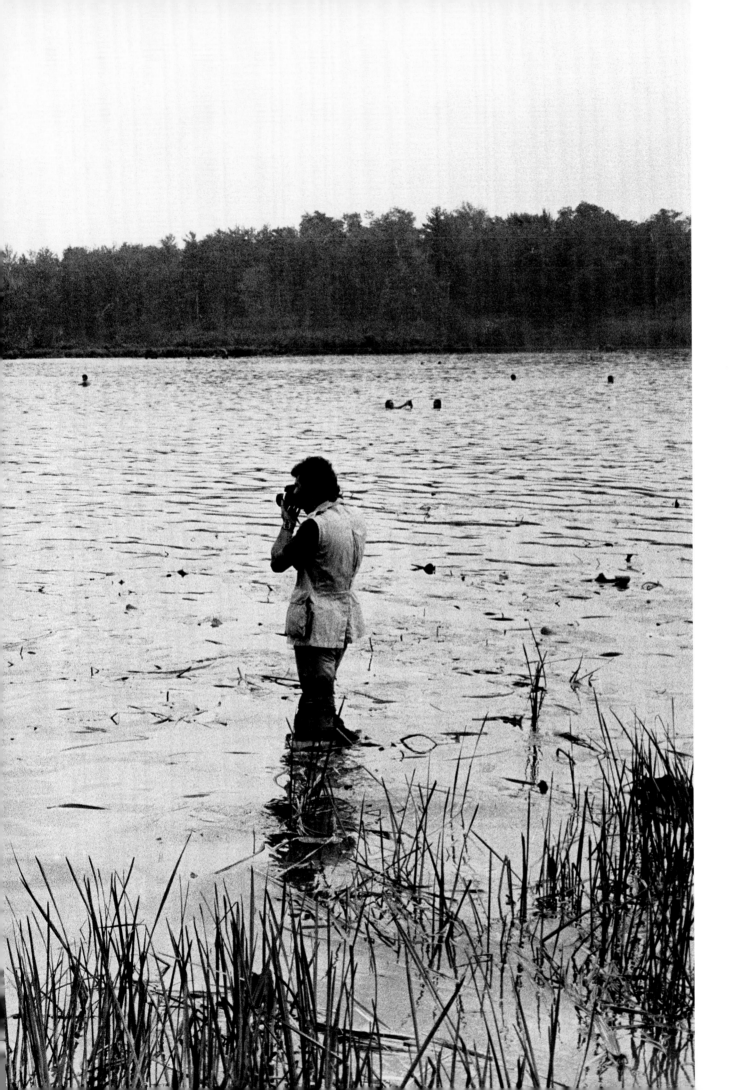

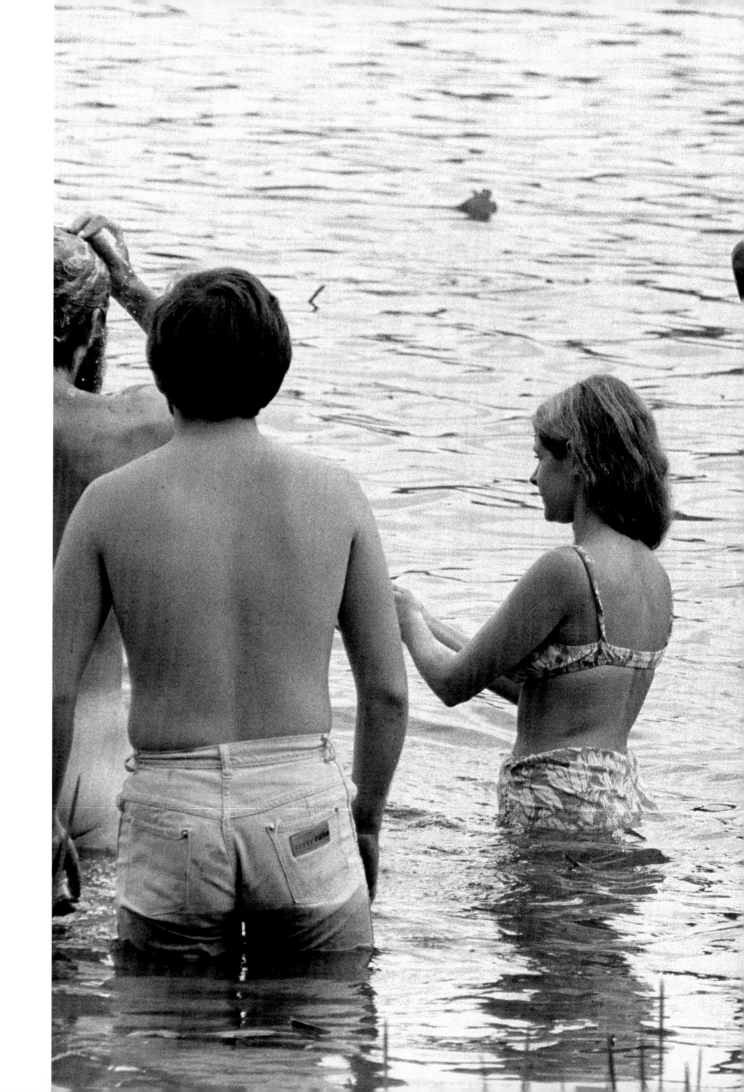

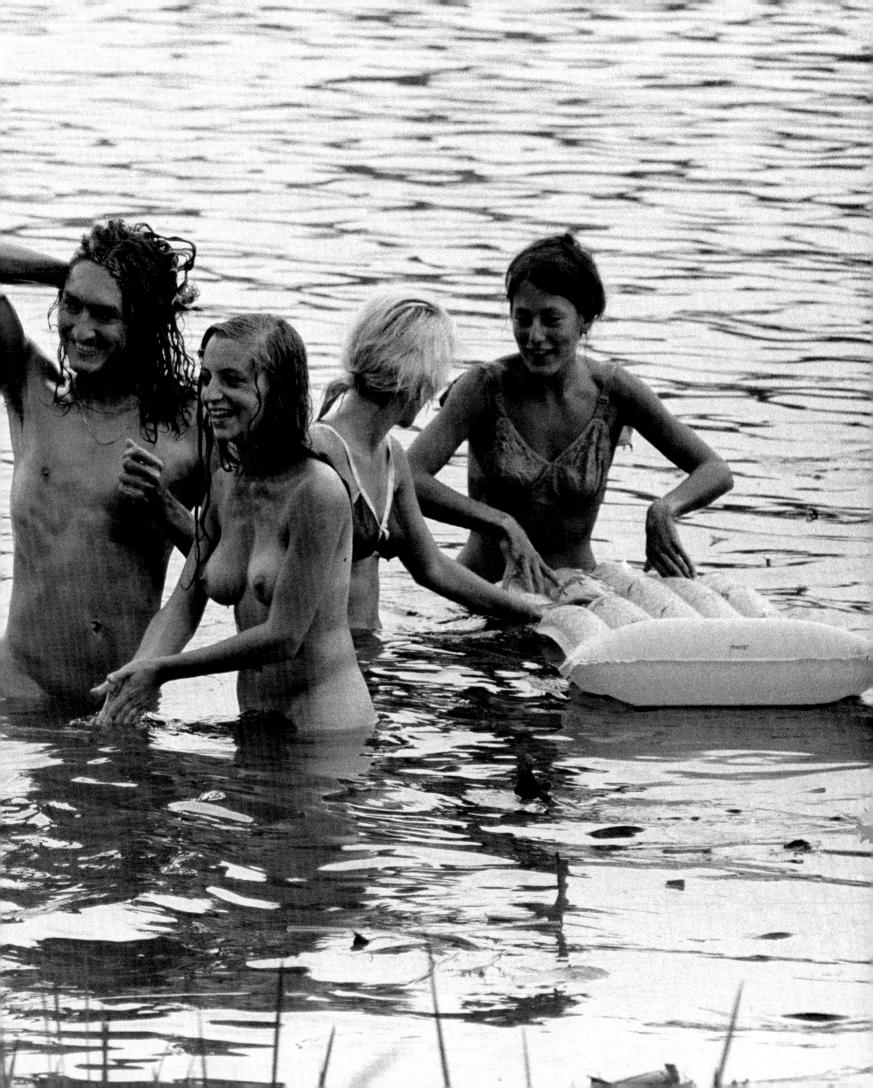

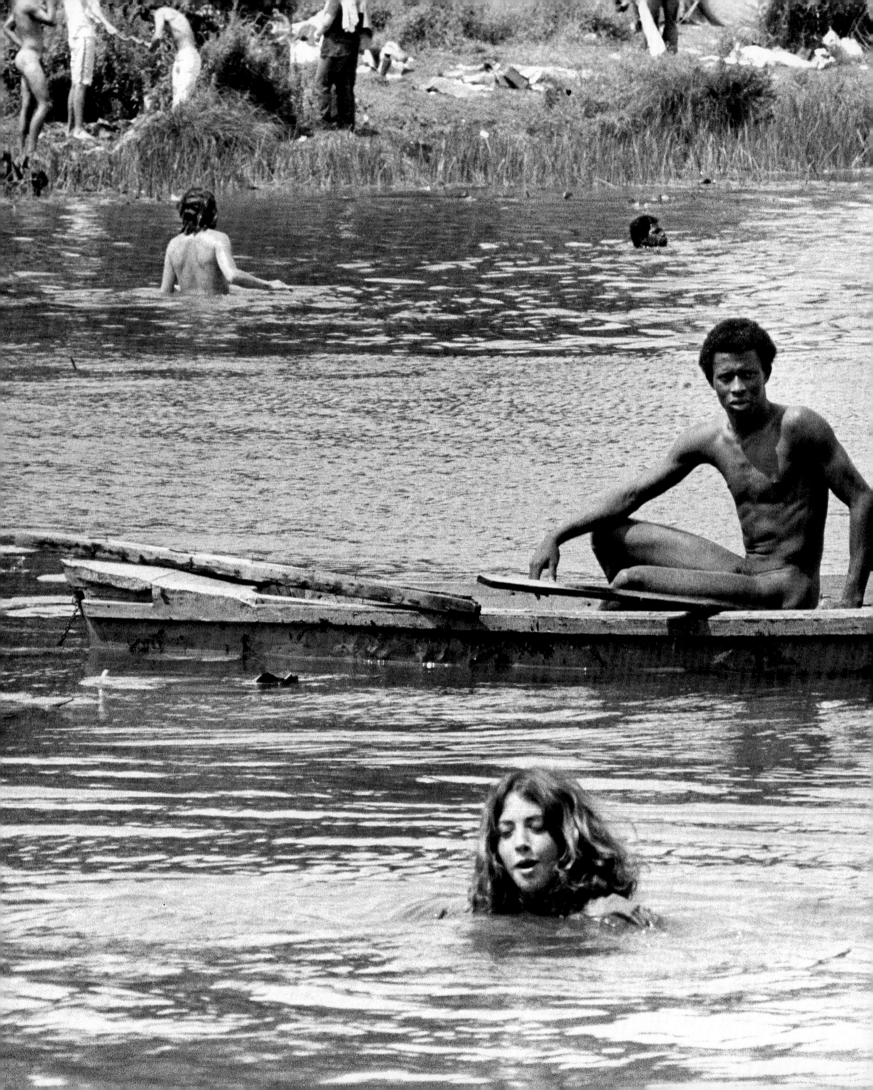

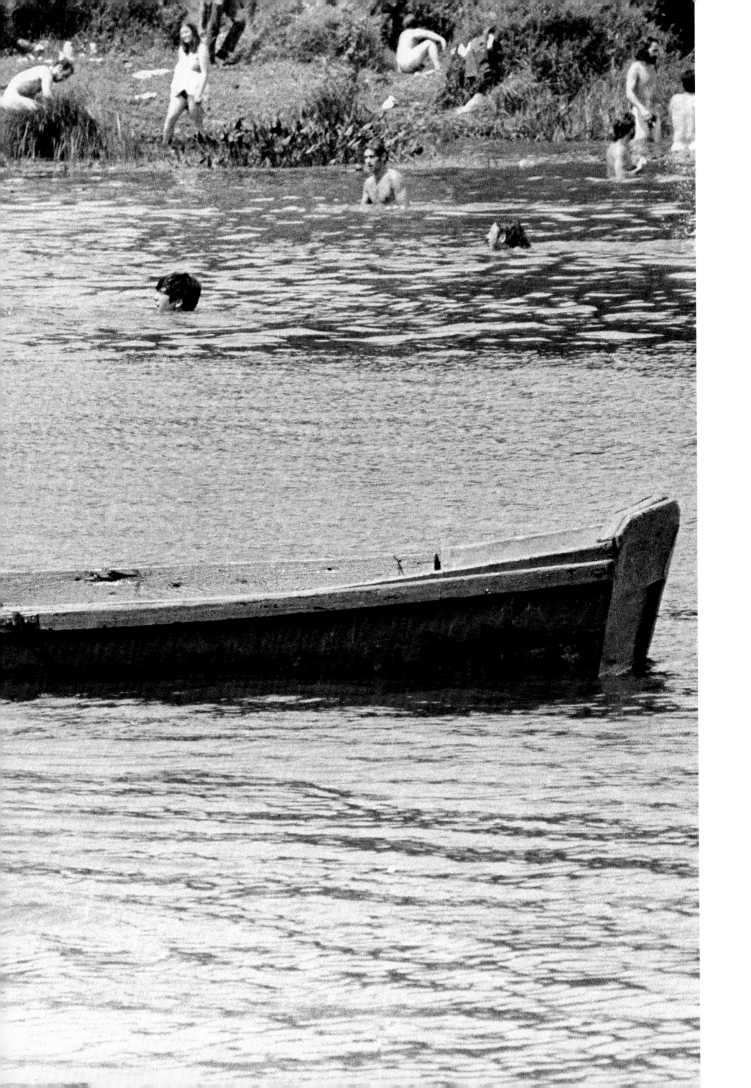

"

*I ended up spending
most of my time
out in the wild
with the crowd because
what was happening
'out there'
was just too interesting
not to explore.*

"

- Baron Wolman

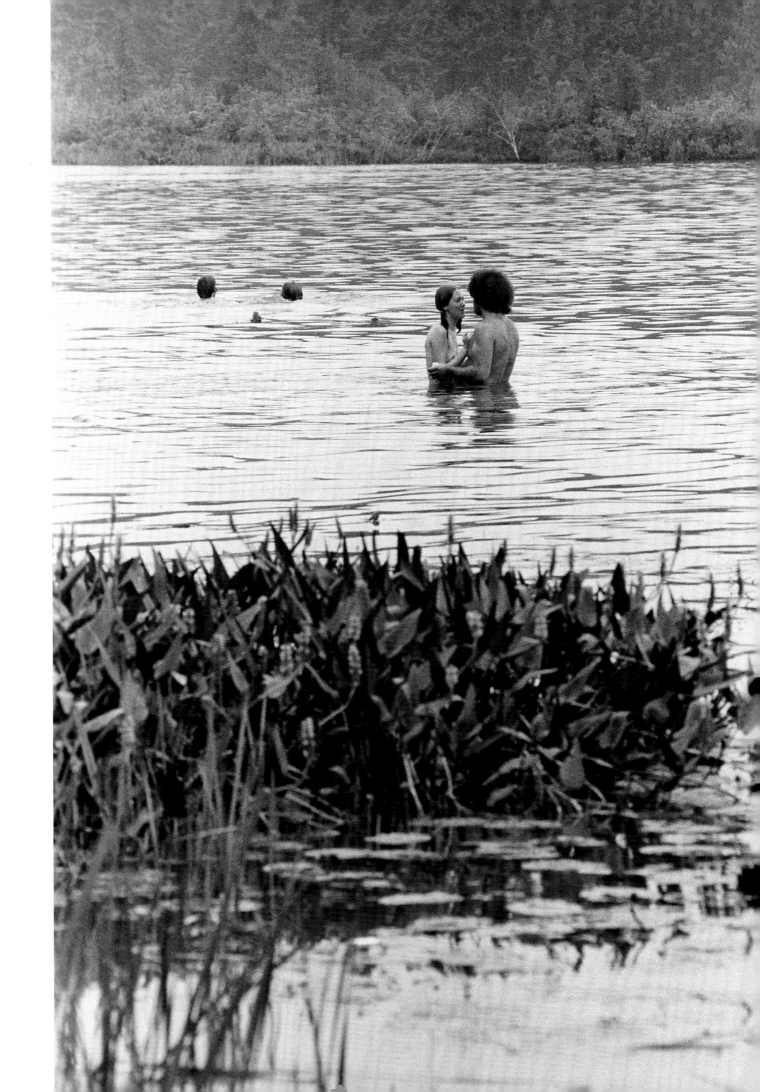

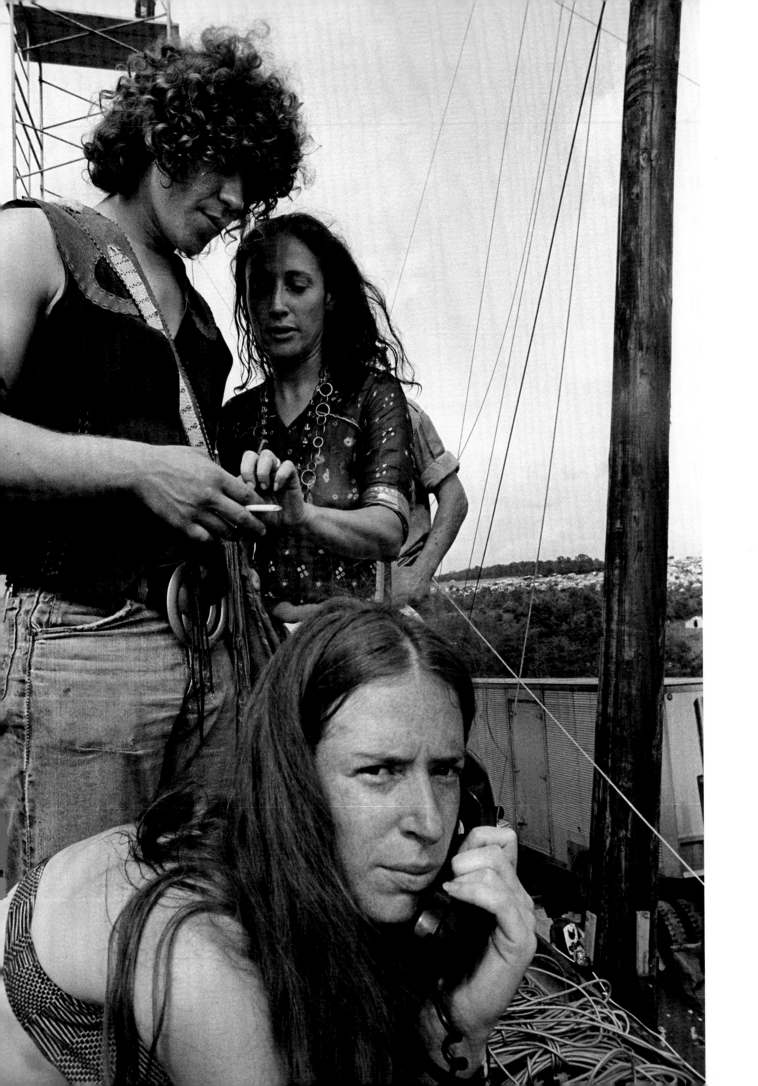

BARON WOLMAN

&

MICHAEL LANG

TALK WITH

DAGON JAMES

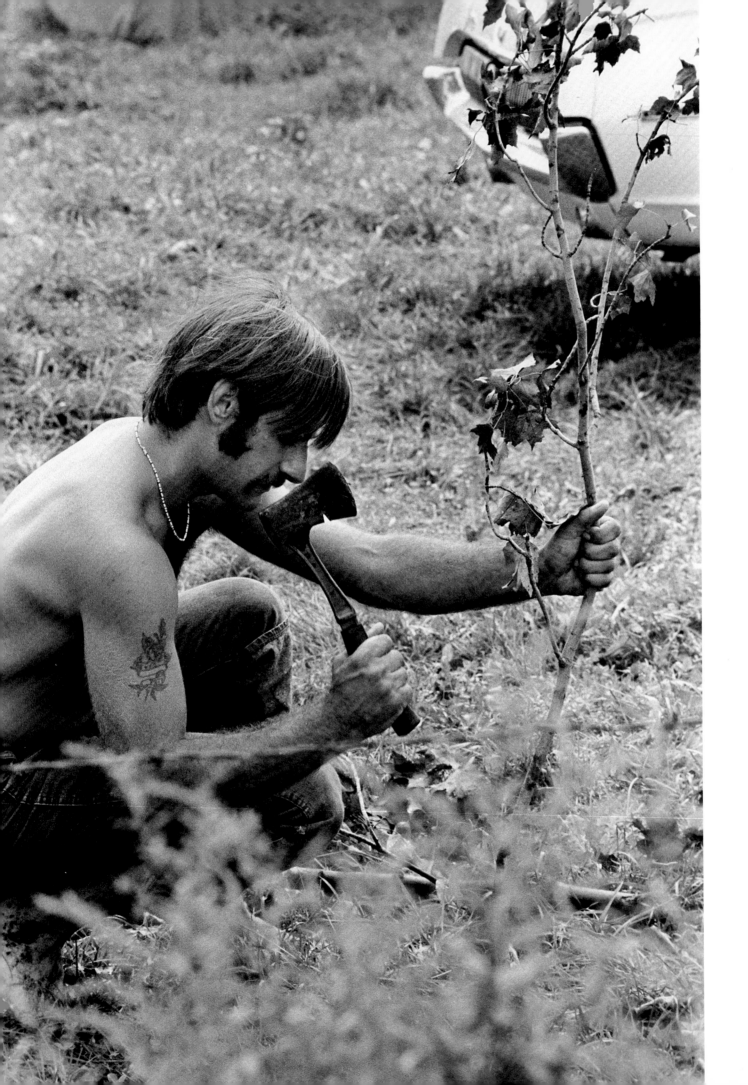

Dagon James: Hi guys.

Michael Lang: Hi Dagon.

Baron Wolman: Hey Dagon, so let's talk about Woodstock!

DJ: That's the plan. Baron, since this is a book of your photos, let's start with how you got to Woodstock ...

BW: In 1969 my friend, photographer Jim Marshall, and I had a contract to shoot photos for a book about American music festivals. The idea was for us to go around the country and photograph every type of music festival that was happening at the time. In those days rock wasn't that big yet and most of the festivals were centered on country, jazz and bluegrass. Plus, of course, the already famous Newport Folk Festival, which was starting to add a bit more rock. (As it turned out, at Newport we were shooting the very night that Neil Armstrong became the first man ever to walk on the moon!) Anyhow, Jim and I tried to photograph everything and everywhere we could.

DJ: Did you go to the festivals together or split them up?

BW: We worked out an itinerary that started in late spring. We each chose the festivals we wanted to shoot; some we shot together, some alone. When we started out, Woodstock wasn't even on our list yet. I think we first heard about it sometime in June and decided to add it to our journey. At the time we figured it would be just another music festival among the many we were photographing. Man, were we in for a surprise!

DJ: What was it like actually getting out to the site through all the stalled traffic and caravans of people?

◂▴▸

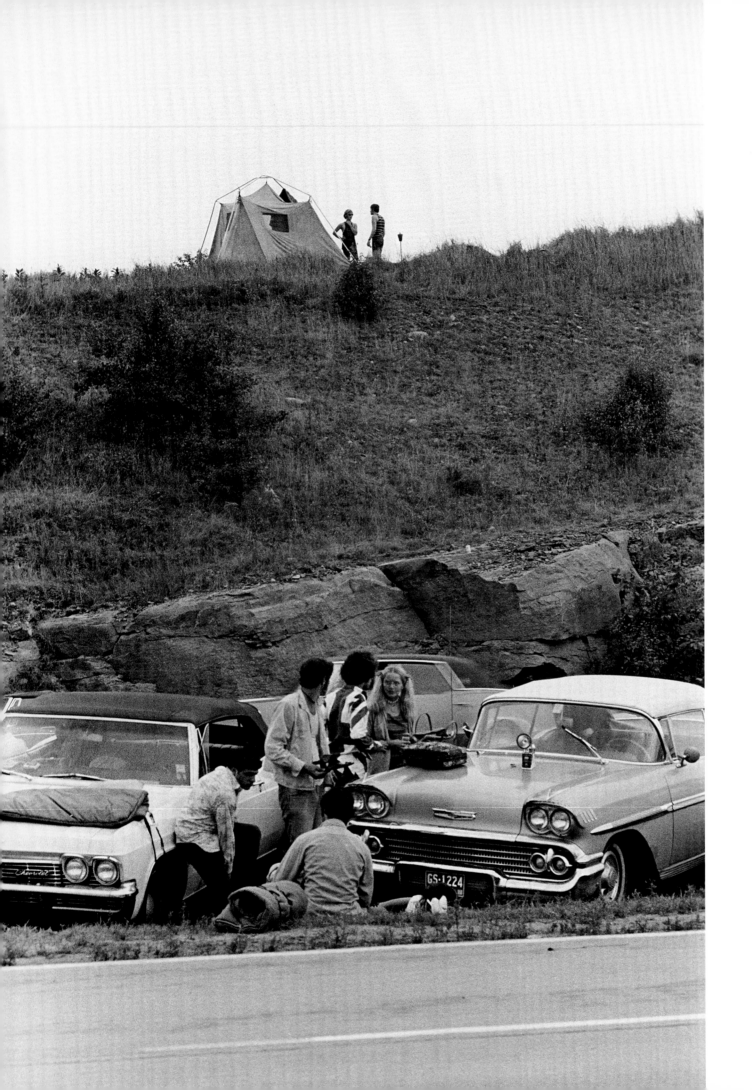

BW: I flew in to New York, rented a car at the airport and headed out to Bethel with my press pass. I was still miles from the site when I hit the traffic jam. I couldn't believe how many cars there were on Highway 17B, the road to Bethel; the traffic was moving maybe 3 mph at best. I pulled out my trusty AAA road map, found the concert site and then worked out an alternative route by taking country back roads so I could get around the hippie parade. On the way I even found a back road motel that had rooms and booked one for the weekend. I think everyone else who was shooting at Woodstock stayed at the site getting high and taking pictures all night in the dark while I came and went since I had a place to crash.

DJ: A luxury famously afforded to few that weekend. What was your initial reaction when you arrived at the site?

BW: I was blown away, excited, and try as I might, I couldn't get my head around what was happening. There was already a huge crowd there by the time I arrived. I had imagined a whole lot of people were probably going to attend but they just kept coming, and coming, and coming, there was no end to that stream of people filling up the place; even the people who put it on had no idea how big it would eventually be. I had no clue, I was stunned!

ML: Every act, every musician, had the same reaction when they arrived on the scene.

DJ: Did you guys know each other before Woodstock?

ML: We hadn't met yet but I knew your photos well from *Rolling Stone*.

BW: Of course I saw and photographed Michael that weekend. I didn't want to bother you because you were dealing with so much logistical stuff like the weather, sanitation, food, the bands – how to get the bands to and from the venue because it was impossible for them to drive in and out.

DJ: It's pretty amazing to think of someone at such a young age putting on a festival the scale of Woodstock.

BW: Wasn't it the previous year that you had backed up some flatbed trucks and put on a concert in Florida?

ML: Well it was a bit more involved but the flatbeds was the staging plan. I was 24 when I put on the Miami Pop Festival in May of '68 and, like Woodstock, Jimi Hendrix headlined.

BW: What gave you the idea to go from that to such a huge event at Woodstock?

ML: It just seemed like the time to bring everybody together. We publicly announced 50,000 but planned and built everything for 200,000, which was unheard of. It felt like it was in the air, things were getting uptight and all the assassinations in '68 and all the political violence, and it seemed that we lost the plot. It was the right time to bring everyone together and live the dream for a minute and remind ourselves of what was possible.

BW: So you really were going for the big scale event!

ML: We were looking to make it big, most of the fun for me in doing it was figuring everything out.

DJ: What did the planning look like for you?

ML: That's where things got interesting. For example, we sent Stan Goldstein to train stations and bus stations to time people going to the bathroom in public so we'd know how long someone stayed in and then we multiplied that by 200,000 to figure out how many toilets we would need. There was no book written because no one had ever done it. We even went to the Army Corps of Engineers to get help with planning a temporary city because that's what we were building. They knew how to do it but they turned us down at the last minute. Basically, we took paper plates and food packaging and typical garbage we accumulated ourselves and weighed it and multiplied it to figure everything out.

BW: Multiplying by scale.

ML: Exactly.

DJ: What about the planning for the community of people?

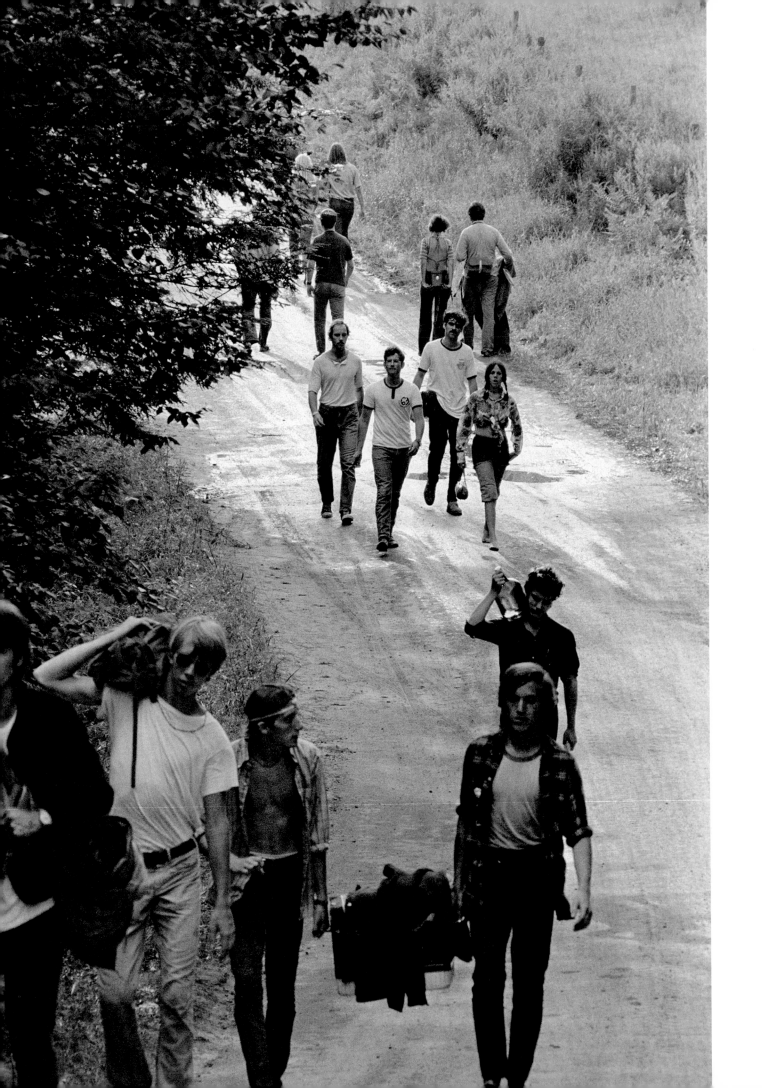

ML: We thought about things like mood planning, how people would feel coming in, how they would interact and feel when they got there and preparing people's minds for the open and sharing experience. We were immersed in the whole concept. There was not a huge body of experience out there but luckily I hired the best people possible in every area and that's why it all held together and worked. Most people got it and those who didn't at first followed my ideas and got it later.

BW: There was much more planning than people realize.

DJ: Michael, how long did it take to put the festival together?

ML: It took ten months to put the festival together from formed idea, to funding it, to finding the location.

DJ: Did you get out into the crowd or were you mainly close to the stage?

ML: I was on the stage a lot overseeing and coordinating as best I could. Communications were different in those days but I had my walkie-talkies and I had a motorcycle so I went up the roads and checked things out daily.

DJ: So you got to see the traffic jams approaching the site. How far ahead of time did you start building for the festival?

ML: We were there a month in advance; we started building the stage first.

BW: Henry Diltz has photos of the construction.

ML: Henry came two weeks ahead of time, I think.

DJ: People set up stands for their crafts and whatever they were doing. Was that by design?

ML: It was by design. We planned Woodstock for everyone and part of that was helping people set up their clothing shops and mobile head shops. We wanted to create an open environment where you could have a campground, or make food, or have your own space to sell or barter whatever you were into and do your own thing which made it feel a more idealistic place.

DJ: You advertised the festival for 50,000 people, planned for 200,000, and 500,000 finally came. At what point did you decide it would be free? Was there a debate about that?

ML: It was a foregone conclusion. We knew it was going to be huge when people started arriving on Tuesday.

BW: Did they all have tickets?

ML: Most people were looking for a place to buy but some had tickets already.

BW: Did you plan to sell tickets on site?

ML: We did, we built ticket booths on wheels, but they were never rolled into place because they were stuck in the mud and we couldn't get them out so there was no place to buy tickets. We looked out at 150,000 people sitting in a field and realized how many kids were there ... what are you going to do?

BW: From my point of view, making it a free concert was probably the most important decision you made because it kept everything calm and alive and fun. Really, what else could you do? There was this chain link fence which wasn't really designed as a deterrent but simply to define the area. People were just pushing over the fence and coming in; there was really no way to control the huge waves of people streaming in, it would have taken an army ...

DJ: Whatever happened to Jim Marshall in this story?

BW: That's right, Jim showed up, camera in hand, ready to shoot.

DJ: With his Leicas I presume?

BW: Yep, his Leica and his Nikons. Jim loved his Leica and he would swing it around like a weapon, it was like a small heavy stone at the end of a leather strap. You remember Jim – he was always threatening to do some kind of violence, although happily he seldom did. I also used to shoot with Leicas in the '60s but for Woodstock I had my Nikons with me because I could shoot a lot faster with them.

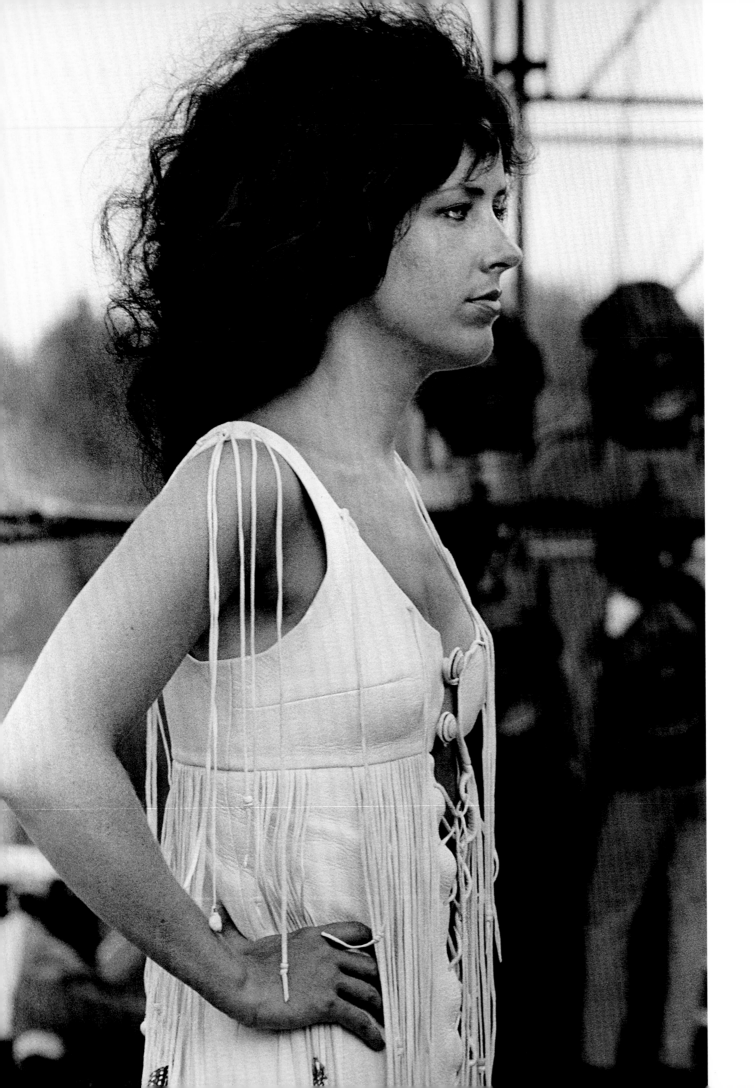

DJ: How did you and Jim work it out since you were both shooting the same festival for the same book?

BW: By this time I was kind of bored with shooting the bands on stage because that's all I had been doing in San Francisco for years up until that point, and by then I wanted to shoot other subjects. I always considered myself a photojournalist rather than strictly a music photographer, which is why I focused mainly on the people and culture of community that weekend. Keep in mind that there had never been a crowd like this before, and the music felt less interesting to me than what appeared to be a tribal gathering of sorts. I wanted to walk among the people, see what they were doing, capture the moments beyond the stage. I especially love the shot of the guy with the axe chopping the sapling down.

DJ: He could have pulled it up with his bare hands.

BW: I'm not sure what that photo represents but it means something.

DJ: So while you were out lurking in the bushes with your camera, Jim stayed closer to the stage and the acts?

BW: Yeah, Jim focused a lot more on the musicians that weekend but he did walk the grounds occasionally and got some terrific crowd shots himself. It's amazing that he took as many good pictures because he was stoned half the time, and his pictures are still just so great. I greatly admired his eye and his technique. It was funny, at the end, when we were putting the *Festivals!* book together, we competed to see who got the most Woodstock shots in! A friendly competition, of course …

DJ: Still, you did get some interesting on-stage shots. Grace Slick of The Jefferson Airplane comes to mind …

BW: I really loved Grace, she was pretty much the coolest lady around and like a lot of other guys, I fantasized about sleeping with her; she was really beautiful and pushed the social limits of the times, was always willing to take chances. She wore her famous Girl Scout vest as a fashion statement against the concept of the Girl Scouts. Grace definitely did not accept society's restrictions upon herself or anyone else.

DJ: Your shot of Bill Graham is also fantastic, I like seeing him somewhat outside of his element as he is in your photo. How did Bill get involved with Woodstock?

ML: Bill Graham was an interesting guy. Bill got involved, I guess, after I had done most of my booking, which we started sometime in February. He called John Morris who was working for me at the time; John used to work for Bill and I guess Bill had heard about what we were putting together. Bill was pretty upset. How dare we book all the acts that he had booked to play at the Fillmore. Bill was running the Fillmore West in San Francisco and he had opened the Fillmore East in New York City which, basically, was a venue for all the bands he put on the West Coast. I told John, "Tell Bill we'll figure it out," and so we met at Ratner's deli on Second Avenue next to the Fillmore East and we had this big sit down and worked out a deal. I agreed not to advertise any acts playing at his venue and he sent me Santana who hadn't even released a record yet and I think maybe one other act. I invited Bill to come out, which he did, and of course he has that famous scene in the film talking about the ants and building a burning oil trench. I don't think he forgave me for that scene but we remained friends after that.

DJ: Was Bill there the whole time?

ML: I think so because I saw him near the end but I'm not sure if he was there for Hendrix.

DJ: Santana gives one of the most captivating performances, they were really on fire!

BW: Oh man, they were incredible! The amazing thing is that Carlos had taken LSD or mescaline or something thinking they still had several hours to go before they had to play when suddenly they were told, "If you don't go on now you don't play at all," and so they went out and gave one of their best performances ever.

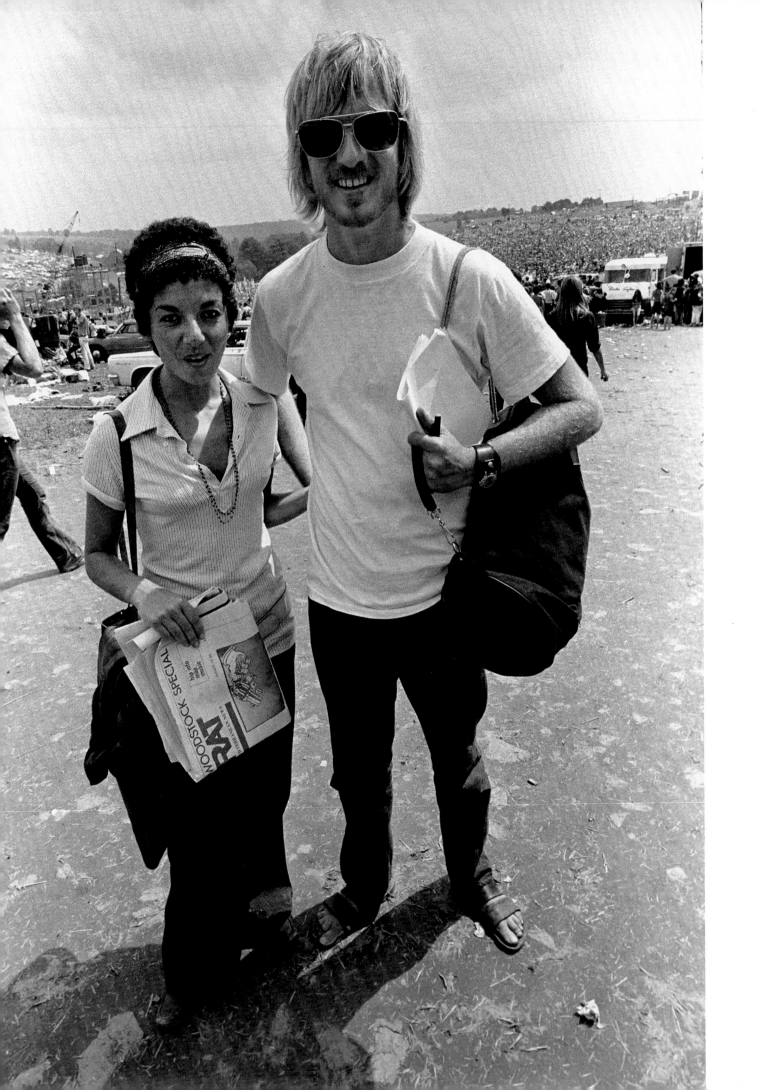

(continued) Carlos admitted later that his guitar neck was moving like a metal snake while he played, that he could hardly control it and had no idea what sort of music he was making.

DJ: I couldn't imagine having to play a show in front of a crowd like that high on anything! It's a testament to the brilliance of Carlos and the band's artistry that day ...

BW: That's true. They were one of the best bands out there and Bill Graham saw it before anyone else did. I knew Bill pretty well from San Francisco and there he was, sitting on stage behind the band playing the cowbell along with Santana. I went over and took a picture of him and he jumped up reaching for my camera, "Let me get a picture of you, Baron." He took a shot of me with the cowbell and Carlos walking behind me perfectly positioned between the amplifiers. Bill took a better picture of me than I did of him! To this day Carlos gives Woodstock a lot of credit for his success.

DJ: At what point did you decide to go out and document the attendees?

BW: I went back and forth but I ended up spending most of my time out in the wild with the crowd because what was happening "out there" was just too interesting not to explore.

DJ: Did you have friends explore with you or did you go it alone?

BW: I had a few hippie friends there that I ran into. Jan Hodenfield who was assigned to cover Woodstock for *Rolling Stone* was there and we hung out some but I mostly wandered around by myself.

DJ: What was it about the people, the "inhabitants," that you found so attractive?

BW: The thing to remember about the '60s, even near the end in '69, was that everything was so totally different, the behavior was new and unexpected. Plus, the '60s were simply wildly photogenic in every way imaginable, the clothes, the dancing in the streets, the general attitude of the people ... the changes that were taking place in the heads of the people were visually manifested. I mean, how could you not take pictures? As I began to examine the photos in detail I was surprised to discover that in the summer of '69 virtually nobody was wearing sneakers, there were no branded T-shirts, nothing to read or be seen on the clothes. It was all just very simple and pure.

DJ: I see what you mean about the lack of branded clothes. I like seeing everyone dressed in their normal everyday pants and shirts and not trying to be "hip" with their attire.

BW: I know, the '60s were an honest and almost naive time, but keep in mind that the changes were happening really fast and the free spirit of the times disappeared as quickly as it appeared.

ML: Most of what you see that's colorful was homemade, it was a very non-commercial moment. We didn't have T-shirts except for what we had made for our crew so you could identify them. It was the pre-merchandise world.

BW: Michael, when you see these pictures what goes through your mind?

ML: I'm transported back to those moments, and also I think about the complexity of the whole thing and how it managed to hang together.

BW: Complex beyond anyone's imagination!

DJ: How did either of you sleep through all of this ... ?

ML: Over three days I slept maybe a couple of hours but my god I was in heaven. I love moving parts and wanted to watch it all unfold.

DJ: Did you see every act?

ML: Just about. It was a way of keeping the pulse, there were no cell phones, we had limited communication, the stage was the home base.

BW: That stage was enormous, unlike any other I had seen!

DJ: Didn't you plan a revolving stage?

ML: We did, it was my invention. Unfortunately, because of the rain the wheels broke down after the first day. It was set up like a turntable and divided into three wheels of a pie.

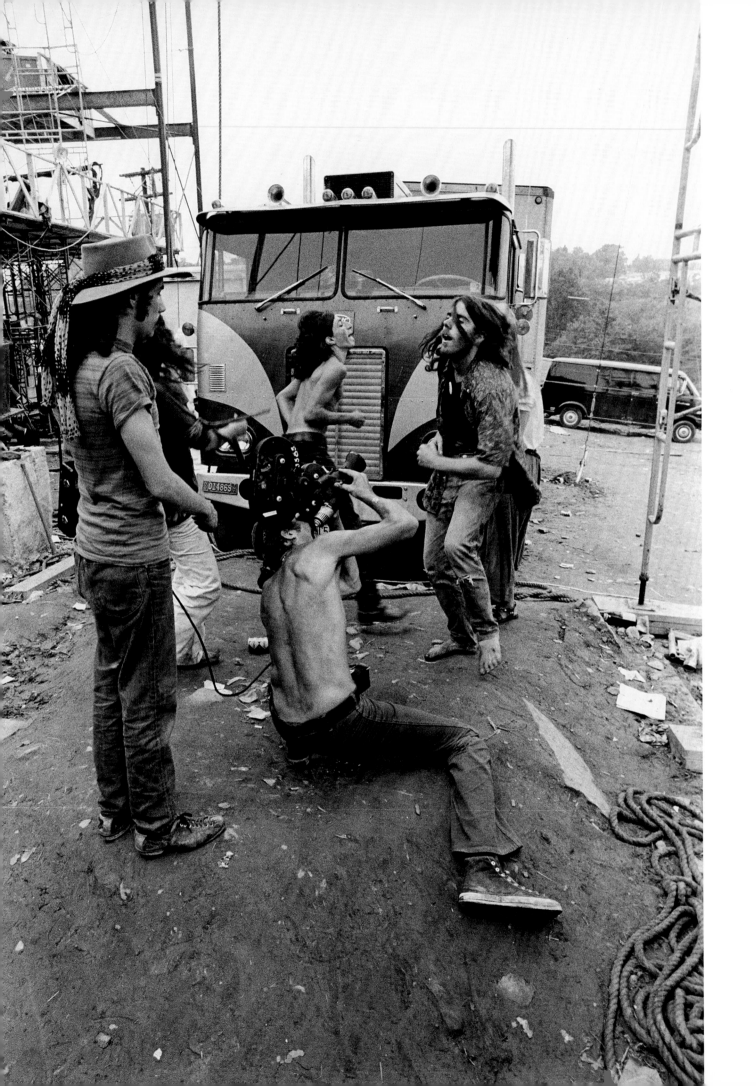

(continued) One band playing on their section while the next two bands set up and prepared on their sections, and then it would turn for each act and keep things moving.

BW: It was really something. To your credit you did it right with the big stage and I think about what they didn't do at Altamont. You separated the fans from the stage and built it high and had room for a more secure environment.

ML: At Altamont there was no real plan.

BW: They originally had a stage built at Sears Point and on the day before they pulled the permit and were forced to move to Altamont.

ML: There was no real security and the Hell's Angels were stuck between the crowd and the stage.

DJ: A curious decision to hire the Angels as "security."

ML: They were miscast.

BW: But you can't fully blame the Angels, they were doing the job they were hired to do.

ML: They were eating handfuls of acid. You've seen the Maysles' film.

BW: In the film you can see that it was a perfect storm.

DJ: From the beginning of the film, when you see the mood of the crowd arriving on the scene and even the location itself, it's chilling.

ML: Definitely.

BW: I have a great shot of you and Sam Cutler standing on the side of the stage in my book, *The Rolling Stone Years*. It was the puniest looking stage you've ever seen. It was clear that something bad was going to happen at the dawning of the day. If all those people hadn't gotten involved and fucked it all up with the city of San Francisco it would have been at Golden Gate Park and it would have been good.

ML: Really? That all happened before I got there two days before the concert.

BW: After the city said no to Golden Gate Park they went out to Sears Point, great venue, they built a fabulous stage and then the corporate owners of the track said, "No, you can't do it" and with one day left the owner of Altamont said, "OK, you can come out here" and so they built that stage overnight.

ML: I remember, I watched them build it. The truth of the matter is 100 feet out from the stage no one knew what the hell was going on. Close to the stage, it was just chaos.

BW: I was at Altamont all night long as the stage was being built. A bunch of us from *Rolling Stone* were staying in a motor home so we could be there throughout the festivities. The morning of the concert I remember opening the door of the motor home; the first thing I saw was a Doberman run down a rabbit and kill it. To me it was an omen; I just knew the day would end badly.

ML: There was a bad feeling in the air from the beginning of the day, everyone was on edge and there were huge amounts of drugs being taken by everyone. For me it was a question of whether we could get through the day in one piece.

DJ: The differences between the two festivals are remarkably stark.

BW: Woodstock was planned with love and ended up well, wonderful beyond anybody's imagination. Altamont started out nobly but was sidetracked by people with their own petty agendas, and ended up poorly, to say the least. In fact, the Stones were pretty much coerced into giving the people a free concert; it was not done with a spirit of generosity, not something they offered in true appreciation of their fans.

DJ: The tales of Woodstock on and around the stage have been well told over the years but you don't hear as much about the community of people who attended, which is what you experienced and photographed most that weekend.

BW: As a photographer I am a voyeur by profession, I make sense of life by looking through my camera and isolating moments.

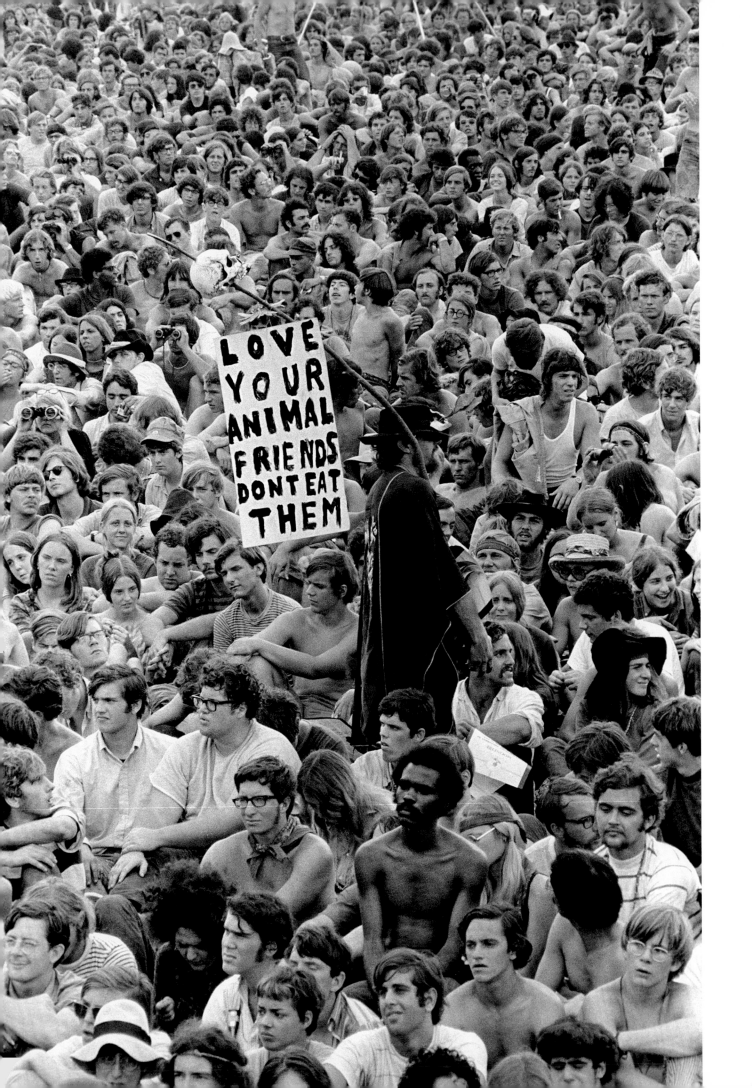

(continued) When I was a kid I found life so noisy and chaotic that only when I picked up a camera and viewed the world through the lens could I quiet the noise and make sense of the chaos. Taking pictures satisfies my curiosity about who or what I'm photographing. By now I've lived long enough that I find few unexpected moments and behavior anymore. I can usually anticipate what's going to happen in a photographic moment, how people will behave.

DJ: I see what you mean, but at the time everything that was happening around you must have been totally new and unexpected.

BW: Of course, I was used to hippies, the counter-culture and all that, but what was happening at Woodstock was very much the culmination of everything that had happened in the '60s up to that point and it was miraculous, almost as if I was walking around in a dream. I had never seen anything like it and was eager to get in the thick of it and take as many pictures as I could.

DJ: How much film did you shoot that weekend?

BW: Maybe twenty rolls, which I suppose isn't that many but I feel I did a pretty good job of capturing the spirit of those three days.

ML: I noticed something interesting looking at these pictures ... you can tell which day it is by how clean people are in the photos.

DJ: You're right, I didn't even think of that. What are some moments that really stand out in your memories?

ML: Lewis Lamb stands out in my memory and there are some great photos of him in this book. He was an animal rights guy who walked around with a lamb following him everywhere he went.

DJ: He's the guy with the signs, I was wondering about him ... and the lamb!

ML: His signs read things like, "Animals are our friends, don't eat them" and stuff like that.

BW: That's so interesting, I didn't know who he was but of course I was curious about him and shot him several times that weekend. I think he was carrying a different sign every time I saw him.

DJ: How about you, Baron?

BW: There are so many memories, like Max Yasgur's cows that wandered around freely among the people. That farm was their home and they weren't going to be run off. I got some pictures of the cows hanging out with the people and walking around the cars and tents. There's one great shot I got of some kids with canteens trying to milk one of the cows. It was so funny watching them try for 30 minutes but that cow wasn't giving up a drop.

DJ: Is it true that the cows were so traumatized by the crowd and music that they didn't give milk for a month?

ML: That's what the neighboring dairy farmers claimed when we were sued.

BW: For lost income ...

ML: They were frivolous suits and for the most part went away.

DJ: The lawsuits may have gone away but at the festival the storms came ...

ML: The storm was really frightening.

DJ: What were you thinking when you realized that there was bad weather coming?

ML: We were worried about the towers. They were well engineered to stay in place but we got hit with gale force winds, which were totally unexpected. It was scary having all the heavy lighting equipment on these towers over everyone's heads. Ultimately we ended up having to cut power from the stage when things got really weird.

DJ: But then the storm and rain turned the whole Woodstock experience into something else entirely, something almost tribal that brought the attendees even closer to nature.

ML: There was definitely a shift that occurred when the rain started.

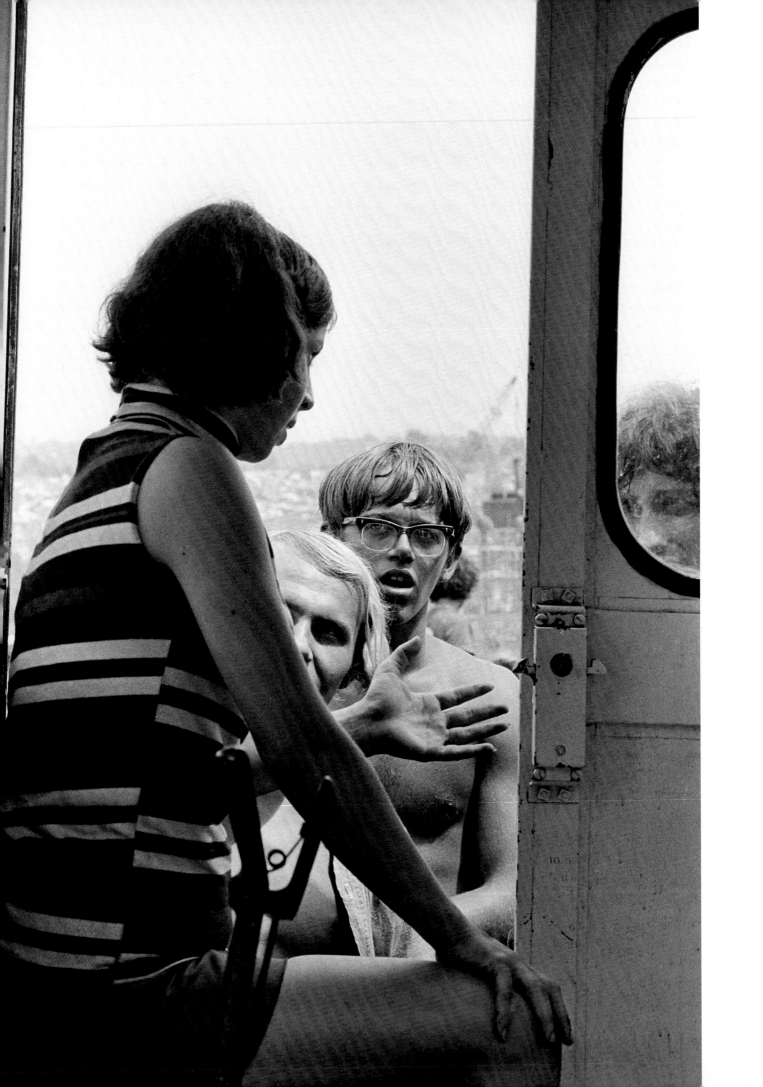

(continued) It was a gathering of the hippie tribes, it was also a gathering of everybody else. Woodstock was such a cool time to be a part of the music and politics, but if you never made that step you could come here and be instantly "in," which is what a lot people did. To be a part of what everyone in the counter-culture was talking about.

BW: From the storm to the mud to the messy fun …

DJ: What sort of feeling did you get when you went out into the crowd?

ML: It was a mellow experience, it was like everybody was having the same dream everywhere you went; it was remarkable, like a feeling of family permeated throughout the whole place.

BW: Did it feel like your baby?

ML: I felt a lot of satisfaction. It felt like heaven; just how everyone picked up on what everybody else was feeling and went with it.

BW: I often say it was a disaster waiting to happen and it didn't and that's part of what makes Woodstock so important. There wasn't enough water or food and it could have gone the other way and it didn't even begin to go the other way, and that's amazing.

ML: I think that's because of the expectations that everyone had coming in and the way they were welcomed and oriented and everyone saw how to take care of themselves and how to take care of others, there were no rules laid on everyone, it was self-generated and self-realized. Hey you can be this way or that way, be whoever you are. There was nothing jarring, no police hanging out, it was really something.

BW: That's so rare, was then and still is today.

ML: Yeah.

DJ: I don't really see Woodstock as being a political event like a lot of other events in the '60s. How much did the politics of the counter-culture factor into your thinking during the planning stage?

ML: Woodstock was planned as a political event by being non-political. The politics were making it work, creating a space where anybody could come. If you didn't have any money there were free kitchens, and free campgrounds, and free stages, we didn't want to turn anybody away, we didn't want to create any hassles or set up any negativity, we wanted to give the experiment a real chance to work.

DJ: Was there any planning with or help from people like Abbie Hoffman who was at the festival?

ML: An underground journalist ran a debate at the Village Gate on Bleecker Street and we invited underground press from all over the country. The debate was about whether Woodstock should have a political message or not, because we went into it with a non-political stance and people were saying we were selling out, so we were presenting our point of view. After the end of the three-hour debate with several hundred people who were part of the underground movement we came out with an agreement.

BW: Were you going to do what you wanted to do anyhow no matter how the meeting turned out?

ML: I hadn't made up my mind going in but probably. At the festival we did let them print up their literature and Abbie would print up his survival sheet every day and they all had their booths set up to give out information. The interesting thing is that eight hours into the festival those booths were all abandoned because all the shit they were talking about was happening right there and they just went out into the world we created.

DJ: So rather than making Woodstock "theirs" they became a part of the body, in a manner of speaking.

ML: Yeah, there were lots of political groups who wanted to own a piece of Woodstock because they felt that the counter-culture was being ripped off and here I was telling them, "You are the culture!"

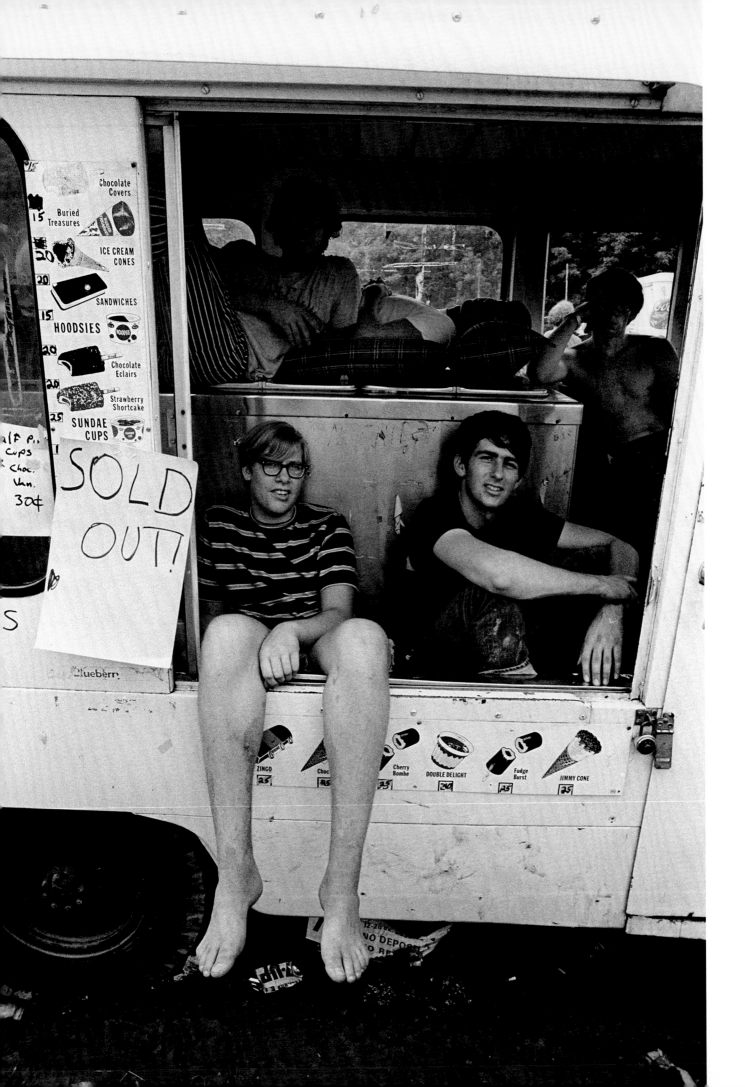

(continued) I think most of the people who attended Woodstock were a little burned out from the political scene after so many heavy years; they just wanted to come and hear some music and feel good.

DJ: Pete Townshend hitting Abbie Hoffman over the head with his guitar and knocking him off the stage to the cheers of the audience speaks to the mood of the crowd.

ML: That was when Abbie tried to take over during The Who set to talk about John Sinclair. I was sitting next to Abbie on the side of the stage and said, "Wait, I'll let you go up after the set" but he was tripping, it was 3 a.m. and he had been working in the on-site hospital for a day and a half and was wiped out. I remember Abbie caught me and said that someone was running around with a gun under the stage. "Come on, we've gotta go find him." So there we were, running around the stage and there was no one there. Of course, somewhere along the way it went from a gun to a knife and finally I said, "Come on, let's go up and watch The Who." There were a lot of people on the stage watching their set at that point and we sat down and we were watching when suddenly he just popped up and grabbed the mic and rushed the stage; Pete turned around to adjust his amp and pop, there it happened. They have the footage of that.

BW: Well you have it too, don't you?

ML: No, they took the original footage somewhere along the line during the edit of the film because they didn't want the proof of it out there.

BW: Proof of what? It was just another rock and roll moment, one among many …

ML: Yes, but a very memorable one.

DJ: When people think of Woodstock, what often comes to mind are the people who shed their clothes and bathed in the lake as a communal experience.

BW: That everyone was getting naked and swimming and bathing together so freely without inhibition is an important part of the Woodstock mythology. Here are 500,000 people all together shaking off the shackles of what conservative society expected of them. In that place and time it was totally appropriate and no one was bothered. There's one interesting photo that I feel perfectly illustrates the role of the photographer in capturing the history. I shot this other photographer wading deep into the water with his camera trying to capture the "naked moment" but he's fully dressed and seems totally unaware that he's walking deeper and deeper into the water, it just didn't matter because we photographers must be able to separate ourselves from the action, to document rather than participate, that's how you get the best, most honest photographs.

DJ: That's a great shot that perfectly illustrates how two people can be in the same place, the same moment and yet both have completely different experiences. Some other shots of yours that stand out are the cars along the highway, miles of cars as far as the eye can see, abandoned and empty. It's like everyone turned off the engines and walked away.

BW: Oh man, that was really something to see. In a way it was like watching refugees on the move only everyone was happy. My cousin who drove to Woodstock left her car along the Interstate and even after the show she never picked it up, she just took a bus back to New York City and that was that. The locals came out, sat in their front yards and watched everyone parading by peacefully, they had no idea what was happening and were awestruck. A lot of them even gave out sandwiches and water to the kids. One of my favorite shots is the woman flashing me the peace sign as I walked past. The locals seemed to be pretty much total squares but in a way were unafraid and even welcoming.

ML: The locals were taken with the kids; there was panic when everyone showed up at first but then they could feel it was benign and everyone ended up being really friendly.

BW: Getting back to the cars, there's one shot I find especially touching of a guy and girl on the trunk of a car, he's playing a guitar and she was so young and sweet, they both were.

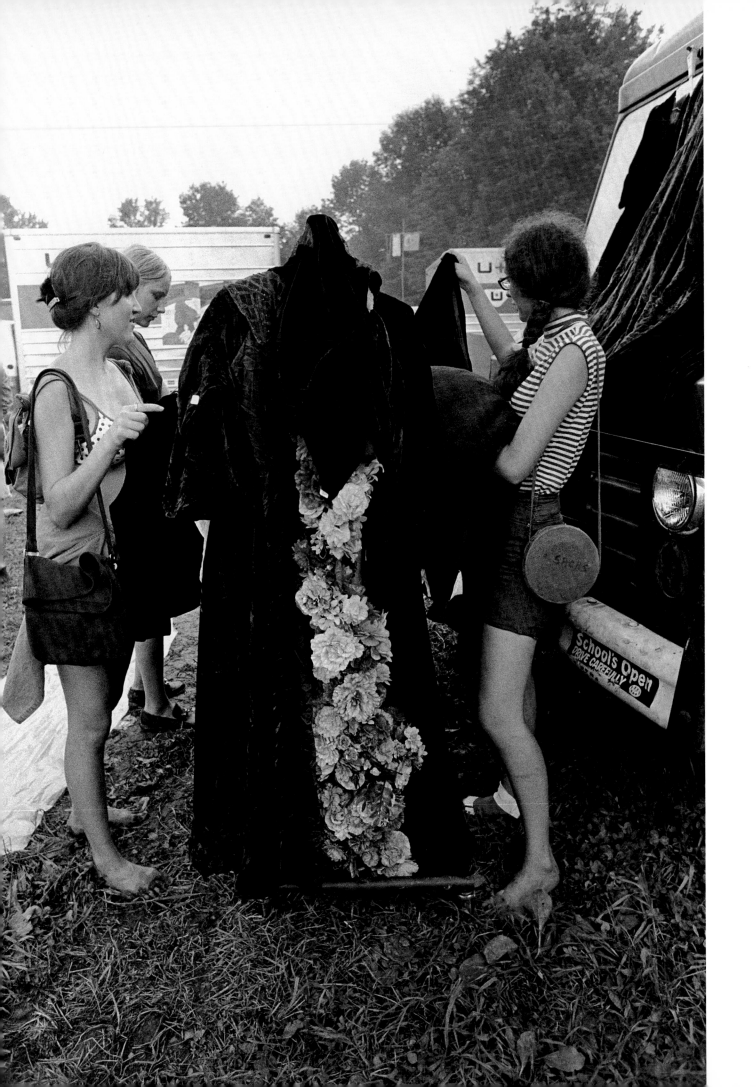

(continued) A few years later her parents contacted me because she had passed away; they had seen her picture in *Rolling Stone* and asked me for a copy, so I sent them a print of that captured moment.

DJ: That must have meant a lot to her parents. Your Woodstock photos mean a lot to a great many people.

BW: I guess so. Over the years several of the people I photographed at Woodstock have been in touch with me to get pictures; that's pretty cool, it somehow ties the pictures to the reality that I experienced, that we experienced together. There's one shot in particular that really sums up the weekend for me. On the right side of the picture there's a woman serving food to someone and right next to her on the left side of the photo there's a guy sharing a joint with someone. In that one shot you can see both body and mind being fed. "Eat & Toke," I call it.

ML: Of course, the body and the mind, share everything!

(laughter)

BW: The guy sharing the joint is now a businessman in Boston and he contacted me for that photo. Even decades later the experience of Woodstock still has a profound effect on those who were there …

DJ: … and many who weren't.

BW: That's true. But Woodstock also touched a place much deeper in our culture. In the '60s there was a lot of contention between the counter-culture and the military, they didn't really like each other or work together except for those three days at Woodstock when the National Guard came and ran medevac helicopters to and from the site. I mean we're one country, all in this together; it should have been this way all along. That was a magic moment for me.

ML: That weekend the generation gaps and cross-generational fears seem to have evaporated and things were brought back to a very basic experience of human interaction in the best sense.

DJ: Baron, every single photograph you took at Woodstock is a magical moment and I could look at them all day. In fact, I have! Woodstock forever changed the lives of a lot of the people who were there.

BW: When I look at these pictures it still blows my mind, even today. I feel like I'm seeing Woodstock for the first time. This was a deservedly mythological experience; by any measure it was a disaster waiting to happen but in the end it didn't. Peace, love and music reigned pretty much as the counter-culture promised.

ML: You know, I showed Ang Lee a lot of your photographs when he was in pre-production for his film, *Taking Woodstock*.

DJ: What did you think of the film and your portrayal by Jonathan Groff?

ML: I thought it was pretty good. It's an odd thing to see yourself played by someone else. On opening day of filming the scene on Yasgur's Farm, Ang had an opening ceremony; it was him and Eugene Levy who played Max, and the rest of the crew, and I felt myself transported because he really had the attitude and spirit down.

DJ: Would you describe the film as accurate?

ML: It wasn't totally accurate but there were a lot of parts of it I liked. I think it should have been a film more about the music. I was on set some during filming and I really liked the extras and the crew, everyone had a great time just being there and they became their own community, which did a lot to capture the spirit of the times. Ang Lee really fostered that sense of community on set. There were a lot of smiles.

DJ: The story aside, I feel the film did a good job of painting a picture of how I imagine it felt to be there.

ML: Ang captured the feeling of the people well, it's a little idealized but naturally that comes from Ang not having been there.

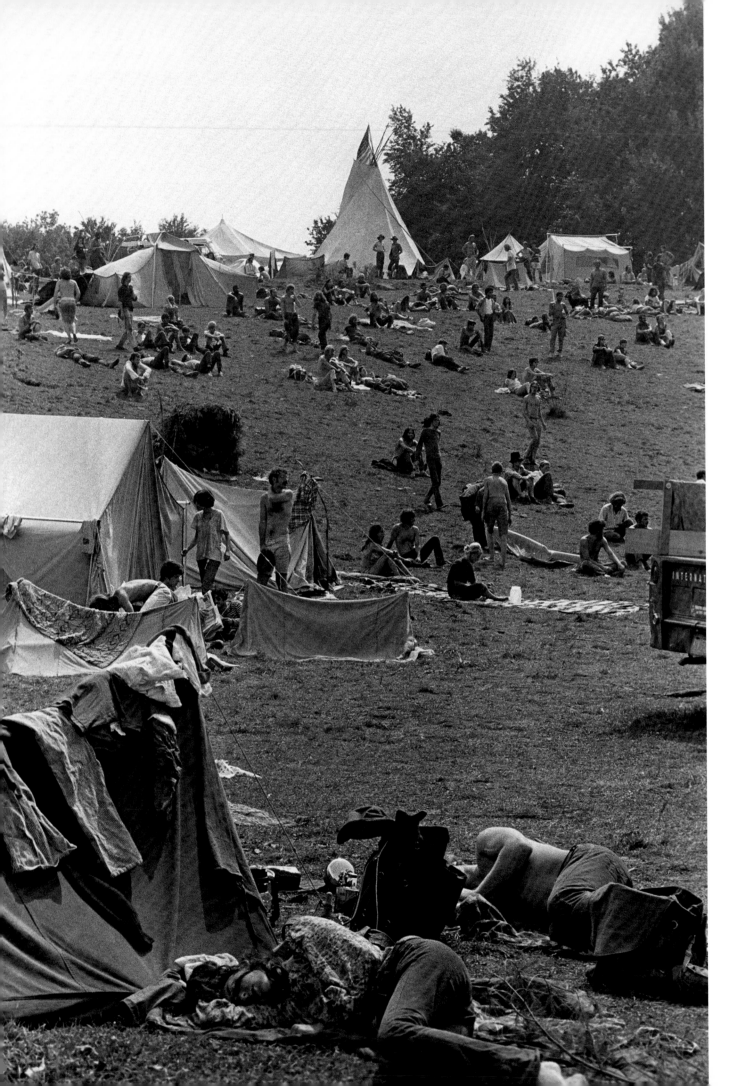

DJ: Did you meet with Jonathan prior to filming?

ML: Yeah we did meet. Jonathan was doing *Hair* in Central Park and we went and saw him and then they all came to the house for the weekend and we talked and everyone was comfortable with how the film was going to be made.

DJ: Keeping to the topic of film, how important was it to capture Woodstock itself on film?

ML: It was something we thought about from the beginning. We wanted to film it but couldn't get anyone to pick it up. *Monterey Pop* came out not long before and didn't have much box office success, at least not at first; it kind of grew over the years and became a lot more popular.

DJ: Ah yeah, *Monterey Pop* is an excellent film but a very different experience from *Woodstock*.

ML: It was great but still didn't do well at the box office so it was tough for us to get anyone interested in our film. We decided to go ahead and film it anyway and put together a camera crew that we brought up early. They shot all the early footage you see in the film right through the entire festival.

DJ: When you first saw the footage were there any surprises?

ML: There were no surprises in the footage, I experienced it all intimately.

DJ: The film went on to become a huge hit, were you surprised by that?

ML: Well, not really. The film captured the spirit that so many people were feeling at the time – feelings that had grown a lot since *Monterey Pop* just a few years earlier. It was a different reality for a lot of people. The audience was there and ready for a film like *Woodstock*. Ultimately the film did a lot to carry that reality and it spoke to what a lot of people were hoping.

DJ: What was it like dealing with the artists in regard to shooting the movie footage?

ML: It was Artie Kornfeld's job to walk the bands to the stage and get them to agree to be filmed because we didn't have an opportunity to work it out ahead of time because the film came together in the final days before the start of the festival. Everybody was pretty cooperative; there was a little push back from a few people but almost everybody agreed. Neil Young in particular didn't want to be filmed but most everyone got it. The performers were blown away by the crowd and in a way the audience was really the star of the event and everyone knew it. Everyone acted that way except maybe The Who.

DJ: Are there any performances in particular that stand out for either of you?

ML: Sly.

BW: Everybody says Sly, Santana too.

ML: Sly & The Family Stone were on fire, they brought a party and they were dressed for it! Sly was such an immense talent and the band so tight and together and ready to boogie. They were infectious and his rapport with the audience was astounding!

BW: It was a shame that back in the day you could book him but never depend on him showing up.

ML: I dropped him three times before I finally confirmed him because he kept cancelling gigs but I'm glad he played. There were so many memorable performances. Crosby, Stills & Nash was a magic moment and Joe Cocker and Arlo, and Joan Baez stands out.

BW: Well she was totally appropriate to have been there ...

ML: And of course Richie opening was phenomenal and Hendrix closing was phenomenal.

DJ: A lot of people may not know that Richie Havens wasn't the planned opening act on the first day of the festival.

ML: Nobody was ready and at about 3 p.m. I was looking for an act due to start at 4. I spotted Richie and his band, which was basically an acoustic unit, and eventually I was able to talk him into doing it.

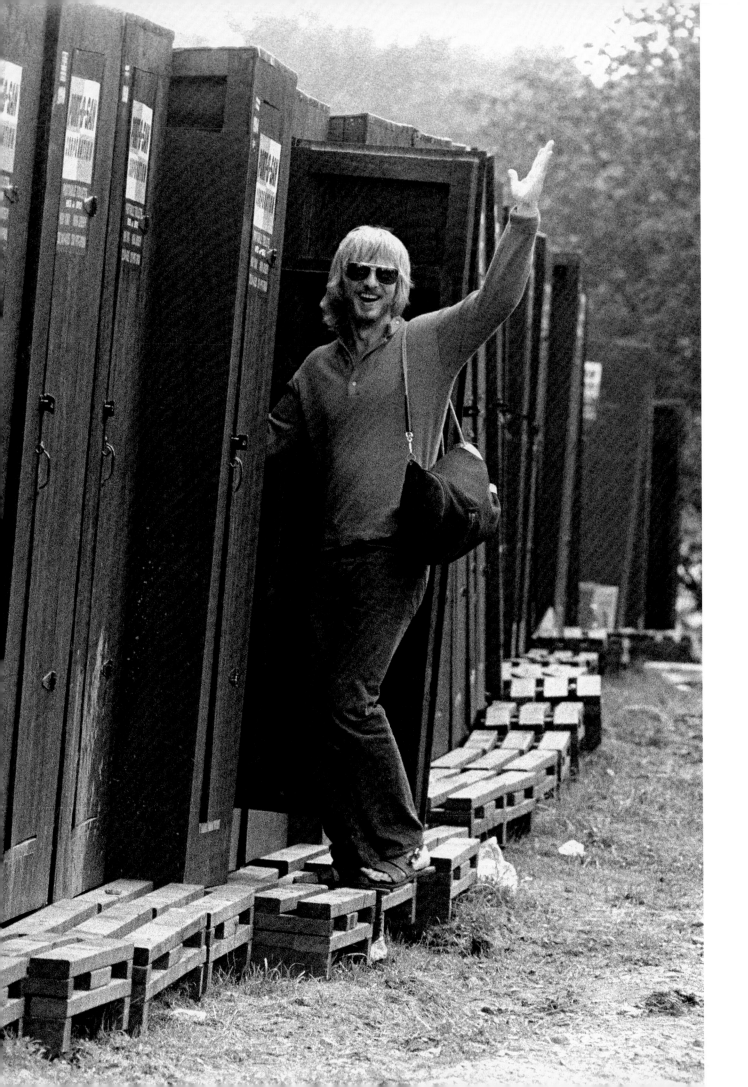

DJ: But he didn't have enough material and improvised on the spot what is now known as one of his greatest songs, "Freedom."

BW: Oh, I didn't know that!

ML: Well, Richie had enough material for a scheduled time slot but we needed him to keep playing longer to buy us some time to get another act ready to play and that's true, he made up "Freedom" right on the spot.

DJ: That's incredible! I heard that before you had Hendrix in the closing spot you tried to get Roy Rogers to close Woodstock.

ML: I wanted him to sing "Happy Trails" but he turned us down. It would have been the perfect way to close, we all grew up with him singing "Happy Trails."

BW: Did you speak with him directly?

ML: I went through his manager.

BW: Somehow I could understand, they were probably afraid of being associated with anything counter-culture, but that would have been so cool.

ML: They didn't get it.

(laughter)

BW: Still, you got a pretty good ending with Hendrix closing the festival.

DJ: By then it was Monday and most of the people had left.

ML: Maybe 10 percent of the crowd was still there, everybody had their lives to get back to.

BW: Nobody knew or understood how important that performance would become. Did he have it in his contract that he had to close the show?

ML: He did, and when he showed up Sunday at noon with Michael Jeffery, his manager, we met backstage and I said, "Why don't you guys go on at midnight, it'll be the peak of everything" and Michael said, "No, he has to close." I told him that things were running really, really behind and midnight is the spot, but he insisted that he close so Jimi hung out all day around the stage and was fine with it.

DJ: That's why he missed the Dick Cavett show in New York City on Monday.

ML: Monday morning he was supposed to be at Cavett but he was closing Woodstock. Cavett is also why Joni Mitchell didn't play Woodstock. We wanted her but David Geffen wanted her to do Cavett so she missed Woodstock.

DJ: She did watch the events unfold on television and wrote her anthem in her hotel room, or so the myth goes ...

BW: For the longest time, I didn't even realize Joni wasn't at Woodstock. I mean, listen to her lyrics: "I came upon a child of God, He was walking along the road ..." One way or another, she was there.

DJ: That Joni wasn't there and wrote such a perfect song speaks volumes to the energy that radiated from all the people at Woodstock. It was felt far and wide.

ML: Yes it reached out and touched people all over the world, the pervasive sense of peace and coming together was understood by everyone who was touched.

DJ: It's interesting to watch that episode with Joni and The Jefferson Airplane and David Crosby talking about this festival they had just played and you can feel the buzz of electricity in the studio. Jimi was scheduled to appear on Cavett with them and they're talking about how he's crashed in his hotel and they can't get him up because he just played Woodstock.

(laughter)

BW: Woodstock really didn't end when Hendrix quit playing, though there was no way to replicate the feeling with the other Woodstock festivals.

ML: Woodstock '94 had a good feeling, it was a great weekend.

DJ: It was a huge event that was a lot more connected to the media of the day.

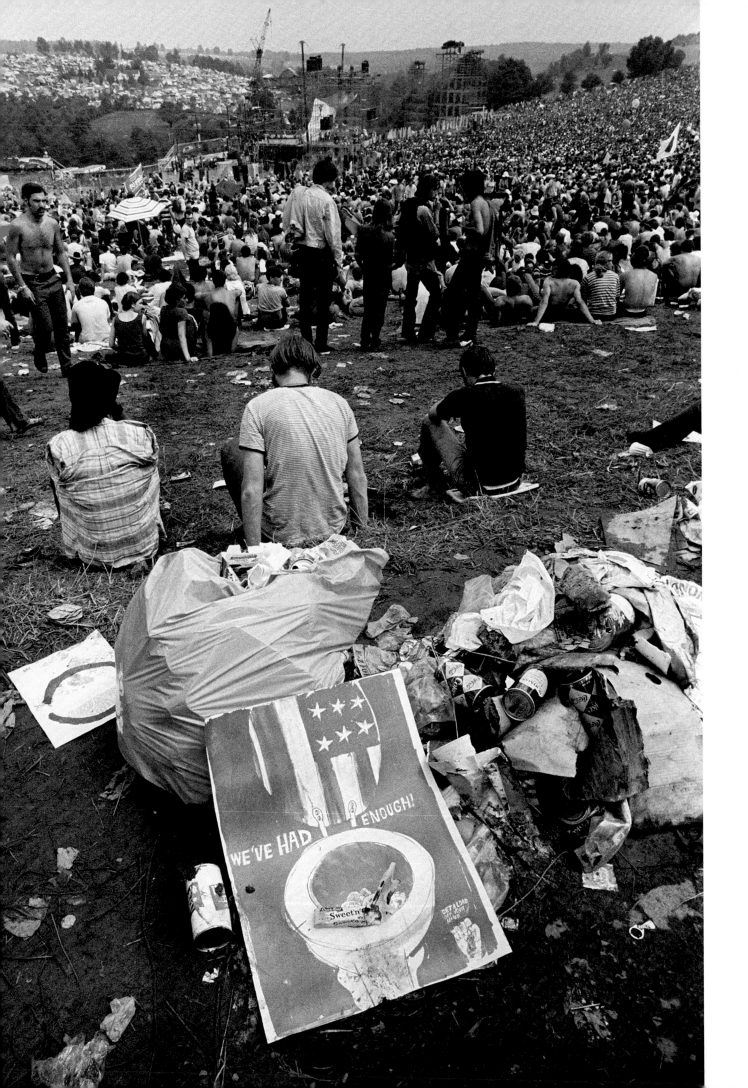

ML: It was an anniversary; we weren't trying to re-live the original. You can't replicate the times and what was happening in the '60s then but we were able to bring the spirit into it.

BW: The original Woodstock was a happy accident and impossible to duplicate. Yes, it was planned, too, as much as it was possible at the time. But those three days took on a life of their own, becoming more than a music festival; they were an ever-changing organism that gathered only the good of humanity and evolved into an almost magical, mythical paradise.

DJ: Something else about Woodstock that most people don't know is that you were in talks with John Lennon to perform.

ML: I invited John but he couldn't get into the country, Nixon didn't want him here because he was anti-war. I was dealing with Chris O'Dell who was at Apple, trying to work it out. When I was researching material for my book, *Road to Woodstock*, I found a box of stuff I didn't know I had and in it was a letter from Chris that arrived the day we lost the Wallkill site so I never saw it. In the letter she offered James Taylor, Billy Preston and Yoko Ono with the Plastic Ono Band. It would have been cool to have had all three.

BW: Did you ever tell her you found the letter?

ML: I told Neil Aspinall.

BW: Did you read her book?

ML: I didn't.

DJ: It's a good read.

BW: It's really good, very personal, she was really in there in a way that no one realizes.

DJ: Michael, how did the trajectory of your life change after Woodstock?

ML: I was sort of in showbiz after that, I hadn't really planned on that. Woodstock was not a career move, it was just a project that lead me down that path.

BW: Were you planning any other concerts after that?

ML: No.

BW: So it was just a single event in your mind.

DJ: You went from owning a head shop ...

ML: ... in Coconut Grove ...

BW: Were you from Florida?

ML: No, I moved to Florida from New York and opened the shop and then Monterey Pop happened and that was the inspiration for the Miami Pop Festival.

BW: Did you go Monterey?

ML: No, but the effect of the music on those kids stayed with me all through Miami and when I moved to Woodstock and decided to put on something bigger.

DJ: What do you think will be the enduring legacy of Woodstock?

ML: It's confirmation of a possibility of a way of living.

BW: Could you do Woodstock now or something similar given the current state of the world?

DJ: Is that even possible?

ML: Hmm ... I don't know if you could do a Woodstock type event now. There are those moments where possibility is demonstrated on a large scale like Barack Obama's inauguration the first time around. It's those moments that speak to a kinder and more compassionate world.

DJ: Those moments don't happen often enough.

ML: No they don't.

BW: If it could only be. ... There was a certain naivety in the Woodstock experience and because of Woodstock the corporations saw the commercial possibility in gathering huge crowds like that.

DJ: Your model of doing things was definitely exploited almost immediately after Woodstock.

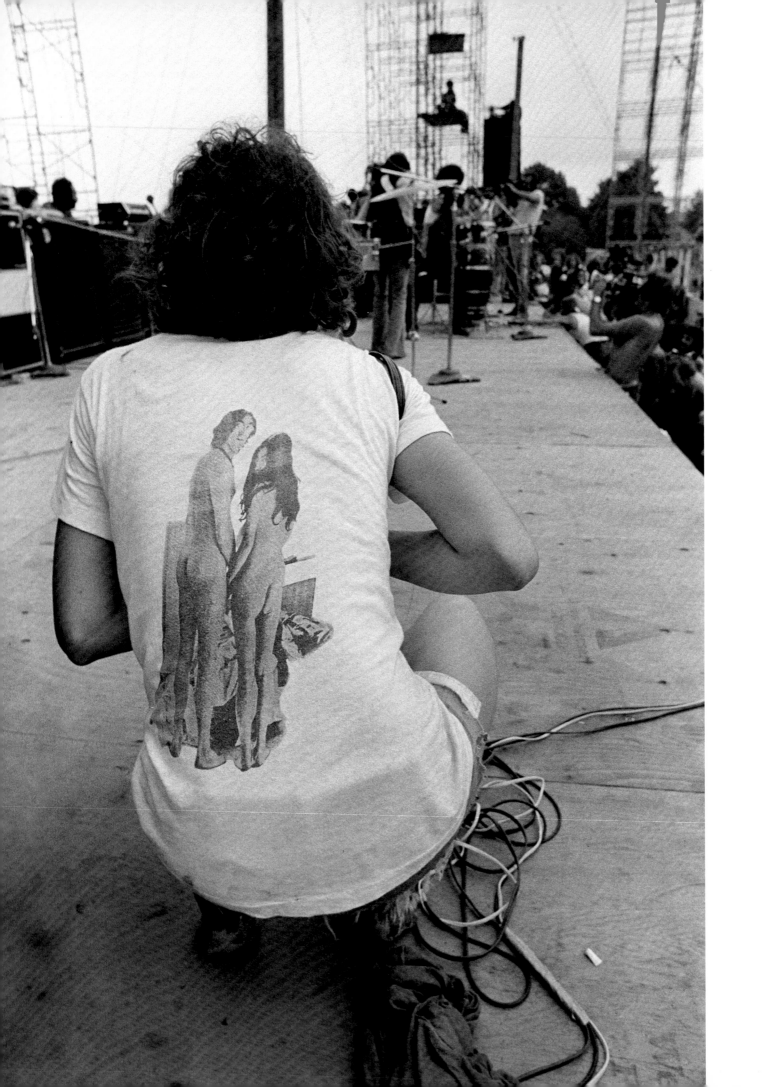

ML: Absolutely.

BW: It's like the Glastonbury Festival now.

ML: That's been going on a long time, the guy farms there all year long and then they have the festival.

BW: It's like a permanent place now.

DJ: You can see the DNA of Woodstock in Glastonbury.

ML: You can see it in every major music festival really.

BW: That must give you some satisfaction.

ML: It does.

DJ: What's next for you, Michael?

ML: I'm opening a permanent festival site in upstate New York because there really isn't one.

DJ: Where will that be?

ML: In Saugerties. It'll be a site that can be set up at the beginning of every summer and taken down at the end, and a setup that can be rearranged in different configurations. In addition to that, we're developing a musical.

BW: What's that like?

ML: It's still early and up in the air. The story has to be right and we'll have all the original music from the period.

DJ: That'll be great.

BW: There were so many good times in those days, so many good memories. Not that there aren't good ones now but there's something truly holy about that period in time.

ML: There is.

DJ: I was born after Woodstock and even I feel some kind of almost spiritual nostalgia for a place and time I never got to experience firsthand. I think a lot of people feel that way about the '60s.

BW: People often tell me, "You're so lucky to have lived through the '60s."

ML: I hear that all the time.

DJ: How do you feel looking back on Woodstock after 45 years?

ML: All of us together created that moment, the culmination of all our desires and hopes … things weren't changing the way people had hoped they would change. We got through the '60s, which was an intense decade, and by the time we got to Woodstock it was like here it was, and that was it. We set out to make Woodstock a non-political moment to see if we could get back to our core ideals and I think it worked; then Nixon and Kent State happened and suddenly we were in a different world. Woodstock speaks to the hopes of that generation and even so many years later the spirit of Woodstock hasn't diminished, it's endured. The spirit of Woodstock will continue to make people feel good and hopeful for generations to come.

DJ: Woodstock feels eternal in our culture. How would you sum up your feelings about Woodstock, Baron?

BW: Woodstock demonstrated the possibilities of peaceful coexistence among mankind and that message reached those who were there and so many who came after. For me personally, the residual pain of the Woodstock experience is that its spirit of peace and love didn't persist, we became a more aggressive and war-like society. The "Woodstock effect" was real and tangible; sadly it has not been sustainable. Woodstock showed the world how things could have been and for this reason it's important that we never forget this experience, this place, this time, this dream that came true, if only for three days …

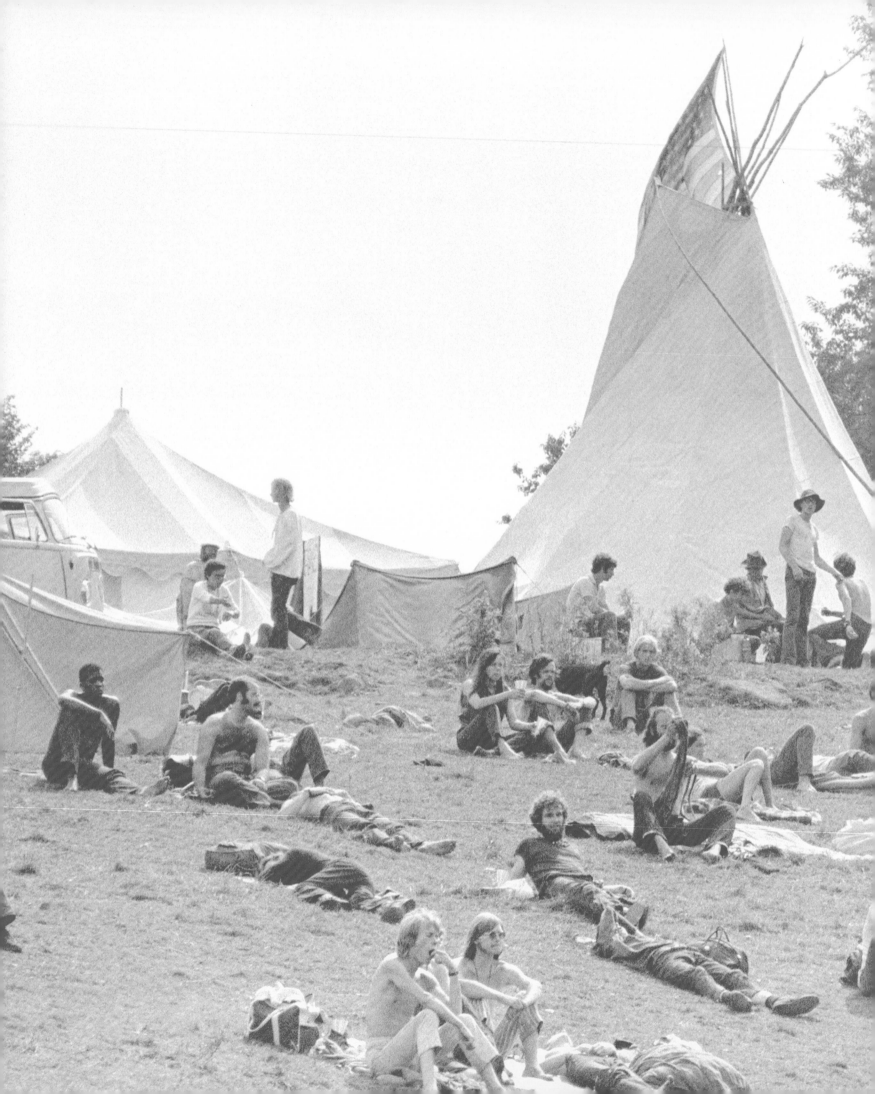

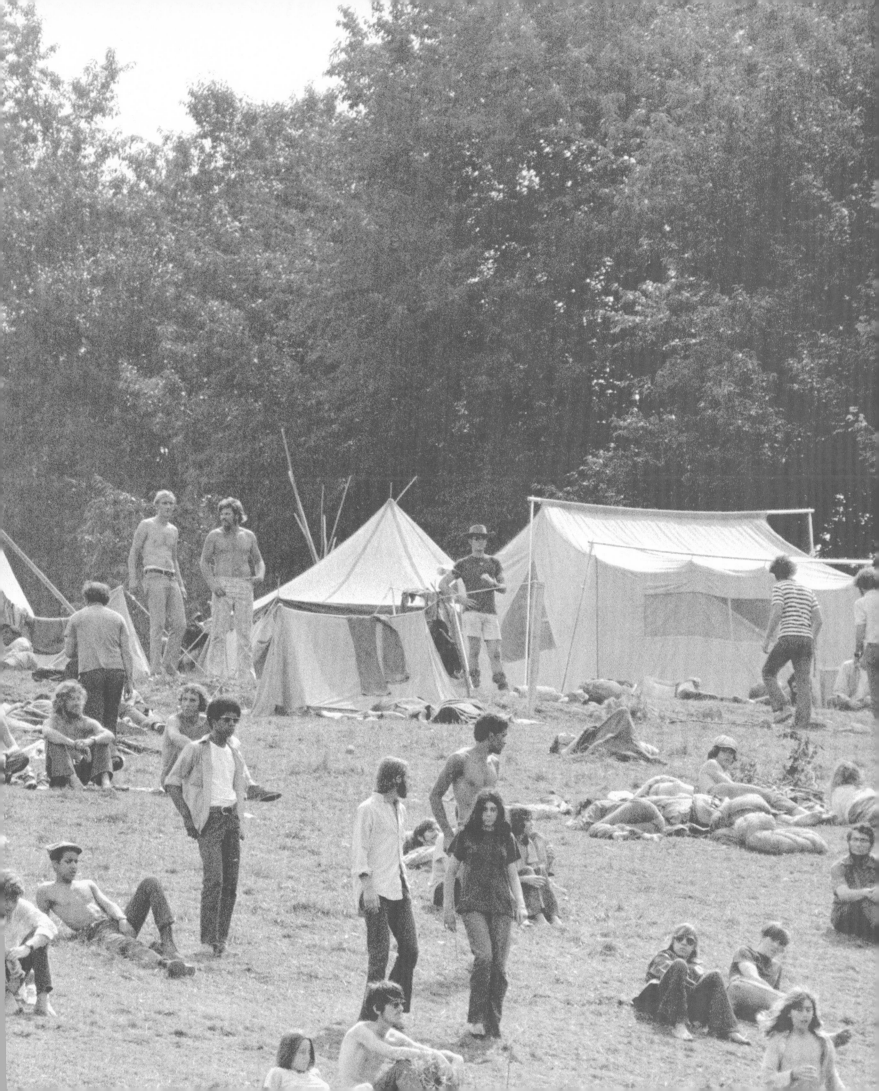

THE CONTACT SHEETS

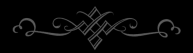

Imagine trying to explain what Woodstock was really like without this collection of photographs. One would hardly believe it, or at least be accused of exaggeration: half a million people from all across the country, making their way to a remote field in upstate New York just to listen to some music! Highways closed, bemused locals feeding the masses, the hippies and the military helping each other, side by side, city dwellers trying to milk cows, career-making and defining performances, life-changing moments, a three-day period still unmatched and still fascinating 45 years later.

Baron Wolman's previous book, a collection of his music photos that included his years as first chief photographer at *Rolling Stone* magazine was subtitled, "Every Picture Tells A Story." The text gave explanation or background where possible but mostly the words were there to convey a sense of the times and the challenges that resulted in those photographs.

Wolman's Woodstock pictures, on the other hand, perfectly tell the story of the festival as it unfolded, from the abandoned cars and foot traffic marching on Bethel, to the definitive image of the never-ending sea of people viewed from center stage and disappearing over the horizon – a breathtaking, technically brilliant and historically important image.

It is a rare and fascinating treat when photographers allow us to see their contact sheets; imagine writers publishing their notes and ideas alongside the finished text. Many photographers are reluctant to show everything; anxious to reveal nothing they believe to be less than the ultimate shot. What is remarkable about this selection of contact sheets is that almost every frame is as good as the next, and we get to see Woodstock exactly as Baron saw it, every single unbelievable moment ...

Dave Brolan
London, 2013

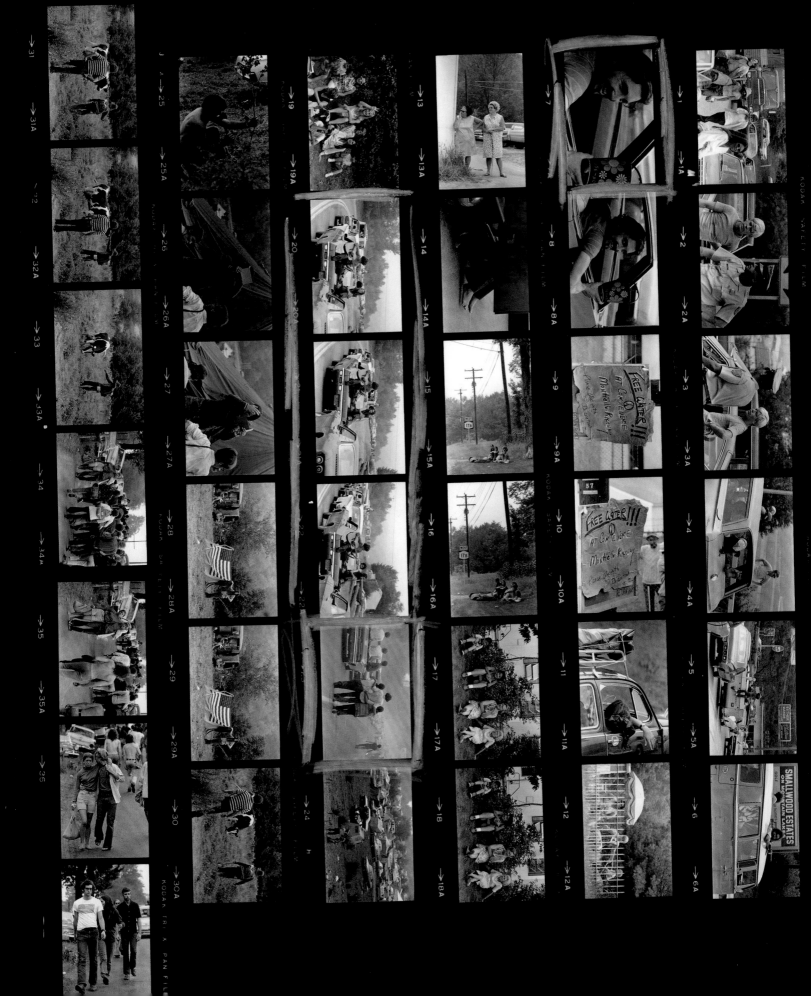

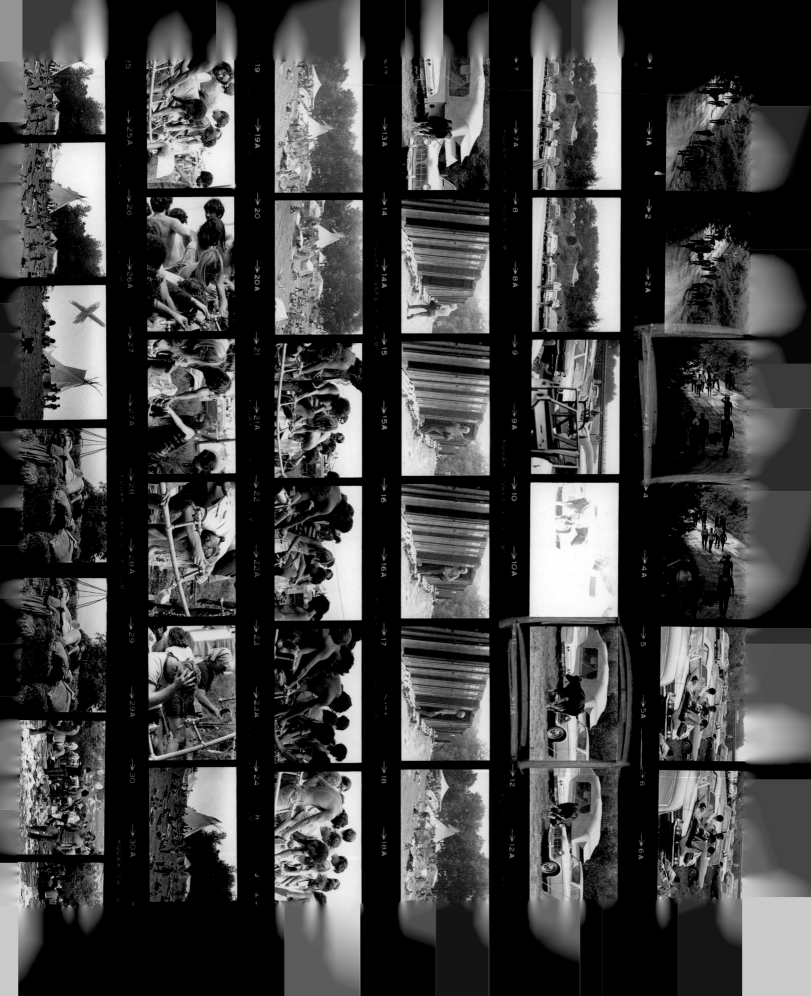

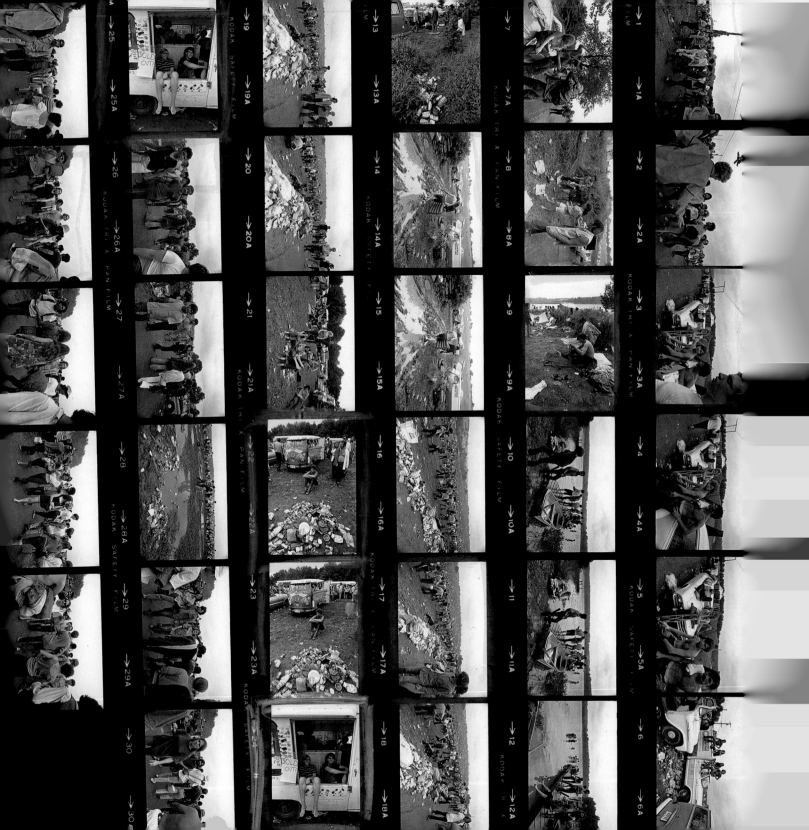

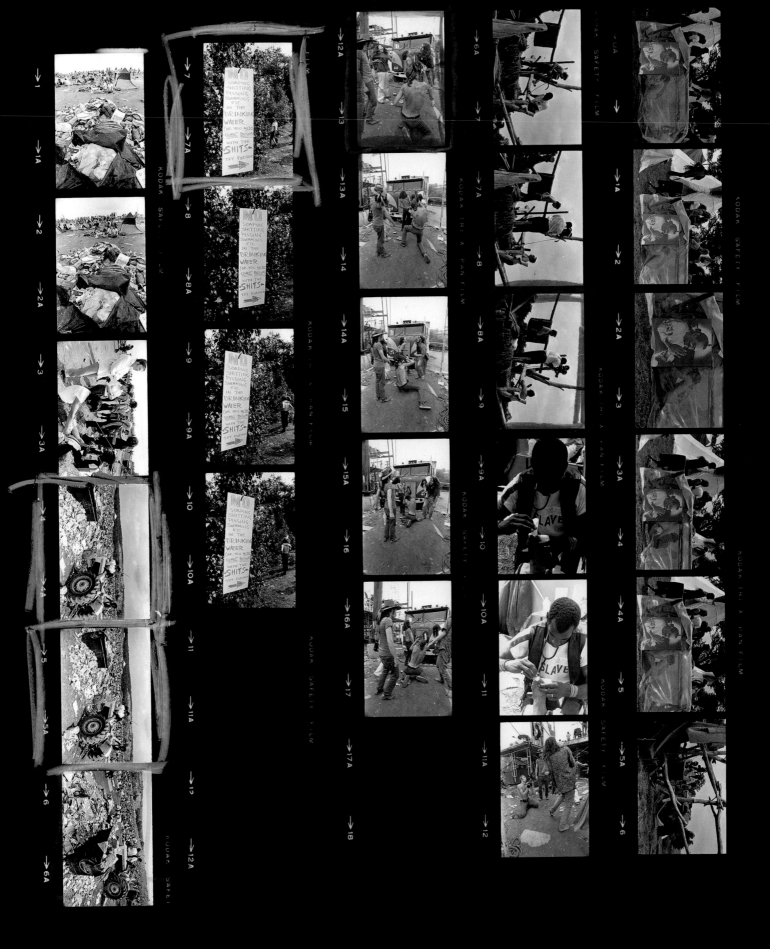

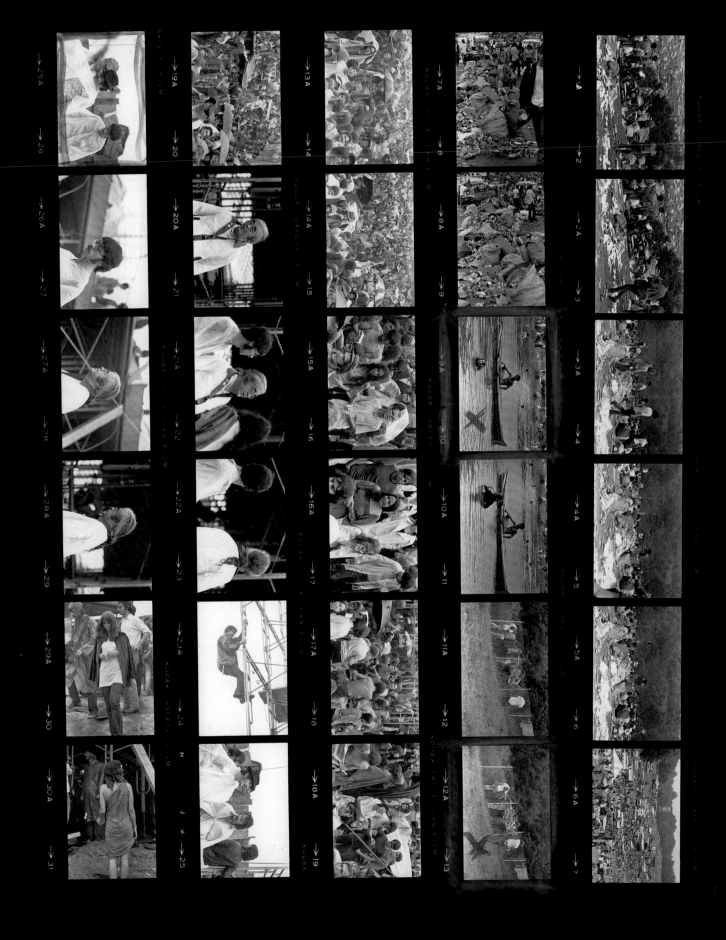

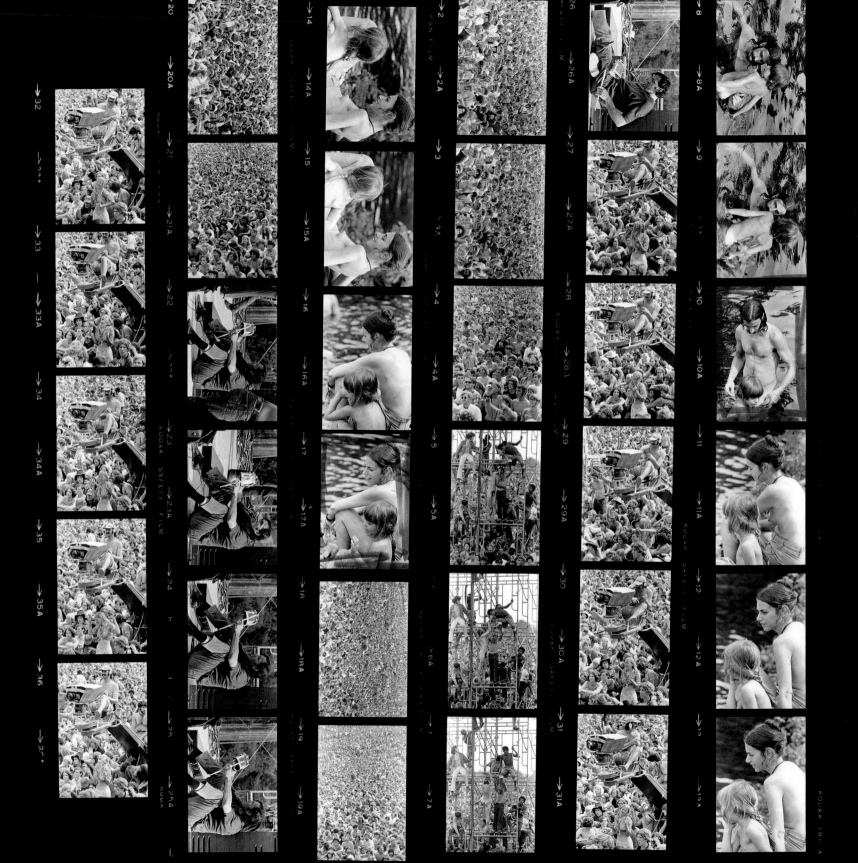

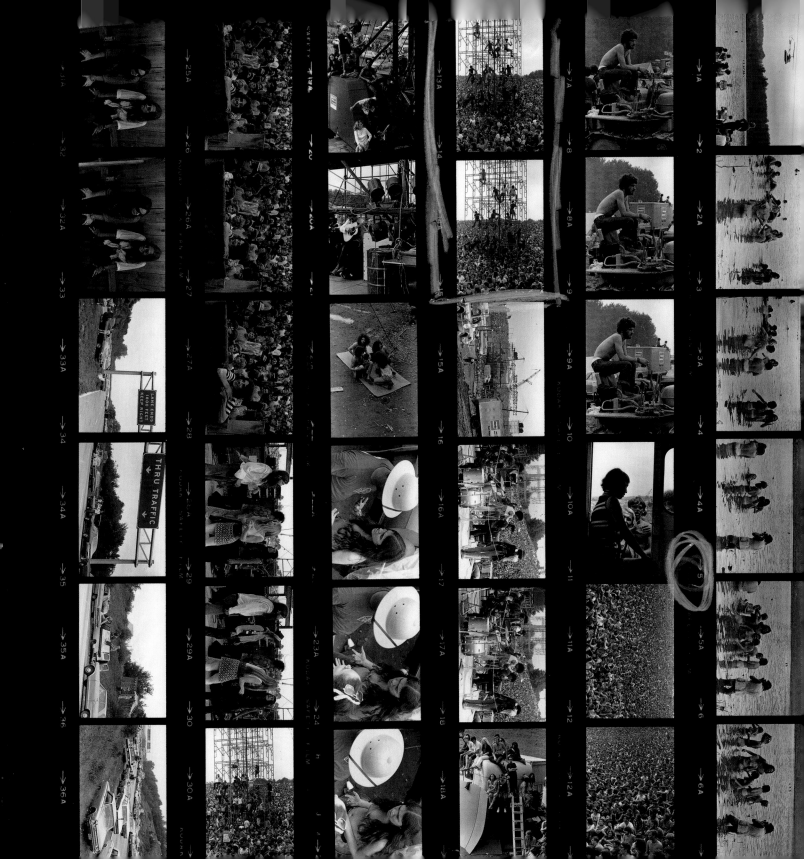

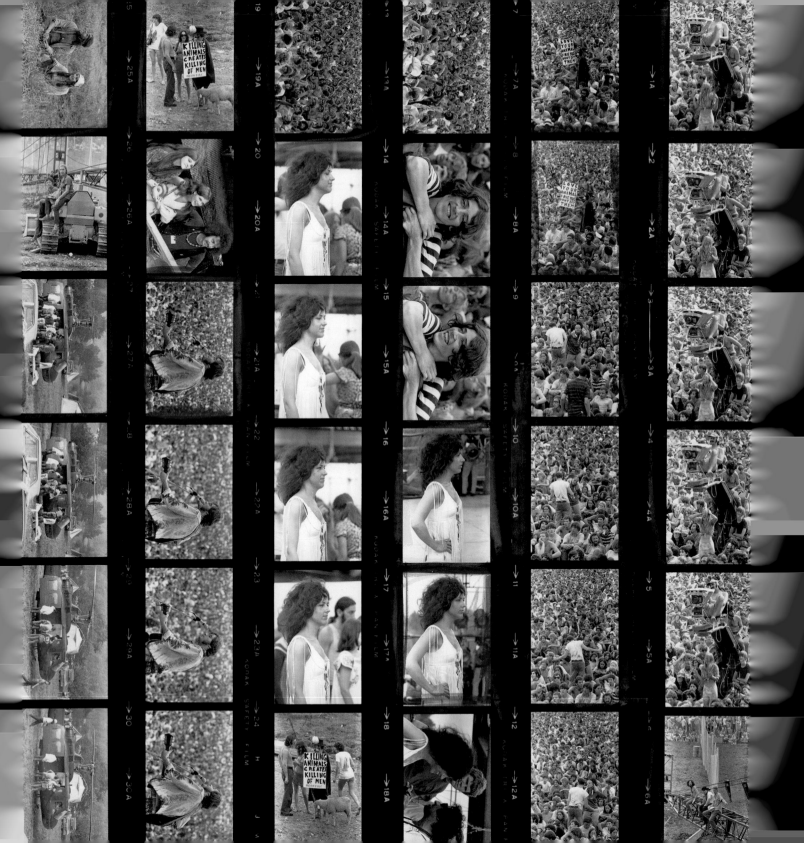

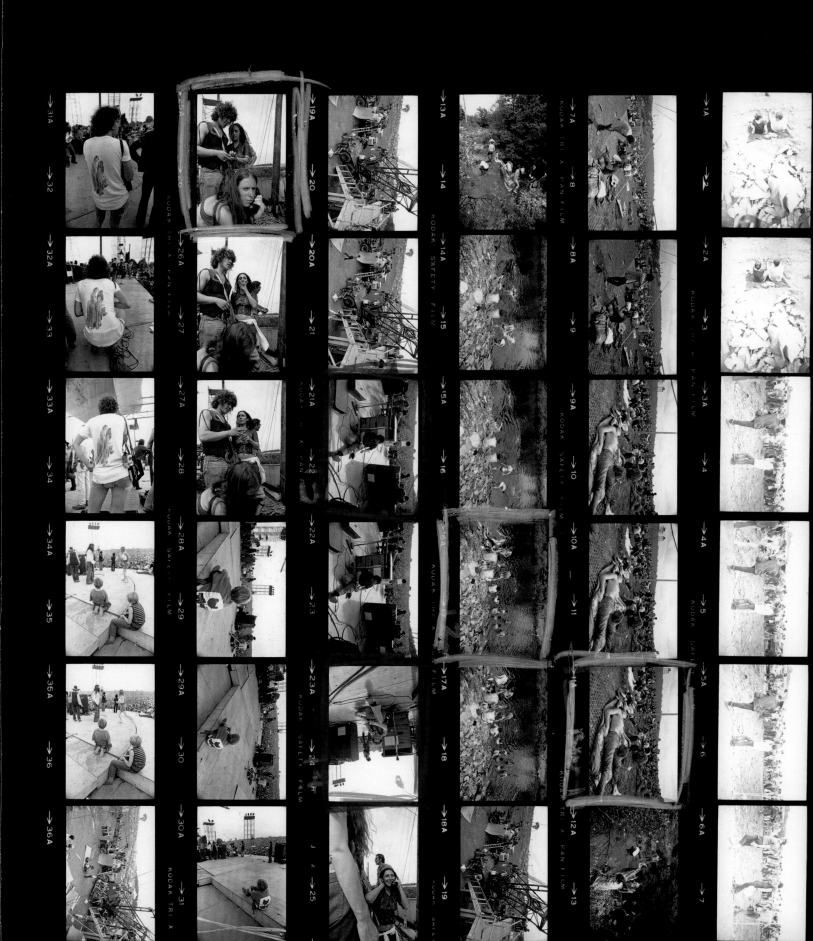

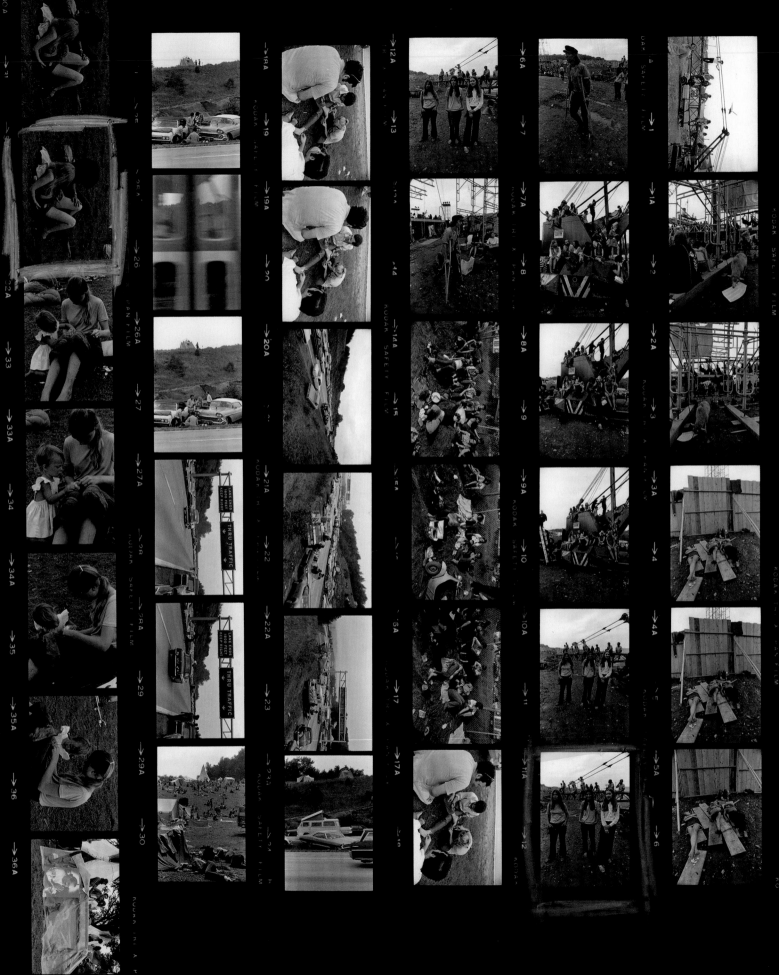

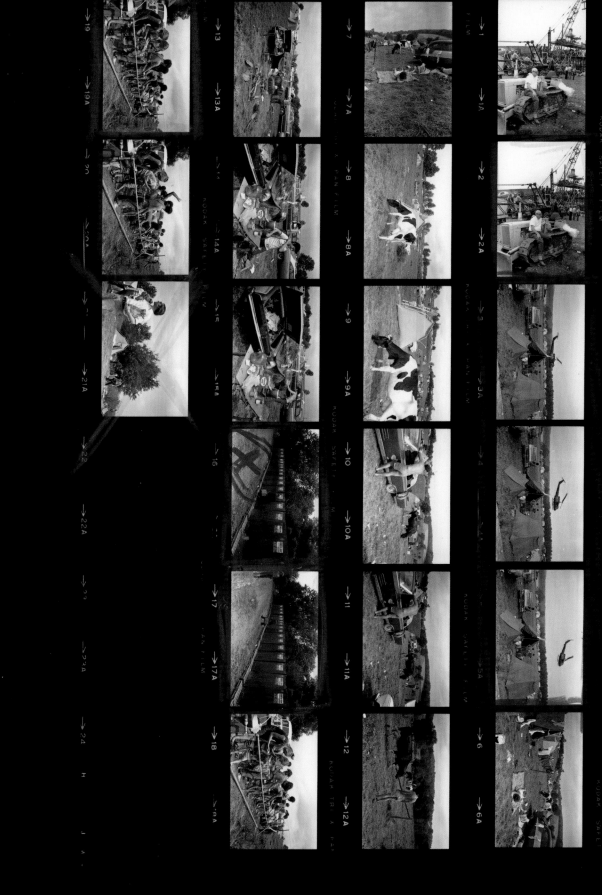

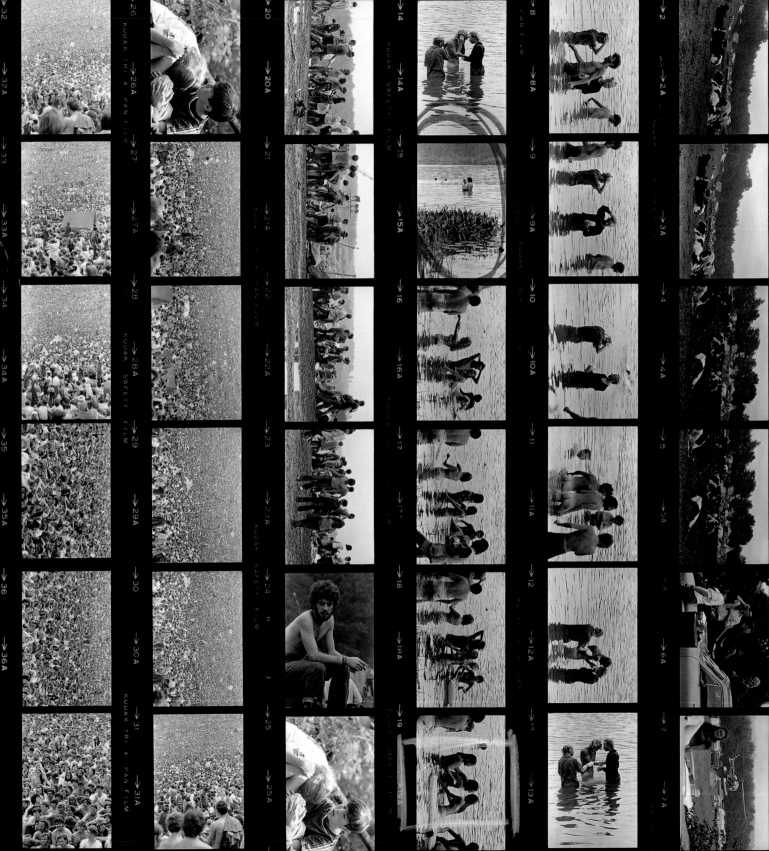

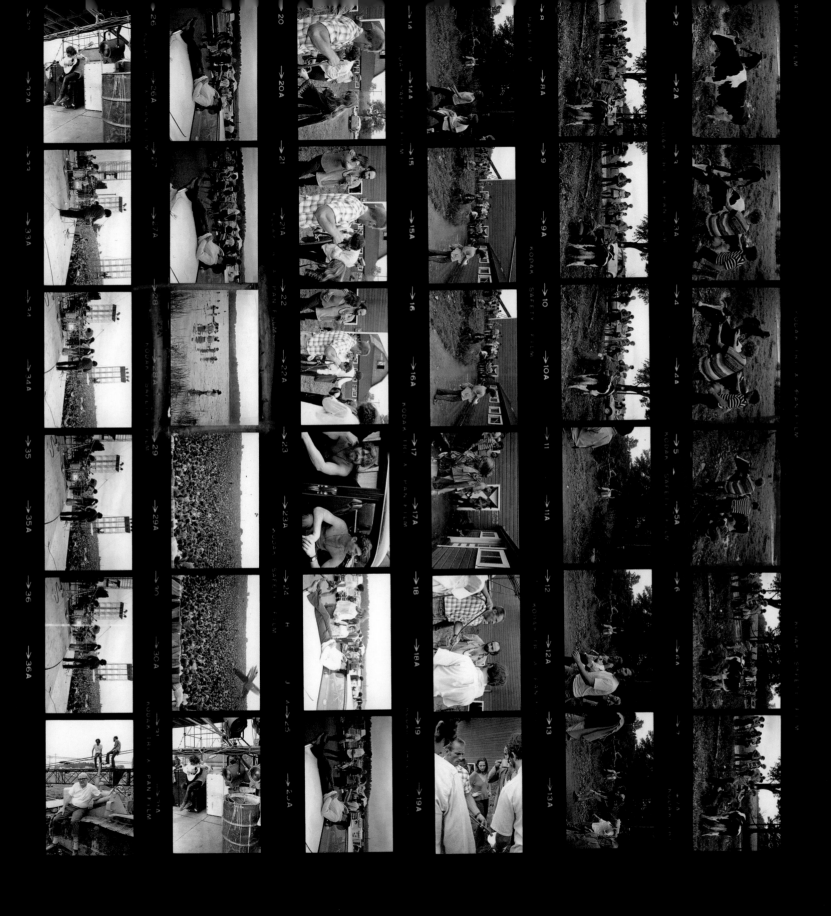

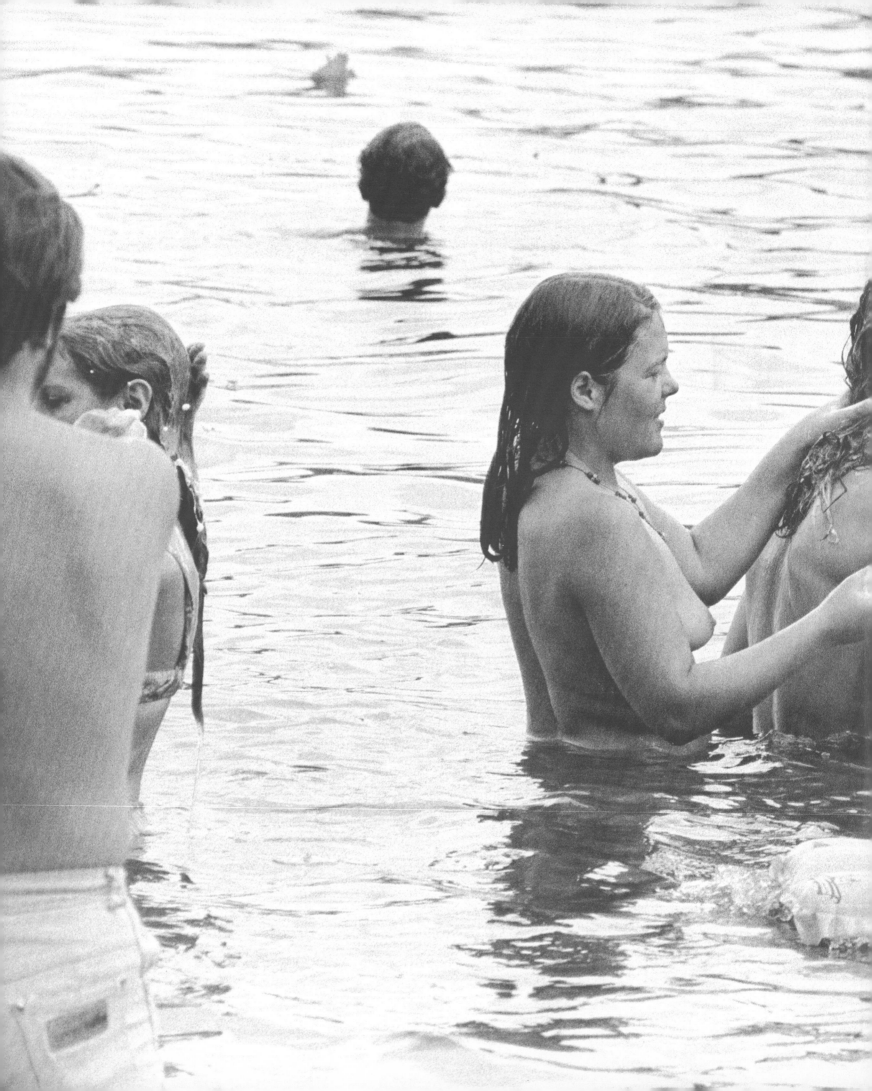

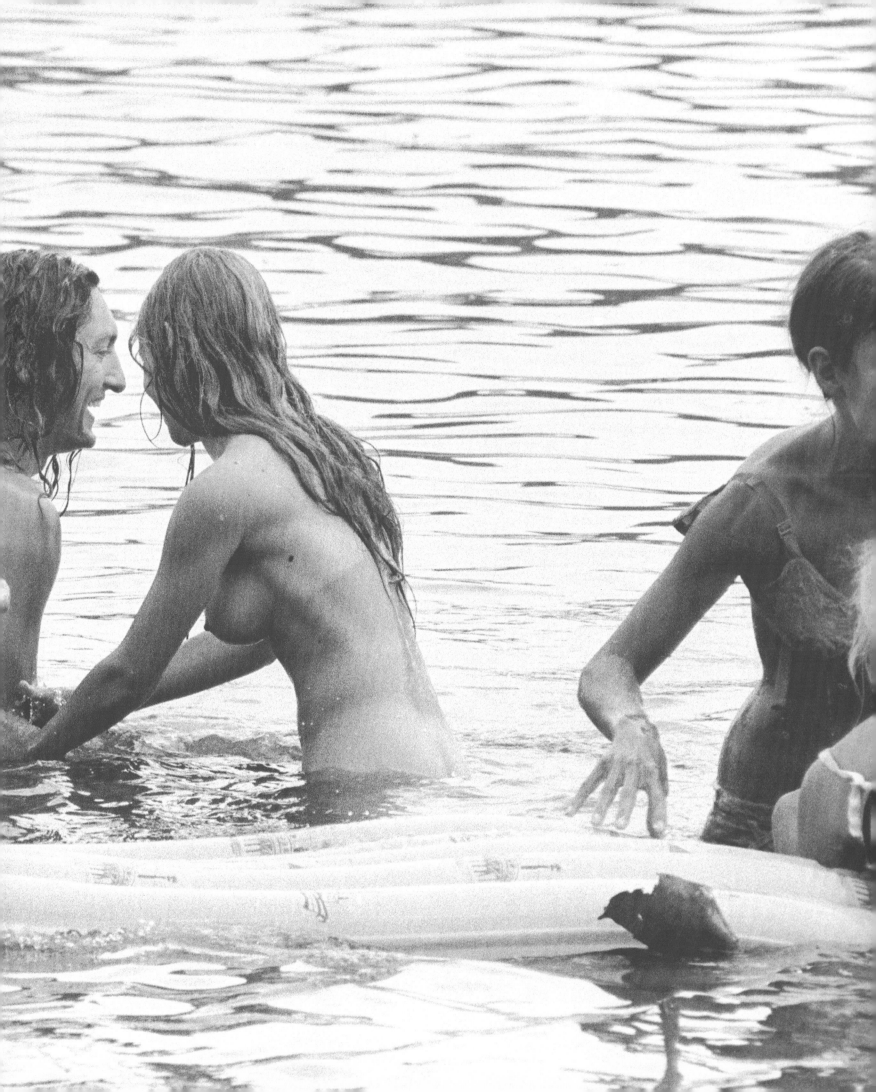

BARON WOLMAN

Baron Wolman is an American photographer best known for his work in the late 1960s for *Rolling Stone* magazine, where he became the magazine's first chief photographer in late 1967. Wolman's professional photographic career began in West Berlin in the 1960s where he was stationed with the military. From Berlin he sold his first photo essay, images of the then newly-erected Berlin Wall. After his discharge from the Army in the early 1960s, Baron moved from Germany to California. It was in San Francisco, in April 1967, that Wolman, then 30, met the 21-year-old Berkeley student Jann Wenner, who was preparing to launch a new kind of music periodical with *San Francisco Chronicle* music writer, Ralph Gleason. Wolman agreed to join *Rolling Stone*, for stock in the company rather than pay, and on the condition that he own all of the photos he took while giving the magazine unlimited use of the pictures. With virtually unlimited access to his subjects, Wolman's photographs of Janis Joplin, The Rolling Stones, Frank Zappa, The Who, Jimi Hendrix, Pink Floyd, Grateful Dead and countless others were intimate and evocative; they became the graphic centerpiece of *Rolling Stone*'s layouts. For the most part, Wolman eschewed the studio and never used on-camera strobes, preferring informal portraiture, a style appropriate to both the musicians he was documenting as well as the audience for these photographs. Wolman's personal approach was gradually supplanted by photographers making highly stylized, mostly studio images, pictures that were published only upon the approval of the musician and his or her management. This evolution can be traced on the covers of *Rolling Stone* throughout the years. Although his work at the magazine has come to define his photographic career, Wolman was involved in numerous non-music projects. After leaving *Rolling Stone* in 1970, he started the fashion magazine *Rags*, housed in *Rolling Stone*'s first San Francisco offices. *Rags* was a counter-culture fashion magazine, ahead of its time and described as "the *Rolling Stone* of fashion." Its focus was on street fashion rather than the fashion found in store windows. Creative and irreverent, the magazine's 13 issues (June 1970 through June 1971) were an artistic success. Wolman followed *Rags* by buying a plane, learning to fly, and making aerial landscapes from the window of his small Cessna. These photographs were the basis of two books, *California From the Air: The Golden Coast* (1981), and *The Holy Land: Israel From the Air* (1987). In 1974, Wolman founded a small-press publishing company, Squarebooks, which published an eclectic selection of illustrated books. In 2001, Wolman moved to Santa Fe, New Mexico, where he continues to photograph and publish.

Baron with his Nikon, his Woodstock camera of choice. Photo by Tony Bonanno.

WOODSTOCK

Foreword by Carlos Santana
Interview text by Michael Lang, Baron Wolman & Dagon James
Edited & Designed by Dagon James
Additional text by Dave Brolan

For information regarding Baron Wolman, please visit www.fotobaron.com

Special thanks to: Dallas Autrey, Dave Brolan, Amelia Davis, Rita Gentry, Stan Hoff, Judith Jamison, Paula Weber and Michael Zagaris.

First published 2014 by Reel Art Press, an imprint of Rare Art Press Ltd, London, UK
www.reelartpress.com

First Edition
10 9 8 7 6 5 4 3 2 1

ISBN Regular Edition: 978-1-909526-11-2
ISBN Limited Edition: 978-1-909526-14-3

Printed in China

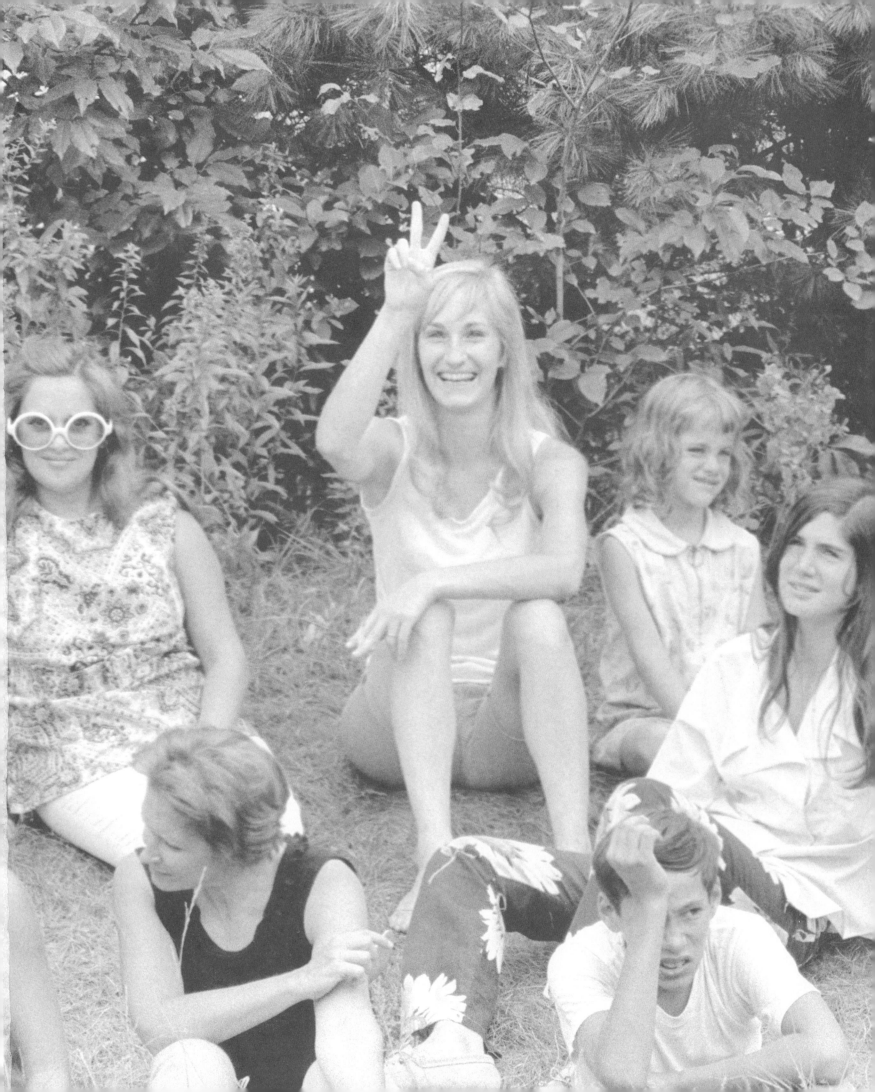

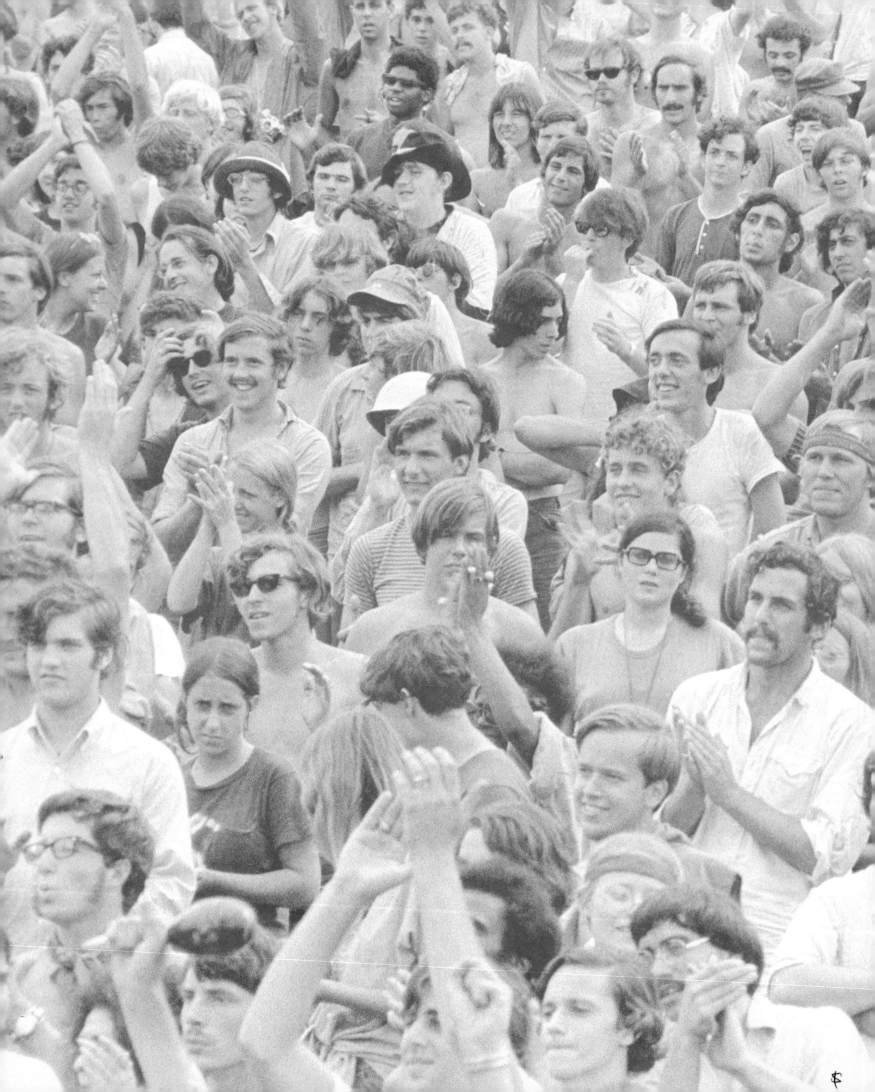